OUT OF MANY, ONE

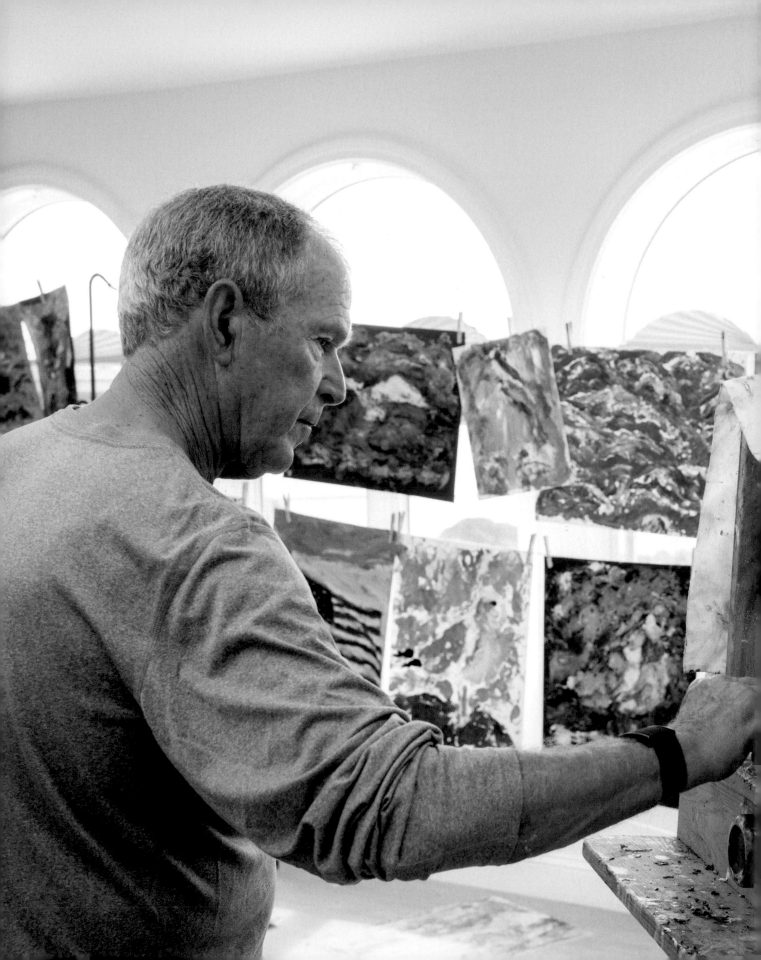

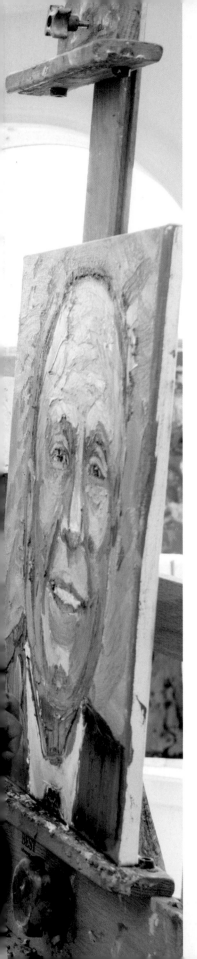

OUT OF MANY, ONE

PORTRAITS OF AMERICA'S IMMIGRANTS

GEORGE W. BUSH

CROWN PUBLISHERS
NEW YORK

ALSO BY
GEORGE W. BUSH
————

Decision Points

41: A Portrait of My Father

Portraits of Courage

Published in the United States by Crown, an imprint of Random
House, a division of Penguin Random House LLC, New York.

Crown and the Crown colophon are registered trademarks
of Penguin Random House LLC.

Library of Congress Cataloging-in-Publication Data
Names: Bush, George W. (George Walker), 1946– author, artist.
Title: Out of many, one / George W. Bush.
Description: New York: Crown, [2020] | Includes index.
Identifiers: LCCN 2020037397 (print) | LCCN 2020037398 (ebook)
| ISBN 9780593136966 (hardcover) | ISBN 9780593237588
| ISBN 9780593136973 (ebook)
Subjects: LCSH: Bush, George W. (George Walker), 1946—
Themes, motives. | Immigrants—United States—Portraits.
| Immigrants—United States—Biography. | American Dream.
Classification: LCC ND1329.B865 A4 2020 (print)
| LCC ND1329.B865 (ebook)
| DDC 757/.6—dc23
LC record available at https://lccn.loc.gov/2020037397
LC ebook record available at https://lccn.loc.gov/2020037398

Printed in Malaysia
crownpublishing.com

2 4 6 8 9 7 5 3 1

Book design by Marysarah Quinn

"Facts on Immigration" (page 200) and "Becoming an
American" (page 202) visualizations by Giorgia Lupi,
Sarah Kay Miller, and Phil Cox, Pentagram.

FIRST EDITION

CONTENTS

———

TO MY FELLOW AMERICANS

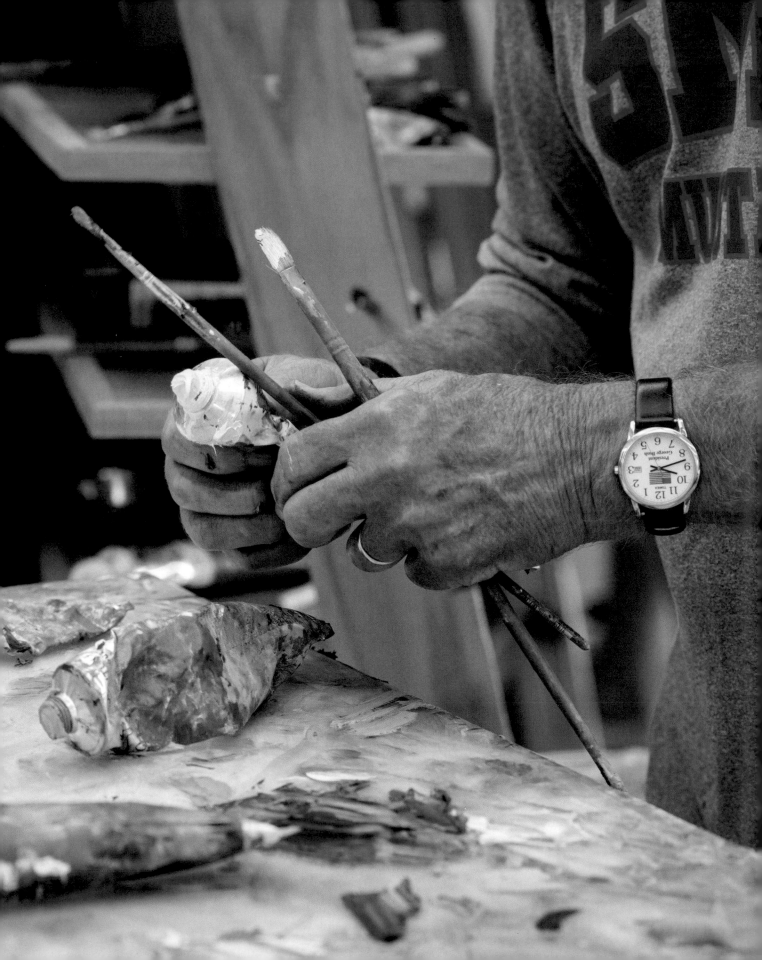

E PLURIBUS UNUM

On a stormy Atlantic crossing in 1630, one of the first immigrants to the New World wasn't sure he would make it. The Puritan John Winthrop knew that America was worth the risk, writing that it would be "a city upon a hill," a place of refuge and liberty. For nearly four centuries, immigration has been—as it will always be—a salient and, at times, controversial part of the American story. A source of strength, prosperity, and hope, the flow of people across the lands and seas has also led to bouts of anxiety and fear. Every American generation, and every American president, has confronted questions about immigration, starting with the first. In 1783, George Washington articulated a guidepost for his successors: "The bosom of America is open to receive not only the opulent and respectable stranger, but the oppressed and persecuted of all nations and religions."

One hundred seventy-five years later, John F. Kennedy published a book called *A Nation of Immigrants,* in which he explained immigration's role in our history. "The wisest Americans have always understood the significance of the immigrant," he wrote. "Among the 'long train of abuses and usurpations' that impelled the framers of the Declaration of Independence to the fateful step of separation was the charge that the British monarch had restricted immigration." The document signed on July 4, 1776, complained that the tyrannical king "endeavoured to prevent the population of these States; for that purpose obstructing the Laws for Naturalization of Foreigners; refusing to pass others to encourage their migrations hither."

President Ronald Reagan devoted a portion of his final speech at the White House to immigration. "This, I believe, is one of the most important sources of America's greatness," he said. "We lead the world because, unique among nations,

we draw our people—our strength—from every country and every corner of the world. And by doing so, we continuously renew and enrich our nation." It was President Reagan who, remembering John Winthrop's brave passage and inspiring words, taught us to think of our country as a *shining* city upon a hill"—a beacon of hope in a world of shadow.

In an attempt to reform what had over time become a broken and outdated immigration system, I spoke to the nation in 2006 from the Oval Office.

"We're a nation of laws, and we must enforce our laws," I said. "We're also a nation of immigrants, and we must uphold that tradition, which has strengthened our country in so many ways. These are not contradictory goals. America can be a lawful society and a welcoming society at the same time."

Yet for all our noble intentions of being a welcoming nation, some throughout the years have reacted negatively, and sometimes harshly, to immigrants. At times, immigration has inspired fear—fear of open borders, fear of job losses, fear of cultural degradation. Presidents have had a choice: to soothe those fears or to stoke them. History shows that the latter route should be the road less taken.

In the fog of war in 1798, when the national existence seemed at stake, John Adams signed the Alien and Sedition Acts, increasing the waiting period for applicants to become citizens and giving the President unchecked power to deport foreigners at will. To Adams and the Federalists, saving America required suspending its spirit. Many disagreed, believing that liberty must be sacred, not seasonal. In a letter to Thomas Jefferson, James Madison called the bill "a monster that must forever disgrace its parents."

Fifty years later, the sight of Europeans fleeing revolution and famine stirred up what I call the three "isms" that pop up in our country from time to time: nativism, protectionism, and isolationism. This time, they took the form of an anti-Catholic, anti-immigrant political party that came to be called the Know-Nothings.

An 1882 law barring any "lunatic" or "idiot" from the country was expanded in 1891 to send anyone considered sick back home. As the historian Jon Meacham has written, the inward-looking, shortsighted fits continued "with the Chinese Exclusion Act under Chester Arthur, and with anarchists under Teddy Roosevelt, and with punitive immigration quotas after the Bolshevik Revolution on through the 1920s and '30s (a period of 'America First'), and with refugees from the communist bloc in the early 1950s."

Today, Americans rightly worry about the consequences of a fast-changing

world and a broken immigration system. Unfortunately, as in the past, fear seems to dominate the discourse. In the process, we tend to forget the contributions immigrants make to our nation's cultural richness, economic vitality, entrepreneurial spirit, and renewed patriotism. In 2019, I decided to write this book to help us remember.

Growing up in Texas, I learned about our long history (and long border) with Mexico and the contributions Mexican-Americans have made to our state and country. As governor, I worked with Mexican authorities and honored the Latino traditions in our state. I often said that family values did not stop at the Rio Grande River—that the vast majority of immigrants who crossed our southern border were hardworking people trying to provide for their families by working jobs that America needed them to. I saw that our state's economy couldn't grow without them. I also saw how, oftentimes, undocumented immigrants were exploited by ruthless smugglers, or "coyotes," who preyed on the desperation of those seeking a better life. When I ran for President, I said that new Americans are not to be feared as strangers; they are to be welcomed as neighbors.

Throughout my life and career, I have had the privilege of seeing the profound and positive influence of newcomers. In these pages are forty-three portraits of immigrants I have come to know, accompanied by their stories. I painted people who escaped danger and difficulty, and people who came to pursue opportunities that didn't exist in their native countries. I painted the portraits of people who, in the face of seemingly insurmountable obstacles, never lost faith in their future. Many have realized the blessings of our free economy and created jobs for Americans. Those who have succeeded here have, in turn, helped others. In telling their stories, I also describe the great compassion of Americans they met along the way. I write about citizens and organizations who help newcomers resettle, and I talk about the promise of America.

Some of the people depicted are famous—athletes like Dirk Nowitzki and Annika Sörenstam, business leaders like Indra Nooyi and Hamdi Ulukaya, and public servants like Madeleine Albright and Henry Kissinger. Others are lesser known but equally important. One of the first stories is about one of the first immigrants I ever knew. Paula Rendon came from Mexico to help my parents with our household and over time became like a second mother. Jeanne Celestine Lakin escaped genocide in Rwanda; Florent Groberg came from France and earned the Medal of Honor in Afghanistan.

Many in this book are participants in Bush Institute programs. I've included several graduates of the Presidential Leadership Scholars program, or PLS—a collaboration between my presidential center and those of President Clinton, my father, and President Johnson that teaches leadership through the lens of presidential decision-making. I wrote about Kim Mitchell, who was adopted as an infant by an American serviceman after her mother was killed in the Vietnam War. She went on to serve honorably in the United States Navy and graduated from the Bush Institute's Veteran Leadership Program. The first story in the book is of Joseph Kim, a recipient of our North Korea Freedom Scholarship. As a young boy, Joseph survived alone on the streets of North Korea as a beggar and overcame unspeakable odds to escape to America and contribute to his new land.

As I researched the stories of these unique men and women from thirty-five different countries, consistent themes emerged: their resilience and perseverance, their patriotism, their generosity, and perhaps most of all, their gratitude. To a person, they expressed profound thanks for being here and determination to make the most of every opportunity. That's what I hope readers come away with—a renewed sense of gratitude for the freedoms we sometimes take for granted, and for these remarkable people who choose to live among us. I regret that I wasn't able to honor more from countries like Italy, Japan, Australia, England, and Brazil, whose expatriates make up the fabric of America.

I delayed the publication of this book so as to avoid the politics of a presidential election year. I did not want the people I painted to become exploited politically. While I recognize that immigration can be an emotional issue, I reject the premise that it is a partisan issue. It is perhaps the most American of issues, and it should be one that unites us. After all, we are a nation of immigrants. As I have often said, at its core, immigration is a sign of a confident and successful nation. It says something about our country that people all around the world are willing to leave their homes and their families to risk everything and come here. Becoming an American citizen is challenging, time-consuming, and competitive—as it should be. The immigration system is also confusing, costly, and inefficient, and needs to be fixed.

The way forward will not be easy, but we must update the laws. At the Bush Institute, we don't propose to have all the answers or a permanent fix. We do put forth principles to comprehensively address the challenges of our era through policy that protects our homeland, grows our economy, and enriches our soul.

We are focused on the need to enforce our borders as well as the critical contributions immigrants make to our prosperity and way of life.

My hope is that this book will help focus our collective attention on the positive impacts that immigrants are making on our country. Proceeds will benefit organizations mentioned within these pages that help immigrants resettle, as well as the Bush Institute and our work on this issue. As I write this in 2020, a devastating pandemic is destroying lives and livelihoods around the world. At home, thousands of immigrants are on the front lines of this struggle, many in critical roles replenishing our food supply, defending our security, maintaining our infrastructure and utilities, and saving lives in the field of health care. They remind us that a comprehensive immigration solution deserves our serious attention, our benevolent spirit, and our sober analysis.

As I said in 2006, "Our new immigrants are just what they've always been—people willing to risk everything for the dream of freedom. And America remains what she has always been: the great hope on the horizon, an open door to the future, a blessed and promised land. We honor the heritage of all who come here, no matter where they come from, because we trust in our country's genius for making us all Americans—one nation under God."

On American currency, you will find the Great Seal of the United States. Since Congress adopted it in 1782, it has displayed the words *E PLURIBUS UNUM*—Latin for "Out of Many, One." The motto refers to our country's makeup of many states and many backgrounds. It is a nod to one of our greatest strengths—our unique ability to absorb people from different backgrounds and cultures into one nation under God. To forever remain a shining city upon a hill, a beacon of liberty, and the most hopeful society the world has ever known, America only needs to remember that strength.

GEORGE W. BUSH
Dallas, Texas
June 2020

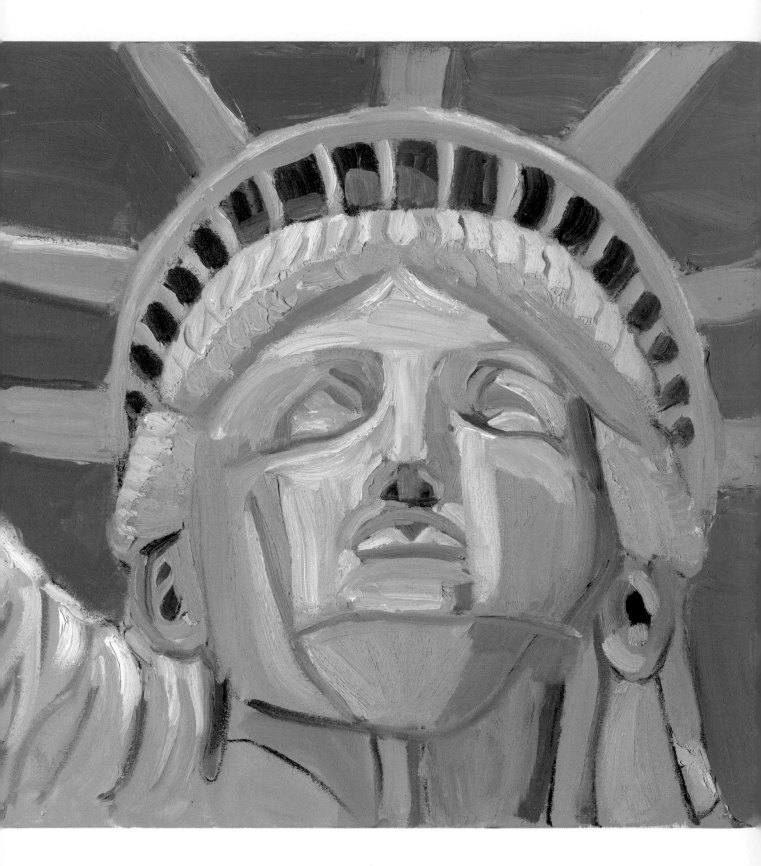

THE NEW COLOSSUS
by Emma Lazarus

Not like the brazen giant of Greek fame,

With conquering limbs astride from land to land;

Here at our sea-washed, sunset gates shall stand

A mighty woman with a torch, whose flame

Is the imprisoned lightning, and her name

Mother of Exiles. From her beacon-hand

Glows world-wide welcome; her mild eyes command

The air-bridged harbor that twin cities frame.

"Keep, ancient lands, your storied pomp!" cries she

With silent lips. "Give me your tired, your poor,

Your huddled masses yearning to breathe free,

The wretched refuse of your teeming shore.

Send these, the homeless, tempest-tost to me,

I lift my lamp beside the golden door!"

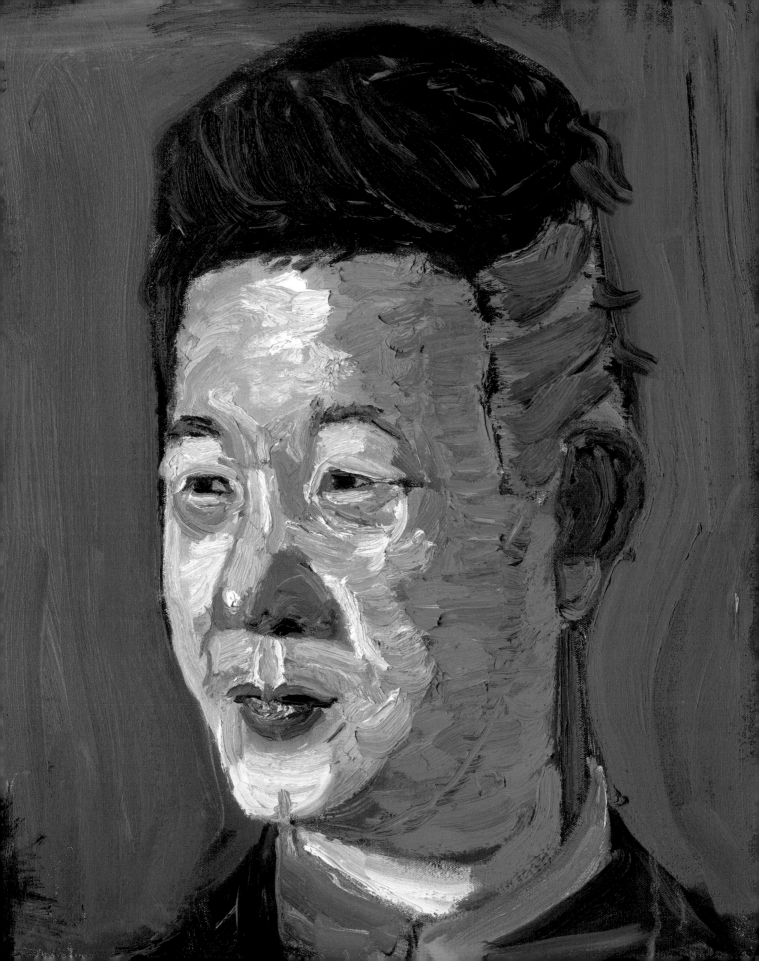

JOSEPH KIM

"The first Bible verse I read was Matthew, chapter eleven, verse twenty-eight: 'Come to me, all you who are weary and burdened, and I will give you rest.'"

DURING ONE OF OUR MEETINGS in the Oval Office, Henry Kissinger recommended I read *The Aquariums of Pyongyang*, the horrifying true story of a North Korean who escaped from one of Kim Jong Il's prison camps. I was so moved by the account that I asked to meet the author, Kang Chol-hwan. He came to the White House and put a human face on the human rights abuses going on in North Korea, which I believe are as grave a problem as the regime's pursuit of nuclear weapons.

For the remainder of my presidency and in the years since, I have made it a point to regularly meet with North Korean refugees. At the Bush Institute in 2015, I asked a young man named Joseph Kim about his experiences under the dictatorship and his dreams for his new life in America. He was charming and compelling, but he struggled with the question.

"I had never had a real dream before," Joseph explains. "When I was on the streets as a homeless beggar, my dream was to have a day where I could eat three meals. Then when I came to the United States, food was no longer an issue. I did not know what to do with my life in the US and was totally overwhelmed by the grand freedom that I suddenly had."

Joseph grew up in Hoeryŏng, North Korea, on the southeastern bank of the Tumen River along the Chinese border. "The famine took about two to three million people, and my father became one of them when I was twelve," he says. As the rest of Joseph's family faced starvation, his great-uncle selfishly suggested that Joseph's mom and sister sneak into China to earn enough money to support the family—including the great-uncle. Joseph's mom returned alone with the equivalent of about $200.

Joseph explained what had happened to his sister, Bong Sook, in his memoir, *Under the Same Sky*: "Seven out of ten refugees who leave for China are females; eighty percent of them become bride slaves. It's a sad fate, but not uncommon. My mother, who had no money to feed Bong Sook, must have felt she had no other choice. Perhaps she was trying to save me by letting go of my sister. And being a bride slave is not the worst thing that can happen to North Korean girls. Others cross the border, led by Chinese or North Korean guides, and become sex slaves."

It crushed Joseph. "What I thought would be a short separation with my sister turned out to be a goodbye. One of my greatest regrets in life is that I did

not give my sister a hug the night she left," he says. To make matters worse, the North Korean authorities found out what had happened and sent Joseph's mom to a labor camp, where she died.

"To become a homeless orphan all of a sudden—it means you see your friends rejecting you. It means being stripped of all the humanity and pride that you used to have," Joseph says. "For the next three years, I was on the street. I would sleep in abandoned trains or under the bridges. Anywhere that can protect you from the wind. My hometown was near Siberia, so the weather was not friendly, for sure."

Some days, Joseph found work in a coal mine. Compensation consisted of lunch and as much coal as he could carry back at the end of the day. At his age and size, he counted himself lucky if he could make the two-hour walk to town with enough to sell for a paltry dinner of dandelion soup or rice.

"The first stage of homelessness is the hardest: you must learn how to break your pride," Joseph says. Even after going days without eating, he was ashamed to beg—especially when everyone around him was also impoverished. "You realize that begging is not a solution, because there is no guarantee."

Joseph says the next stage of homelessness, pickpocketing and theft, took boldness and patience. And the tactics didn't always yield results. "It's a lifestyle that is not sustainable," he says. "I don't have a recollection that anyone survived over the age of twenty. You're living on adrenaline. So I basically said, 'Enough is enough. I can't live this way.'"

At the age of fifteen, Joseph decided to try to escape and find his sister in China. He knew the chances of surviving were low, but at this point, he didn't see any other options. So he went all in. "I realized I hadn't heard a single story about someone who tried to cross during the daytime," he says. "It's almost committing suicide." On February 15, 2005—the day before Kim Jong Il's birthday, a national holiday when security was rumored to be even higher—Joseph went for it. "I didn't have a lot to pack, so that saved me time," he jokes. He ran across the frozen Tumen River and snuck across the border into China.

"I climbed a mountain to a pagoda and looked across at my hometown, the city where I spent all my life. All the memories, whether happy or sad . . . it was surreal, and I was just crying," Joseph recalls. "My plan was to find my sister, get some money, and go back to North Korea. I thought that everyone lived in that city until you died. That was my understanding of life. It just didn't occur to me

to think about living in China, and definitely not coming to the US. That was just beyond my imagination."

First, he had to find something to eat. He thought he would have more luck at the bigger, nicer houses, but no one helped him. Eventually he knocked on the door of a hut that "didn't look any better than the homes in North Korea. And the first thing this man said was, 'Yes, of course, you are my compatriot,'" Joseph says. The poor Chinese man, of Korean descent, gave Joseph rice, cigarettes, and directions to the village where he hoped to find his sister.

He walked through the mountains for three days, keeping the river in his sight for navigation and sleeping in the snow-covered valleys along the way. When he reached the home of the man who had sold his sister, Joseph learned he had died two days earlier. "My hope was completely shattered. I didn't know what to do," Joseph says.

An elderly woman Joseph came across suggested that he find a church for support. He didn't know what a church was, or who God was, and he didn't really care. He just wanted help. For weeks, he wandered from town to town, begging for food and shelter. He was welcomed at churches, which were often undiscovered or ignored by authorities in that part of the country. "The first Bible verse I read was Matthew, chapter eleven, verse twenty-eight: 'Come to me, all you who are weary and burdened, and I will give you rest.'" It was written on the wall of a church Joseph entered. When he came back a second time, the pastor's wife invited Joseph to stay with them. "I felt like a human again," he says.

Eventually, a South Korean missionary working in China offered to buy the boy clothing, food, and the possession he wanted most: a soccer ball. Then she offered one more thing. "I want to help you go to America. I can't help everyone, but I want to help you." With assistance from Liberty in North Korea, an organization started by students at Yale University, Joseph boarded a train and traveled to the American consulate in Shenyang.

North Korean propaganda was all Joseph knew of Americans—"horrendous images of American soldiers killing innocent North Korean people," he explains. The United States Marines guarding the consulate melted those perceptions away. "None of them had the ugly noses I saw from the images I had grown up with," he laughs. "They would sneak in and give us candy or pizza. None of us could understand a word of English, so they would show their muscles and basically say, 'If you eat this, you'll look like this.' Sometimes we played Hacky Sack, and they

taught me the proper way of doing push-ups. My interaction with the Marines really helped me get to know America in a healthy way."

After four months living in the consulate, Joseph's refugee paperwork cleared, and he flew to Richmond, Virginia, where Catholic Charities found him a foster home. Describing his feelings when he graduated from James River High School four years later, he says, "I felt like a newborn baby. I didn't know anything about society. I was not ready to become independent, and I was nervous because my tactics surviving in North Korea and China were not applicable." He had heard the saying that if you can survive in New York City, you can survive anywhere, so he decided to test himself. Soon after arriving in the Big Apple, he once again found himself starving and alone. Once again, he survived.

Joseph worked during the day and took community college classes in the mornings and at night. After two and a half years, he gained acceptance to American University, Hunter College, and Bard College. He was awarded a full-tuition scholarship to Bard, where he earned a bachelor of arts in political science in December 2018. A scholarship from the Bush Institute helped cover his room and board.

Joseph was the first person I painted for this book for two reasons. One, I want Americans to know about the human suffering that still affects millions of North Koreans. And two, it was easy to get his photo. Joseph's office is just downstairs from mine at the Bush Institute, where he works as an assistant and expert in residence in our Human Freedom Initiative. He is a cheerful, friendly, funny, and talented member of our team. And, five years after our first meeting, he no longer hesitates when asked to describe his dream: to reunite with his sister, open up an orphanage, and help Korea become free and united. In the meantime, Joseph helps remind Americans about the blessings of liberty in his new land.

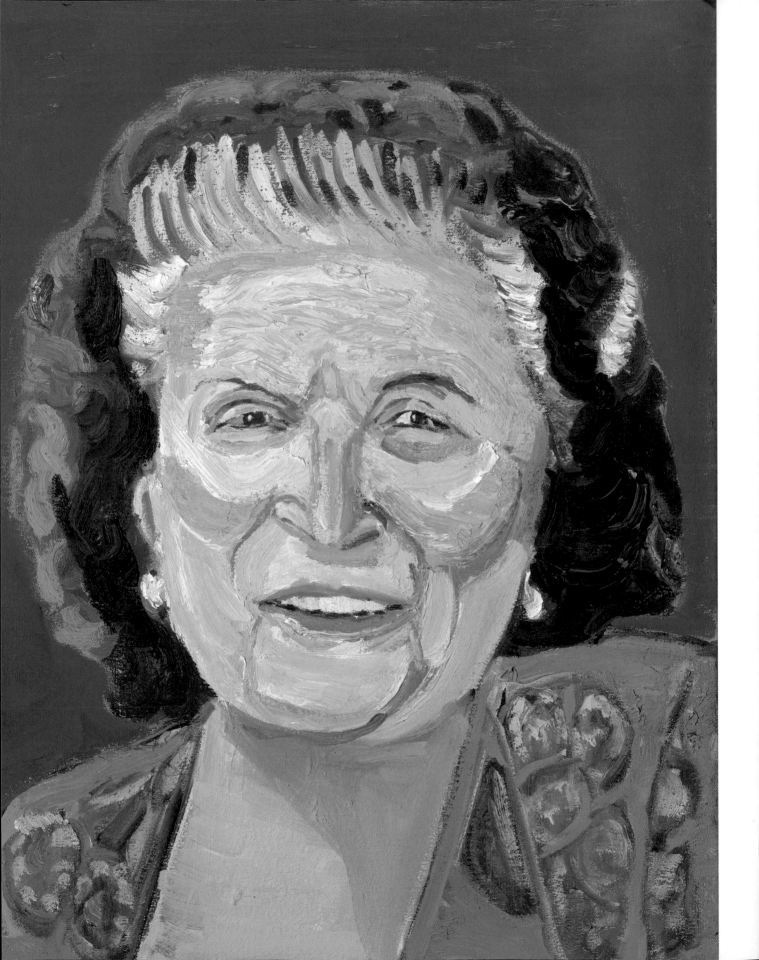

PAULA RENDON

O N A RAINY NIGHT IN 1959, the doorbell rang at 5525 Briar Drive in Houston. I was thirteen years old. When I answered the door, a tiny woman huddled in a raincoat was standing there carrying a small suitcase. She seemed scared and timidly said, "Hola, I'm Paula."

I didn't realize at the time what a life-changing moment it would be for me, Paula, or our families. Over the next six decades, Paula became an integral part of our family. She was like a second mother to my siblings and me. The first immigrant I really knew showed me how hardworking, family-oriented newcomers add to the cultural fabric, economic strength, and patriotic spirit of America.

I had three young brothers—Jeb, Neil, and Marvin—and a newborn sister, Doro. My parents had decided they needed help with our growing family. (Well, mostly my brothers and me, who were responsible for turning our mom's hair white at a young age.) An agency referred them to Paula Hernandez Rendon, who was living in Cuernavaca, Mexico. She had a small house with a dirt floor. Her husband had recently passed away, and she was coming to Texas to better the lives of her three children. In doing so, she bettered our lives, too.

All of us have vivid memories of Paula. "She was uncomplaining, hardworking, and a most loving influence in our lives," my brother Neil says. "I always thought I was her favorite because she had a twinkle in her eye when she called me by her nickname for me, '*ojos azules*' (blue eyes)."

Marvin remembers staying up late watching reruns of *Bonanza* and *Gunsmoke* with her—Paula learning how to speak English, Marvin learning how to be a cowboy. "When my parents' car would pull up in the driveway, she'd throw me off her lap and yell, 'Get in bed!'" Marvin recounted while admiring Paula's framed photo in his office.

"She let us throw away our vegetables without getting caught," Jeb says. "She secretly gave me her green sauce recipe, which I use today."

Doro remembers sitting in the kitchen watching Paula cook homemade tortillas or sew dresses that Doro would wear to grade school. "They were beautifully done—even though the patterns Mom picked out were ridiculous," she laughs.

"There was nothing more gratifying than being in the kitchen when those fresh tortillas were coming off the grill," Marvin says. "When I was sick, she would feed me a big flour tortilla with lots of butter and salt, and we were convinced those provided medicinal benefits."

Paula's devotion to our family was second only to her devotion to her own children. She saved money to bring Alicia, Teresa, and Luis to the United States. They all became proud American citizens. When Dad was elected President, Paula—a Mexican-American immigrant who had risen from poverty—moved into the White House with him and Mom. "I don't think Dad would have become President without Paula Rendon," Marvin says. "Her presence gave Dad, and Mom, the comfort to travel and build the relationships that were essential to Dad's career success."

She spent the summers working at Walker's Point, our family's home in Kennebunkport, Maine. Mom posted rules on the bedroom doors for the grandkids. Number seven was, "Ask Paula if you can help her." At the end of every season, Mom gave out bonuses to the local high school students who worked on the property. Coleman Lapointe, one of my dad's aides, recently told us that Paula would secretly slip $500 to each of the "summer lads" on top of whatever Mom gave them. We never had any idea. That was typical of Paula.

Mother and Dad set up a generous retirement plan for Paula, but she had become such an important part of our family, and vice versa, that she refused to retire. At age ninety-five, she continued to help Mom oversee the household. As Doro puts it, Paula did more bossing than working in her later years, but all that mattered to us was that she was there. "She was a constant," Doro says. "We were so lucky to have her. Who stays for fifty-six years? Especially after all the grief my brothers gave her."

When I set out to work on this book, I narrowed the vast pool of worthy subjects by deciding to write about first-generation immigrants who are still alive. Sadly, Paula died in February 2020 at the age of ninety-seven, shortly after I finished painting her. Four generations of Mexican-American family members

attended her funeral. On that day, Elysia Ramirez, one of her thirty-six great-great-grandchildren, gave a touching eulogy:

> *This incredible woman went from making* huaraches *[sandals] with my great-great-grandfather, to owning her own torteria, to finally accomplishing one of her earliest aspirations when she came to the United States to work for the Bush family. This opportunity allowed her to bring her children to the United States. She loved kids and flowers. She was of strong Catholic faith. She never forgot where she came from, and she always remembered to give back to people less fortunate than her. "Recuerda a tus paisonos"— "Remember your countrymen"—is what she would always say. She could never stand a dirty home. She made that "hmmph" sound if there was something she did not like or approve of. And she let you know if you were overweight.*

Doro says that she probably cried more at Paula's funeral than she did at our mom's. "Not that I loved Mom less," Doro says, "but Paula was really part of our family." In a way, she was the last of our family to pass from that generation, and we will miss her.

We learned a lot from Paula. She taught us what it means to work hard. She taught us what it means to sacrifice for family. And she taught us to be grateful to immigrants, who keep the American dream alive by realizing it and passing it along to new generations of diligent, determined United States citizens.

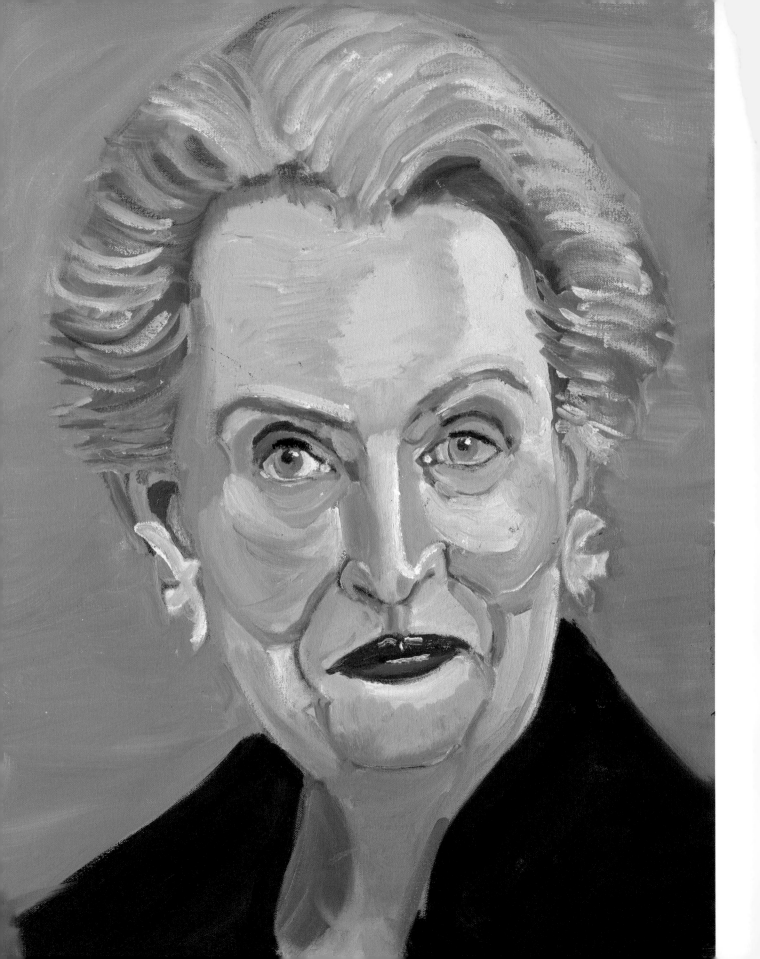

MADELEINE ALBRIGHT

"I believe in the goodness of America and our capability to help people in other countries."

I'M PROUD THAT OUR COUNTRY has the confidence to choose American immigrants as our top representatives on the world stage. And I'm pleased to honor two such Secretaries of State in this book: Henry Kissinger (page 31), who served under Republican Presidents, and Madeleine Albright, who served under a Democratic President.

Secretary Albright remembers participating in a naturalization ceremony on July 4, 2000, at Thomas Jefferson's home of Monticello. "I was handing out the naturalization certificates, and all of a sudden I heard this man say, 'Can you believe I'm a refugee, and I just got my naturalization certificate from the Secretary of State?' I went up to him afterward and said, 'Can you believe that a refugee is Secretary of State?' That, to me, is the epitome of the American dream."

Madeleine was born Marie Jana Korbel in Prague, Czechoslovakia, in 1937—just a year before Adolf Hitler's troops crossed the border and annexed the Sudetenland. "My family escaped to England," she says, "where we spent World War II in London during the Blitz and then outside of London." She still remembers huddling under a metal table for protection during Nazi air raids.

When the war ended, the Korbels moved back home to Czechoslovakia. Months later, however, there was a coup. After fleeing Nazism just a decade earlier, the family fled again—this time from Communism, and this time for good.

"We came to the United States on the SS *America*, a glorious ship with a wonderful name, arriving on November 11, 1948, and sailing by that wonderfully welcoming figure, the Statue of Liberty," she recalls. The family moved to Long Island, near Lake Success, the temporary home of the United Nations. She remembers singing "We Gather Together" that Thanksgiving—Madeleine's first—and asking for God's blessing. "I asked because I wanted to be an American," she explains.

The Korbels headed west when the University of Denver hired Madeleine's father, Josef. He went on to become dean of what is now called the Josef Korbel School of International Studies. I can vouch for his prowess as an educator in the subject. One of his students, Condoleezza Rice, became a successor of Madeleine's when I appointed her Secretary of State.

Madeleine showed an early interest in her father's passion. As a high school student, she started Kent Denver School's international relations club and served as its first president. She then went to Wellesley, where she received the blessing she had asked for a decade earlier—becoming a naturalized American citizen.

From there, Madeleine continued her studies at Johns Hopkins University's School of Advanced International Studies and eventually Columbia University, where she picked up her PhD in public law and government.

One of her Columbia professors, a fellow European immigrant named Zbigniew Brzezinski, took note of her. A few years later, after being named National Security Advisor by President Carter, "Zbig" recruited Madeleine to the White House. It was the start of an impressive career in foreign affairs.

In 1992, President Clinton appointed Madeleine Ambassador to the United Nations. And in 1997, he promoted her. "I never dreamed that I would be a part of US history as the first woman Secretary of State," she says. "To be able to come here as a child, to have positions that allowed me to have some influence over how the United States behaves abroad, to do some good and feel that I have made a difference . . . I really am proud to be an American—a grateful American."

Madeleine is particularly proud of the work she did in the Balkans during her time in office. "In 2019, I was able to go to Kosovo to celebrate the end of the war that freed them from ethnic cleansing and walk through hundreds of people waving American flags, saying, 'Thank you, USA. Thank you, USA,'" she says. "I believe in the goodness of America and our capability to help people in other countries."

While Madeleine and I come from different political parties, we have become friends. I respect her love of country and public service. She has generously joined Laura and me at Bush Institute events, where she once joked that I shocked her by being a President who arrives on time or early.

Ultimately, we're just a couple of proud American grandparents. "Every day," she says, "I wake up and make clear to everyone who will listen to me that I'm a grateful American. I have three daughters, all of whom are married, and six grandchildren. And they all make me very happy."

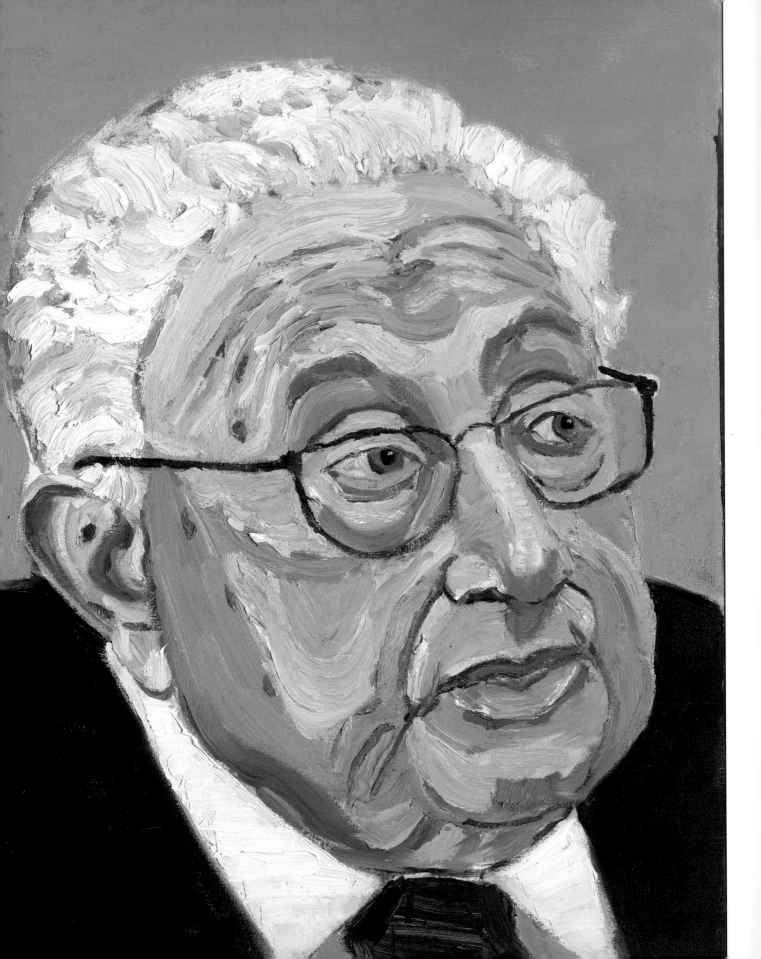

HENRY KISSINGER

T O M Y E A R , there is no voice more unmistakable than Dr. Henry Kissin-
ger's, and none more authoritative on world affairs. As I write this, I'm
somewhat reluctant to refer to him by his first name because of his stature and
my high regard for him. Plus, I can hear Mom shouting from the grave, "Respect
your elders!" But he is a dear friend, and I'm honored to know the great statesman
as Henry.

He was born Heinz Alfred Kissinger to Jewish parents in the small town of
Fürth, Germany, in 1923—five years after the armistice that ended World War I
and ten years before Adolf Hitler became dictator. "I was a discriminated minor-
ity as a child once Adolf Hitler took power," Henry explains. Soon, his mother
was shunned by the very people with whom she had grown up. His father lost his
job as a history teacher because of his faith—and with it, his pride. "He never
recovered from that," Henry says. As anti-Jewish sentiments whipped up by the
evil Führer reached a fever pitch, Kissinger's family decided to flee to America.

"I came to this county as a refugee in 1938," he says. They boarded a French
passenger ship and arrived in New York Harbor on Labor Day. They had only
one case of belongings. Henry enrolled in George Washington High School.
When he reached the minimum working age the next year, Henry got a job at
a shaving brush factory during the day and went to school at night, eventually
studying to become an accountant. He would have become one, he says, if he
hadn't been drafted in 1943.

"It was really the Army that brought me into America," he explains. Indeed,
Henry became a naturalized citizen alongside his fellow soldiers at a ceremony in
Spartanburg, South Carolina, during basic training. There was prejudice toward
Germans in America at the time. But he recalls being welcomed unconditionally

by the men in the Eighty-Fourth Infantry Division from Illinois and Wisconsin. "Nobody ever asked me about my accent. I thought I had lost it," he jokes.

His unit deployed to France, then the Netherlands. "Then—how accidents change your life—I was on latrine duty one day," he laughs. "And the general of the division came by the company in which I served, and he said, 'Soldier, come here.' There was a battle map on the wall. And he said, 'Explain this map to me.' So I did." Henry's presentation was so impressive that the general transferred him to the intelligence section. Thus began Henry Kissinger's seventy-five-year-and-counting career looking after America's national security interests.

"After the war, under the GI Bill of Rights, I got a big break when they let me into Harvard," Henry says humbly. He earned a bachelor of arts in political science summa cum laude (and capped it off by writing a four-hundred-page thesis). He then completed MA and PhD degrees. Henry joined the faculty and published articles on international affairs while consulting for the National Security Council and contributing to the Council on Foreign Relations.

Henry Kissinger became a household name when President Richard Nixon made him his National Security Advisor in 1969 and Secretary of State in 1973. I asked Henry what it meant to represent America abroad as someone who was born abroad. "I considered it an honor," he says. "To me, America has always had a magic quality as a symbol to the world and as an example to itself. Here was the greatest country in the world having a foreign-born who still spoke with an accent as Secretary of State."

Secretary Kissinger's time in office had a profound effect on the world, perhaps most significantly in the Far East. "China was in the midst of the Cultural Revolution," he remembers, "and they had no contact with most countries in the world. So we thought the first thing was to establish a way of talking to each other."

During a trip to Pakistan in 1971, he faked an illness and took a secret flight to China to meet with Premier Zhou Enlai. At the height of the Cold War, the stakes could not have been higher. Finding an opening with the USSR's neighbor was of vital strategic importance to the United States. "There were so many disagreements between China and the United States that if we started with any of them, we could get deadlocked," he says.

Henry secured an invitation for the American President to visit China. The next year, Nixon's historic trip shocked the world. The breakthrough resumed diplomatic relations between our countries after a twenty-five-year rift, opening

up a vast market for American goods and services and helping shift the balance of power in our favor during the Cold War.

As Henry approaches the century mark, he isn't showing any signs of slowing down. In 2019, Henry kindly agreed to come to Dallas for a conversation on *World Order,* his most recent book. "I came here for three hours and an eight-hour plane trip and consider it an honor to have been asked," he told the audience with a chuckle.

Ken Hersh, the president and CEO of the Bush Center, asked Henry whether he thought true statesmanship is possible in the Twitter era. "You may find it hard to believe," Henry deadpanned, "but I have never consulted Twitter for anything." As the conversation moved toward emerging global threats and opportunities, he showed he was more than up to speed on modern technology. "In my ninety-fifth year, I became fascinated by the problem of artificial intelligence," he said. Henry has studied it with the appetite of a young PhD student and published papers on the topic.

Henry is finishing up his eighteenth book, a case study of leadership. And he still provides counsel to Presidents, as he has done for every administration since Kennedy's. I was fortunate to meet with him often during my own time in office. He gave me the best kind of advice a President can receive: sound, intellectual, and confidential.

On January 20, 2009—my final morning in the Oval Office—I sat down at the Resolute Desk and wrote to some of the people who had been most important to me during my presidency. "I am thankful for the people with whom I have worked and for the friends who stood by me," I wrote to Henry. "I thank you for your friendship and advice for the past eight years. I will miss my regular Dr. K briefings. With respect and appreciation, George W. Bush."

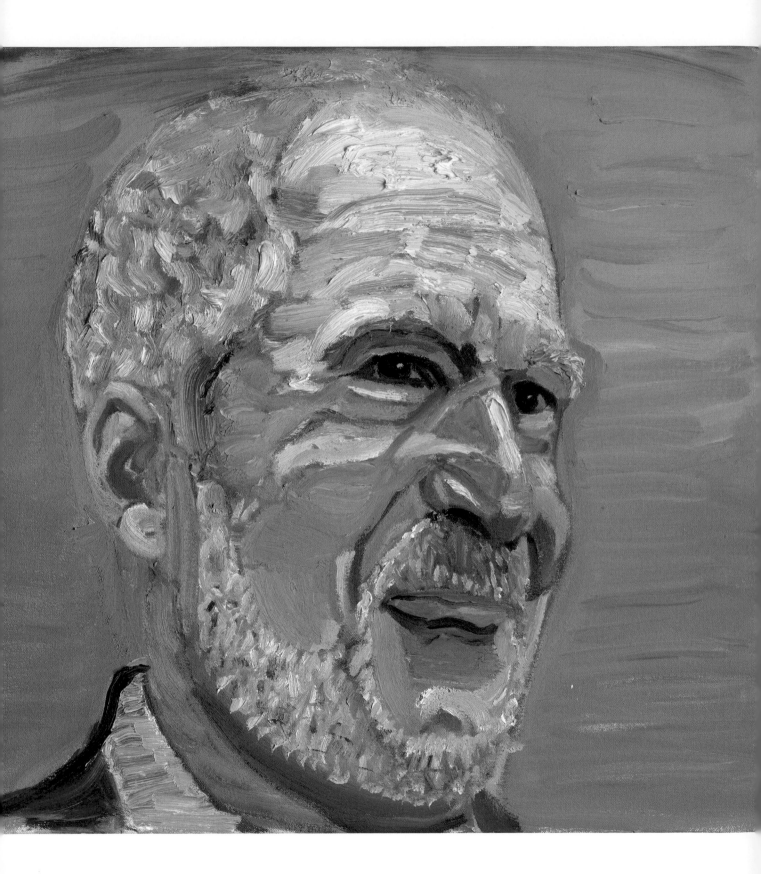

SALIM ASRAWI

"If you put in the time and effort,
you will succeed one way or another."

THE FOUNDER OF Texas de Brazil Churrascaria Steakhouse hails from neither Texas nor Brazil. Salim Asrawi was raised in Beirut, Lebanon. And he's as fine a restaurateur, Texan, and American as they come.

In 1981, Salim became one of the one million people who fled Lebanon while a civil war raged from 1975 to 1990. "War became part of life," he says. He remembers walking to his grandmother's house or to visit cousins, stopping regularly to take shelter whenever gunfire would erupt. When it got too dangerous to go outside, he played soccer in the hallways of his family's apartment building.

Salim recalls the uncertainty of those years. "One day you go to school, the next day you can't. Some days you have electricity, some days you don't. Sometimes it would take hours to get a phone line. Some days you have running water, some days you don't. But I was very fortunate. There were many others over the years who suffered worse."

Salim doesn't remember being too frightened by explosions or stray bullets. He does remember being scared one day when a gun battle started on his way home from school. "The scariest part was the bus driver," Salim laughs. "In order to protect himself, he ducked down, and the bus was driving itself for ten to fifteen seconds. I'll always remember thinking, *He's gotta drive the bus, or we are going to wreck!*"

When the violence intensified, Salim's parents encouraged him to go to the United States for high school on a student visa. A lot of what he knew of the United States came from watching *Dallas* on TV, so he was not in for a total culture shock when he arrived in Bryan, Texas, where he had some family. "I celebrated my fourteenth birthday with a delicious meal at Luby's," he says. "Then we drove to the school." Salim recalls being welcomed by the principal of Allen Academy. "My English was not that good yet. He asked, 'Would you like to visit the restroom?' and I thought, *Oh great, there is going to be a place where you can sit and relax.* Then I realized, *Gee, this is the toilet.*"

As it turns out, Salim would never need a room in which to rest. Relaxing is not in his DNA. He worked hard, sharpened his English, made friends, and did well in school. He got a bachelor's degree from the University of St. Thomas in Houston, then a master's in hospitality. He spent three years nurturing his passion

and talent for hospitality at a Ritz-Carlton before deciding he was ready to start his own business.

After visiting an uncle in Brazil, he thought the concept of a *churrascaria*—which roughly translates to "barbecue"—would do well in America. "All-you-can-eat meat," he emphasizes. He had become a Texan through and through.

With his savings, a loan, and backing from his mom, his uncle, and even his landlord, Salim opened the first Texas de Brazil in Addison, Texas, a Dallas suburb. It was tough going, but Salim loved every minute. And he embraced an American creed: "If you put in the time and effort, you will succeed one way or another. It required me to dig as deep as I've ever dug. As of today, we have sixty-seven restaurants."

On April 4, 2007, Salim became a US citizen, and America gained an entrepreneur and a patriot. Salim says he's proud to have created four thousand jobs for his fellow American citizens. He enjoys giving back charitably to organizations he cares about—particularly those that support veterans and children's health.

Texas de Brazil's most important contribution to Salim's life came in the form of a family. Salim met his wife, Shaundra, at work. Today, they have twin girls and triplet boys. "My family gets to live in the greatest country in the world," Salim says, "a country that is stable, peaceful, and where my voice is heard via my vote. For that, I'm very grateful."

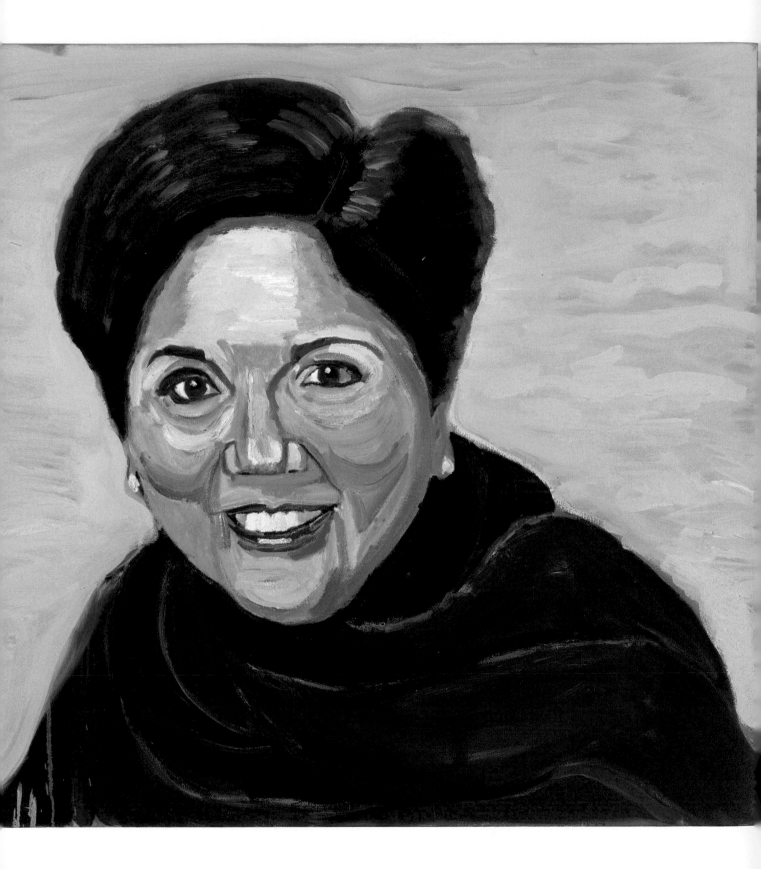

INDRA NOOYI

Anyone who has met Indra Nooyi knows that she fits right in at West Point, home of the United States Military Academy. Sure, she's a little older than the average cadet, having joined their ranks after a successful business career. But she is as tenacious, disciplined, and patriotic as any you'll find.

The day Indra stepped down as head of PepsiCo, the military academy asked her to become their chair for the study of leadership. "I agreed immediately," she says, "to thank everyone at West Point for their service to our country." The academy had chosen a fabulous representative of the long gray line's motto: *Duty, Honor, Country.*

"Growing up in India through the fifties, sixties, and seventies was a simple but comfortable life," Indra says. "In my conservative Brahmin family, the emphasis was on education, learning, respect for elders, and making a difference in society and the world at large." They didn't have a phone, a television, or many toys—but they had access to books, and Indra devoured them. She also had access to the radio. Rock and roll struck a chord with her. Creedence Clearwater Revival, America, Cream, and the Beatles inspired her own rock band, named the Logrhythms—as did her math minor at Madras Christian College, where she majored in chemistry.

"Through all my reading, it was clear that there was one country in the world where creativity flourished, individuality was cherished, innovation was rampant, and the future of the world was going to be determined by it," she says. "I longed to come to the US to study, to understand it better, to blossom, and to be a part of this glorious country." After she graduated from Madras and earned a postgraduate degree at the Indian Institute of Management, she decided—like many who come here—that education was her ticket to America. So she applied to the Yale School of Management and was accepted into the class of 1980.

The culture shock when she arrived in 1978 was the opposite of what many immigrants experience. She left behind "the hustle and bustle of the big city to arrive in the quiet town of New Haven, Connecticut." Yet, in other ways, she faced familiar struggles. She missed her family, dealt with with loneliness, and, as a vegetarian in New Haven, really missed her mom's cooking. She made new friends and poured herself into her studies while also working as a mail clerk and receptionist in the dorm. (She discovered yogurt, too, which she says helped a lot.) Over time, she fell in love with New Haven, the New York Yankees, and the United States.

"After I graduated, I paid back the student loan as my first priority," Indra says. "This was very important to me." Her professional career took off—or, more to the point, Indra launched it with a tireless work ethic and relentless focus. She directed strategy projects for several clients while at the Boston Consulting Group, served as vice president and director of corporate strategy at Motorola, and led corporate strategy for a large portion of ABB, a multinational technology company, all before she turned thirty-five.

Later, as chairman and CEO of PepsiCo, Indra dramatically grew the revenue and shareholder value of one of the largest companies in the world. She's particularly proud of her hallmark "Performance with Purpose" philosophy, which focused on delivering financial performance while making the company's products more nutritious, reducing their environmental footprint, and building an inclusive, uplifting corporate culture. For ten years straight, *Fortune* recognized Indra as one of the most powerful women in the world.

All the while, Indra was raising a family. "The one factor that has allowed me to be successful at work and home is the incredible support, encouragement, and love from my husband of forty years, Raj," she says. "He too is an immigrant from India. An MBA engineer, he kept his job going and supported us all his life." Indra and Raj have two daughters, Preetha and Tara, of whom they're deeply proud.

Indra is a prime example of the economic benefits immigrants bring to our country—and she sums up the argument clearly: "In a world where there is an incredible war for talent, we need skilled immigrants to keep our country growing. So we need to attract and retain the best and brightest. But we also need labor to do those jobs local citizens do not want to do. We need a comprehensive, bipartisan immigration overhaul."

Her story speaks to the cultural benefits of immigration as well. Assimilation doesn't mean whitewashing one's ethnic background. It means adding it to our own, and in so doing, enriching America's soul. Indra speaks English better than most; likes baseball, football, basketball, TV, and theater; and says she enjoys "all kinds of cuisines and dining out—you name it, I love it."

"I maintain my Indian culture and heritage," she explains. "I'm still a vegetarian, I don't smoke or drink, I keep a small prayer room in my house, I wear sarees when I go to Indian events, and I cook Indian food regularly. I have blended the best of both cultures. I am lucky because I was born in one democracy, thrived, and succeeded in another."

Perhaps Indra's most important connections to home are her family and their devotion to education. Her brother and sister immigrated here after Indra, who describes them as "super brilliant." Her brother was valedictorian of his college at Yale and set a record at MIT when he got his MBA and PhD in mathematical economics in just three years. And NYU's Tandon School of Engineering is named for her sister and brother-in-law, great businesspeople and philanthropists who donated $100 million to rebuild and upgrade the school.

Indra has a lot to be proud of, and she counts her family, friends, and academic and professional success atop that impressive list. The latest recognition of her success came in November 2019, when she was inducted into the Smithsonian National Portrait Gallery. Her likeness will be preserved for history in a fabulous painting by artist Jon R. Friedman honoring her contributions to the country. My painting of Indra might not qualify for that distinguished museum, but the sentiment behind it is the same. It's my heartfelt salute to Indra's commitment to *Duty, Honor, Country*.

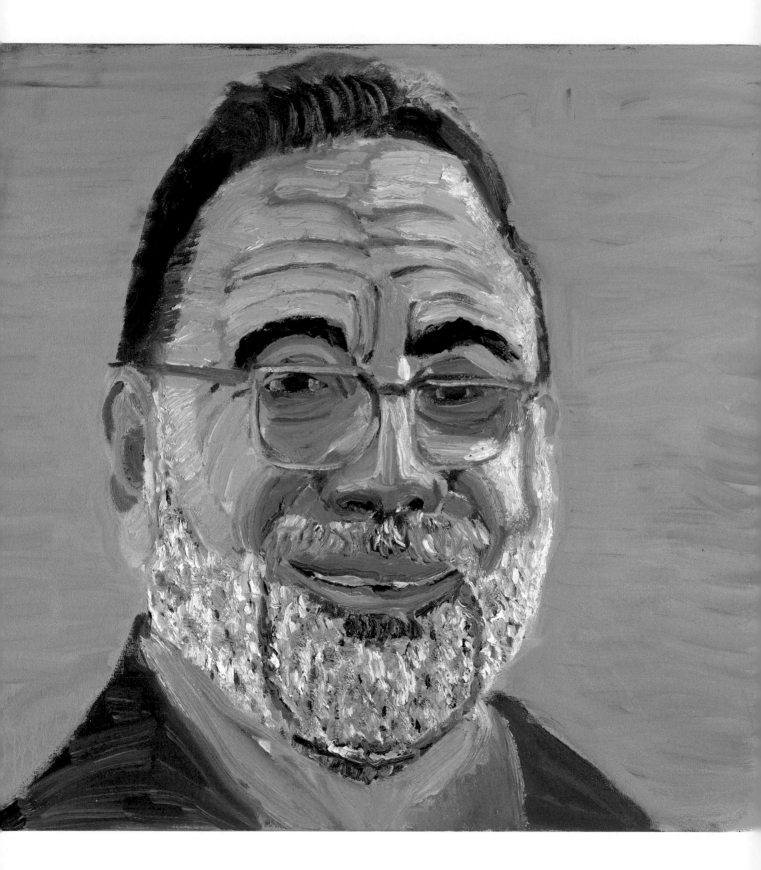

ALFREDO DUARTE

———

O NE MORNING AT BREAKFAST, young Alfredo Duarte noticed a suit-case by the front door of his family's little house along the Sierra Madre Occidental—what he calls the Mexican Rocky Mountains. "My mother was cry-ing," he remembers. "I thought maybe Dad was leaving to work somewhere out of town. Dad got up and said, 'You're leaving, son.'" Alfredo's dad took him sev-eral hours away to a machine shop in Chihuahua. "This is the young man I told you about," Alfredo's dad said to the manager. "Please take care of him." Then his dad left, and Alfredo was put to work.

"I was fourteen years old, working as a machinist," Alfredo says. "I cried for the next three months every evening. I was just a boy."

Alfredo was used to working. He had started helping his parents with ranch work at age five. As he puts it, "In those ranches, when you're old enough to pull a calf and hand it over to your parents, that's when you start contributing to the family." Alfredo's dad never had the opportunity to learn to read or write. He worked hard to provide for his family but struggled to afford essentials such as new shoes. (Alfredo remembers wearing sandals they made from old tires.) His father wanted a better life for Alfredo and all his children than he had himself, and his son ultimately found it by moving to the United States in 1975.

"I'd been thinking about the possibility of coming to the United States since I was twelve years old," Alfredo says. At age seventeen, with borrowed money, he took a three-day bus ride to Tijuana and took the plunge. Literally. "It was during one of the worst floods that river had ever seen," he says. "I will never forget the night we crossed. The river was wide; I thought, *Are we going to drown?*" To pre-vent that, the "coyotes"—the smugglers he had paid to cross—ordered everyone to take off their clothes and put them in a plastic bag on top of their heads. "We

were in a chain, water up to our necks. We were pulling up girls who were falling down," he told *D Magazine* in 2018.

"There was a moment I thought we were all going to die, but we finally made it to the other side of the river, where we ducked and crawled. Given the adrenaline, it was only afterward I realized my body ached because I was full of thorns," he says.

The coyotes, who often exploit and abuse desperate migrants, loaded Alfredo into the trunk of a car with six others and drove him to Los Angeles. "When we arrived three hours later, I couldn't move," he says.

Alfredo had an aunt and uncle in LA who helped him get on his feet, but that didn't make his transition easy. He didn't speak English, he was out of money, and he had come illegally. "I was hit hard by the cultural shock," he said. "This country felt like a speeding train, where everyone moved so fast, everyone looked so happy, everyone had a place to live. I could either stand there or jump on the train, so I decided to jump on the train."

Alfredo worked as a machinist from Monday to Friday, sending his paycheck back to his parents. On weekends he painted apartment complexes to cover his own expenses. Soon, he married a lovely woman named Irma and had two children, Freddy and Alicia. "I've tried to teach them to be the best American citizens," he says.

In 1983, like so many risk-takers over the generations, Alfredo moved his young family to Texas in search of greater opportunities. On the way there, he was given a proper Texas welcome when his family's car broke down outside of Wichita Falls.

"There was a rainstorm like I've never seen before and suddenly, the lights of the car went out and it stopped in the middle of the highway," he recalls. Alfredo walked to a gas station, but no mechanics were on duty. The lady behind the cash register called an elderly gentleman she knew, who met Alfredo at the car and managed to fix the problem.

"All that time while he was working on my car, I was nervous because I only had eighty-seven dollars in my pocket and no idea what I would do if he charged more than that," Alfredo says. "When he finished, I asked, 'How much do I owe you?' He said, 'Give me thirty-seven dollars, which is the cost of the part, but only under one condition. If one day you are in a position to help someone else, do it.'"

In Dallas, Alfredo continued working hard and found more success than his father ever hoped for. In 1985—the same year he became a legal permanent resident—he partnered with an experienced produce salesman, Jesse Mendoza, who happened to be his brother-in-law. They borrowed $1,500 to buy a used pickup truck and drove around town selling tomatoes to restaurants. In 2016, he became a naturalized American citizen, and today their business, Taxco Produce, is a $60 million company. The full-line food distributor sells everything from meat and cheese to paper and cleaning supplies across North Texas, Oklahoma, and Kansas.

"I am very proud that I can provide jobs for more than one hundred twenty people," Alfredo says. "It's a big responsibility. Every decision I make can impact not only our home but all these families." He's been paying it forward for the last forty years, always keeping that kind Wichita Falls man in mind. "Every time I remember him, I force myself to be a better person."

Because he came illegally, Alfredo has an interesting point of view about immigration. "I believe this country needs to play its role as the most powerful country in the world and make sure we have a healthy continent. If more people have a chance to provide better for their families, to have a better life in their country of origin, and travel back and forth to see their families, we wouldn't be seeing caravans."

Some years ago, Alfredo came up with the idea of bringing young Hispanic professionals to high schools and pairing them up with students in the tenth and eleventh grades—the window when the risk for dropping out is at its highest. And the mentorship program has worked, he says. "We've seen the probability of them dropping out is reduced. Many have gone on to exceptional colleges, like Columbia University. In the beginning, it was hard to convince high school students to sign up for the program. Now they line up."

When asked if he thinks he is living the American dream, Alfredo answers thoughtfully. "I don't think the American dream is the same for everyone," he says. "When you come from a place like the one I came from, you surpass all your dreams. I look back where I started out and tell myself, *You've come so far.* I don't think I'm smart; I think I'm just hardworking and very grateful, and that's why we've done well."

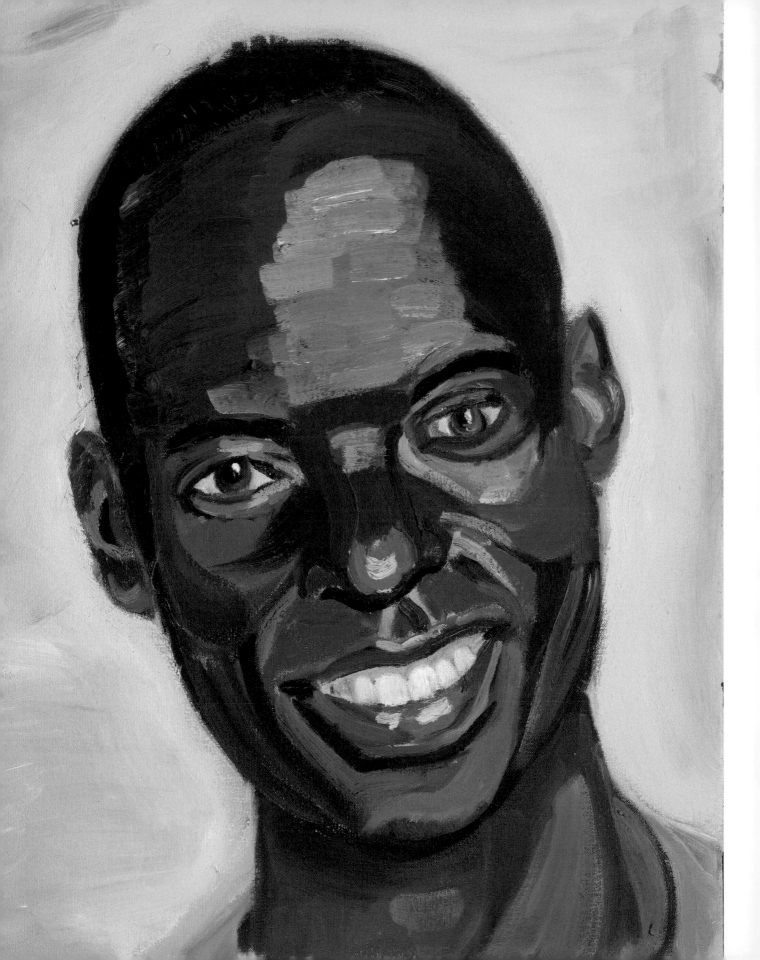

GILBERT TUHABONYE

GILBERT TUHABONYE'S FAMILY NICKNAMED him "Tumagu"—which roughly translates to "fast wind." From his tiny village in southern Burundi, Gilbert ran everywhere. And he ran like the wind. As a young boy, he ran to the river to fetch water for his family. He ran to the cows on their farm and herded them home. When he started going to school, he ran more than six miles each way. He wore USA T-shirts and dreamed of one day representing a college in NCAA track-and-field competitions. He ran for fun, he ran for freedom, and he ran to win. In his junior year of high school, a boarding school seven hours from home by bus, Gilbert became Burundi's national champion in the four-hundred- and eight-hundred-meter runs. The next year, Gilbert was running for his life.

It was 1993, and Gilbert was one of four children in a Catholic Tutsi family. On October 21, the first democratically elected Hutu President of Burundi was killed by Tutsi extremists in the military. Violence between the Hutu and Tutsi people broke out in the region, including neighboring Rwanda. "In an act of retaliation," Gilbert says, "Hutus came to my high school and wanted to eliminate all the Tutsi they could find. They roped us together in a death march, forced us into a building, and set it on fire." Among his tormentors was one of his best friends and track teammates.

Gilbert was trapped inside the burning building among the dead bodies of his classmates. After eight or nine hours, he managed to escape. He had third-, fourth-, and fifth-degree burns on 30 percent of his body, including his legs. Somehow, Gilbert did what he did best: he started running. He ran to a nearby hospital, where doctors could only apply some bandages before the Hutus arrived. He hid inside the maternity ward until he was rescued by the Army and taken to another hospital.

Gilbert spent the next three months recovering in a hospital. Doctors told him he would never run again. Meanwhile, his family heard the news of the attack on Gilbert's school and started planning his funeral. It was weeks before they found out he was alive and were reunited. Gilbert says two things helped him heal physically and emotionally. One was a recruitment letter from Tulane University's track-and-field program. "That letter gave me hope that someone was out there. It pushed me to make a full recovery so I could start running again and make it to the United States."

His other inspiration came from a visit by a schoolgirl named Triphine and the Bible she gave him. "If I start talking about her, it would be another book!" Gilbert laughs. When Gilbert healed enough to go back to school, Triphine shared her notes and helped him catch up on his studies. They dated until April 1996. That's when Gilbert found out he had been chosen by his country to train for the Olympic Games in Atlanta, Georgia.

When he got to Atlanta, one of the fastest men in the world was surprised by how fast life moved in the United States. "People were always in such a rush. They ate on the go. They spoke fast, and it was hard to follow a conversation," he remembers. Other things weren't so different: "In Burundi, people are late for work because of the lack of transportation. Here, they are late for work because of traffic." While Gilbert didn't end up making the Olympic team, he did get to realize his dream of running for an NCAA school. He moved to Abilene, Texas, where traffic isn't a problem, and enrolled at Abilene Christian University. One of the greatest thrills of Gilbert's life came in 1999 when he won the Division II national championship in the eight hundred meters.

Gilbert thrived in Abilene, but his heart was in Burundi. He missed his family, and he constantly thought about Triphine. "I thought I would never see her again," Gilbert says. "I thought, *If I go back, she's going to be married. She's not going to wait for me*." In 2000, Gilbert went home to reunite with his family. Triphine was there waiting for him. "I was just praying that one day she would join me," he says.

The next year, Triphine did join Gilbert in the United States. On the morning of May 12, 2001, he graduated with a business degree from Abilene Christian. That afternoon, he and Triphine got married at Holy Family Catholic Church on Buffalo Gap Road.

Through a fellow Abilene Christian alum, Paul Carrozza, Gilbert was hired at a popular running store in Austin. He sold shoes and worked behind the register

while he continued to train and compete. As local runners met Gilbert and heard his story, they asked him to train them, and his racing company, Gilbert's Gazelles, was born. One of those locals was my daughter Jenna, who was an undergraduate student at the University of Texas.

I was President at the time, and it was comforting to know that Jenna wasn't staying out too late at night, to run with Gilbert in the mornings. "One morning before our workout, Gilbert said he had already run twenty-six miles," Jenna remembers. "When I asked why, he said it was the tenth anniversary of the attack on his school and the day he rediscovered God. Each year on that date, he sprints up Wilke Hill, one of the steepest climbs in Austin, over and over. I had seen the scars on his legs, but I didn't know he had survived the unthinkable."

"Running Wilke Hill always takes me back home to Burundi and to what happened in 1993," Gilbert explains. "It reminds me how blessed I am to be alive, and that running helped me gain my strength and got me to the United States. I use the hill to inspire other people not to give up on anything and to channel their mind with a positive attitude."

"From the moment we met, he uplifted me with his effervescent personality," Jenna says. "The more I learned about him, the more inspired I was by him. No matter how hard he ran me, I always ran a little bit faster when he yelled, 'Jenna, God is good!' He's a sweet soul—a real Texan, a great American."

Gilbert became a naturalized citizen in May 2010. "I had made the hard decision of not returning to Burundi and settling here in the United States," he says. "I was emotional and happy to become an American, and excited because of the privileges and responsibilities that come with it." Gilbert and Triphine have two daughters, Emma and Grace. Both run and swim, and both are competitive like their dad. Gilbert coaches track at St. Andrew's Episcopal School and is a commissioner of the Texas Holocaust and Genocide Commission. He is a public speaker and the author of a book about his experience, *This Voice in My Heart: A Runner's Memoir of Genocide, Faith, and Forgiveness*.

"America has given me everything I have dreamed of since I was a little boy," Gilbert concludes. "Now what brings me joy is being able to get up and work hard for other people." His charitable organization, the Gazelle Foundation, has helped transform villages in Burundi. Thanks to Gilbert, more than one hundred thousand people, both Hutus and Tutsis, now have access to clean water—and they don't have to run to fetch it.

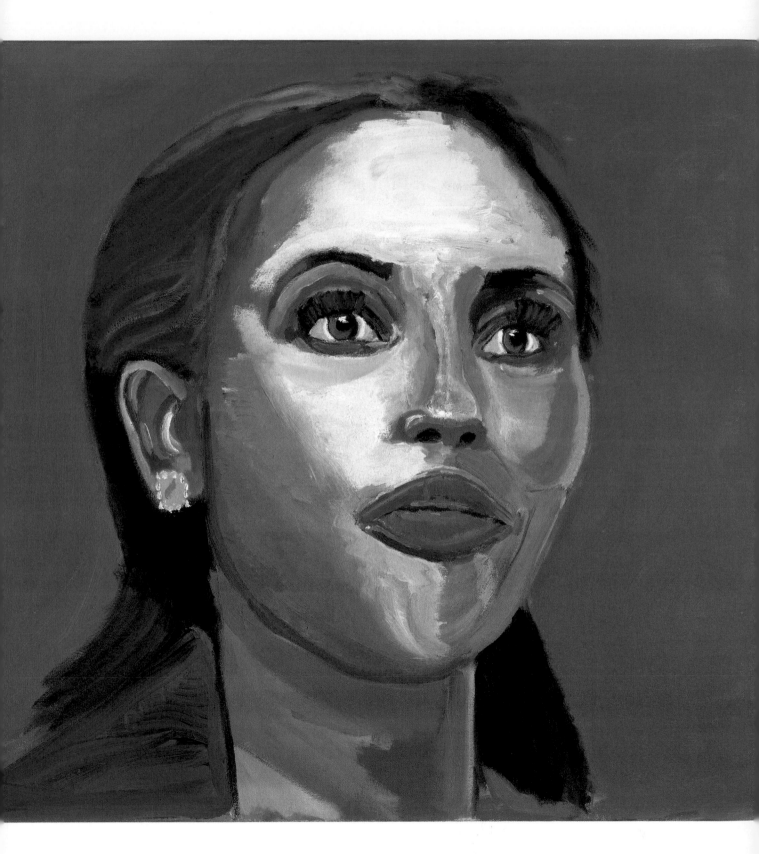

JEANNE CELESTINE LAKIN

"When I think of America, I think of a responsibility to care for one another and give back. Not just to work on yourself, but to push others to do the best that they can, and to give people the hope that they can realize their potential."

Paul Lakin was down on his luck in the winter of 2009. The burdens of his dysfunctional upbringing, rife with abuse and alcoholism, had become too much to bear. He dropped out of school and started drinking. As Paul puts it, he was a wreck who couldn't get his life together. At his lowest point, he met an angel outside of a coffee shop in Spokane, Washington. "When Jeanne came into my life and started telling me her story, I just woke up and smelled the roses," Paul says of the woman who became his wife.

Jeanne Celestine Lakin was born a world away in Nyanza, Rwanda, on July 7, 1985. "I enjoyed the simple village life," she says. "I have a twin sister, Jeannette, and many siblings. We occupied ourselves with games, climbed trees, swam in the lakes, and fed and petted our cows."

Jeanne's parents were devout Catholics and pillars of the community. Her father taught classes at the local business college and ran a successful uniform supply business. The income allowed him to not only support his children's schooling but also pay for other students in the village. "Of course, all that changed when the genocide began," Jeanne says.

The ethnic cleansing and civil war in Rwanda started on April 7, 1994, after a plane carrying the Presidents of Rwanda and Burundi was shot down. This was three months before Jeanne's tenth birthday. The assassination left a power vacuum that was filled by extremist Hutu militias. Over the next three months, they murdered between five hundred thousand and one million innocent Tutsi and moderate Twa and Hutu people.

One day at school, Jeanne's teacher segregated the students by ethnicity. "I didn't understand what was happening," Jeanne says. "I remember just standing there wondering, 'Who am I?' My teacher said, 'Well, if you don't know, you will be expelled from school.' When I got home, I asked my parents, 'Are we Tutsi? Are we Hutu? Are we Twa? Who are we?' My mother said, 'You're a child of God.' My father said, 'In the kingdom of God, there's no Tutsi, no Hutu, no Twa.'"

That explanation didn't fly at school. Jeanne was Tutsi, the ethnicity being described on the radio as "cockroaches and snakes." Just like that, she became an enemy of her friends—of some of the very people whose schooling had been paid for by Jeanne's family. Her father decided that the family should split up and go into hiding before the militias arrived.

Jeanne took her three-year-old sisters, also twins, and sought refuge at the

house of her aunt, who was married to a Hutu. The children were turned away because they were Tutsis. "From there we lived in the bushes and the swamps," she says. They survived on grass, flowers, seeds, and anything they could find. "I tell people we became vegetarians," she now says with levity of those dark days.

As the violence raged on, Jeanne and the twins occasionally snuck back to their village with the hope of seeing their parents and siblings. She recounts one visit to the family's banana farm in her memoir, *A Voice in the Darkness:* "Flies buzzed everywhere. I walked back and forth down the path, delicately stepping over the dead as I examined their bodies and skin. . . . I recognized a woman dressed in a yellow blouse. It was the same type Mom had worn when we fled the house. . . . It was my beautiful mom." On her back, in a bloody swaddle, was Jeanne's infant brother, baby Mucyo.

Desperate to protect themselves, Jeanne and her little sisters tried to pass as Hutu. They stuffed seeds in their noses to change their appearance and practiced declaring, "I am a Hutu! I am a Hutu!" They hoped the disguises would enable them to safely reunite with their father. But as Jeanne approached the village on her next visit, she saw a tall, familiar figure being chased by men brandishing machetes. "There was my father, running down this hill," Jeanne says. "I watched him being cut up and hacked away until they ended his life."

Witnessing the end of her father's life was only the beginning of Jeanne's suffering. (I caution that readers will find the trauma and abuse she endured in the coming years disturbing, but I felt it was important to describe the suffering she eventually overcame.) After confirming Jeanne and the twins were girls by lifting up their skirts, a village elder told them, "I'm sending you to a safe place." "But it was actually a killing squad," Jeanne says. There, she was told to say her prayers before her execution. As she prayed, a man claimed her from the crowd and took her to the Congo, a country on Rwanda's western border. She says that after the man started sexually abusing her, she "snuck out in the middle of the night, went like a kitty-cat." Without food, a map, or even shoes, she wandered through the jungle for months until she made it home.

The violence in Rwanda had subsided, but chaos and confusion were left in its wake. Jeanne momentarily reunited with some of her siblings at an overcrowded orphanage. Because she was ten years old, Jeanne was turned away for being too old. She went to work as a maid for a fellow Tutsi survivor, who beat her and burned her with cigarettes. Next, Jeanne was taken in by a foster family who

eventually decided to move to the United States. "I just knew that was the chance for me to start over. A place for healing, a land of opportunity."

When Jeanne came to Missouri in 1998, she used an English-French dictionary to translate her homework. "An assignment that would have taken someone thirty minutes took me three to four hours," she remembers. Slowly, she learned English—with help from pop music by the likes of Britney Spears and NSYNC. Her teachers helped, too. "I was intrigued by the generosity and positive feedback of the Americans, and the compliments they gave me for working hard. I felt loved, and I felt welcomed. School was my escape."

It was an escape not only from the horrors of her past but from the torture that had followed her across the Atlantic. Like the man who stole her away to the Congo, the adoptive father who took her to America had also been sexually abusing Jeanne. "When I graduated high school in 2004," she says, "I needed to run away from the abuse."

Jeanne knew exactly one person in America outside of Missouri, a Rwandan student at Washington State University. Jeanne applied to the school, was accepted, and flew to the Pacific Northwest with $400—all she had saved from her high school job as a hostess at a restaurant called Sophia's. That money wouldn't last long, so she took jobs in the university registrar's office, at a nursing home, cleaning houses, and bagging groceries. "I did everything," Jeanne says. "I even braided hair for a little bit of cash."

Almost daily, Jeanne had lunch or dinner at the home of a Ugandan-American couple, Dr. Fred and Winnie Rurangirwa. Fred worked at the university, and Winnie was known as "Mother Africa" around campus. To Jeanne, they became Uncle Fred and Auntie Winnie. They, too, had lost family members in the genocide. The couple's tenderness toward Jeanne sparked the beginning of her healing process. "They said, 'Our home is your home.' And that made me cry," Jeanne says. For the first time in a decade, someone had made her feel safe. They made her feel loved. "Little by little . . . it was the first time I started sharing deeply what I experienced, and they would just sit and listen. I thought, *This is what my parents used to be like*."

What Jeanne told me next was remarkable. "It was my mother who used to say that when you pray with bitterness in your heart, there is a cap on your prayers. I needed God to hear my prayers, because I couldn't carry all of the pain. So I asked Him for the strength and the courage to forgive."

Forgiveness is a fundamental tenet of the Christian faith, and the hardest to put into practice. And Jeanne had more to forgive than most. But Jeanne felt that until she forgave those who had wronged her—who had killed her family, destroyed her country, and abused her—she was living with the same sins as the sinner. "I felt this weight lifted once I said, 'I forgive these people,' and God said, 'You need to pray for them.' The minute I started praying for them, I felt this sense of love for them. It was like stepping into a new body."

In 2007, Jeanne transferred to Eastern Washington University in Spokane, where she finished her degree and met Paul. As their relationship developed, they shared their stories with each other. Their lives began to change, and they both started to recover. They fell in love, they married, and in 2012 they graduated—Paul with a bachelor's, and Jeanne now with a master's—and moved to Texas. When Jeanne was naturalized later that year, she changed her middle name to Celestine, after her father, Celestin. "It was a mix of joy and tears," she says of becoming a citizen, "and it was just surreal to finally feel like I can fully participate in it all. When I think of America, I think of a responsibility to care for one another and give back. Not just to work on yourself, but to push others to do the best that they can, and to give people the hope that they can realize their potential."

Jeanne does so by sharing her story with schools and churches, spreading her message of forgiveness. She often receives text messages and letters from people like Paul whose lives she helped transform. Both Jeanne and Paul work at Lone Star College in Houston, Texas, where Jeanne is an academic advisor and sexual assault prevention representative. She and Paul started a charity together, One Million Orphans, to carry on her parents' teaching and support God's children around the world.

When we met in person, Jeanne told me that she was struck by a comment I'd made in Rwanda toward the end of my presidency: when we see suffering, we act, because we believe we are all God's children. It was the same thing her parents had told her, she said. Then Paul and Jeanne told me that they themselves have become parents—of an "amazing" son, Samuel, who has Down syndrome. "They are the most innocent," I told them. "*They* are God's children."

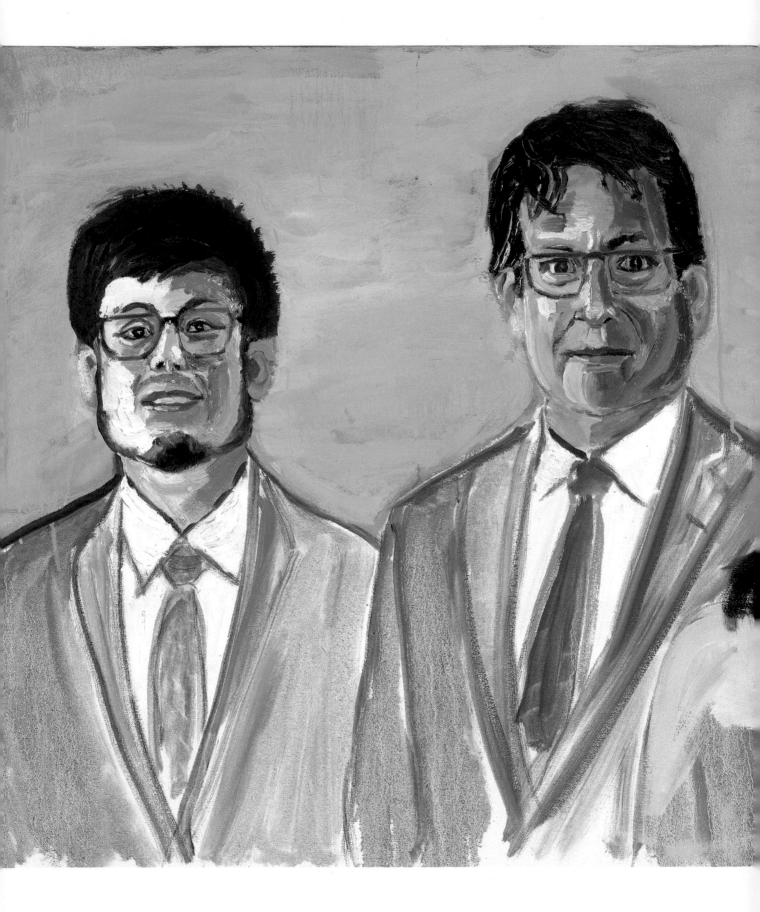

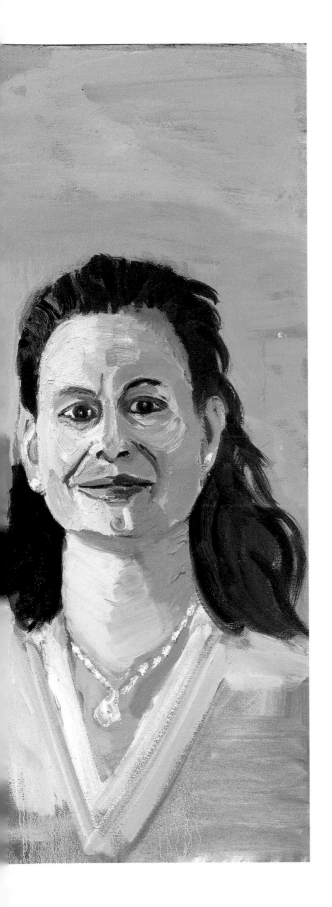

DENNYS HERMOZA, SAMANTHA TASAYCO, *and their son,* SEBASTIAN

Witnessing a US naturalization ceremony is among the most powerful, patriotic, emotional experiences an American can have. Over the years, I've had the honor of watching hundreds of individuals raise their right hands and swear their allegiance to the United States. At a Bush Center naturalization ceremony for dozens of new citizens on March 18, 2019, Laura and I watched a Peruvian family become an American family when Dennys, Samantha, and Sebastian took their naturalization oath together.

Their journey toward that day had started twenty years earlier in the Peruvian capital city of Lima. "Our country was going through some difficult times," Dennys explains. "The economic situation was bad. I lost my job.

There was a point when I reached my limit and thought, *We have to make a decision to leave. We have this chance, take it or leave it.*"

"For our kids," Samantha adds.

The Hermozas applied for a tourist visa. "The official looked at our papers and said, 'I cannot give you that visa. With this amount of money, you can't even go to Disney.' And he just closed the file." After some creative negotiating, they were granted a six-month tourist visa. Samantha, Dennys, and two-year-old Sebastian arrived in Plano, Texas, in July 1999. They settled into their new community and looked for work.

After six months, the Hermozas faced the kind of decision that torments many who come here: overstay their visa and knowingly break the law, or give up their new life and go back to Peru. They decided to stay. "We were thinking all the time that at some point there was going to be a fix . . . something to let us stay here legally. We were trying to be on the good side. We paid our taxes, didn't get into trouble, worked hard, just focused on our family," Dennys says.

The same month their visa expired, they got their fix when President Clinton signed the Legal Immigration Family Equity Act into law on December 21, 2000. It would allow them to obtain green cards after a ten-year waiting period and paying a $1,000 fine each. In the meantime, they couldn't leave the country.

For years, the arrangement worked satisfactorily—until Dennys's mom in Peru was diagnosed with pancreatic cancer near the end of their wait. "We got the papers on January 11, 2011," Dennys remembers. "I told her we got a green card to visit her. That was the last time I talked to her. January 18, she passed away."

Meanwhile, Dennys and Samantha had been working to get by in Plano. They juggled two or three jobs at a time and sent what they could back to their family in Peru. They shared a mattress with their son. In order for Samantha to earn money cleaning houses, they enrolled Sebastian in daycare. "We didn't have enough money to pay, and they offered, 'Do you want to clean the school?' I was so happy," Samantha says. "Even the principal said, 'I never saw anyone so happy cleaning bathrooms.'"

She and Dennys were in awe of the Texan hospitality and generosity. One Christmas, after their two daughters had been born, the parents couldn't afford gifts for their children. "The principal said, 'Come here, I have a surprise for you,'" Dennys says. They had been adopted through a Salvation Army Angel Tree. "The donations were from the generous people of Plano. Oh my gosh, I

had to do two trips. The car was full of presents. Clothing, toys, food, even a rice cooker for Samantha. I still have the pictures.

"So many people help you without wanting something back," Dennys says. "They don't make a big issue about where you are from or your accent. There are people who pay attention, make an effort to understand you.

"We were lucky in every aspect," he continues. "Jobs, people that we know, the people that she was working for that took care of us . . . That's what we most admire about people from America."

"They help you," Samantha adds.

Today, Samantha and Dennys are in a position to help others. "Every year, we go to the church and pick a name and buy presents," Samantha says. And they're instilling that grateful generosity in the children. "We teach them to volunteer in the school and the church," Samantha says.

The morning the Hermoza family was naturalized at the Bush Center, I told them and their fellow candidates, "You paid America the high tribute of aspiring to live here, leaving behind familiar ways and places, and accepting a process that everyone knows is not easy. Our country, in return, honored your efforts, and soon we will be honored to call you citizen."

Upon returning here from a trip to visit family in Peru, Samantha and Dennys presented their American papers to the customs officer in Dallas. Dennys will never forget what happened next. "The guy told us, 'Welcome home.' *Oh, my gosh*, we thought. *This is our home*," Dennys says. "We came here with all the disadvantages we had, and we did it. We live in a beautiful house. We have our own cars. Our kids are going to college. It takes time. It's going to be hard. You have to earn it. If we can do it, you can do it."

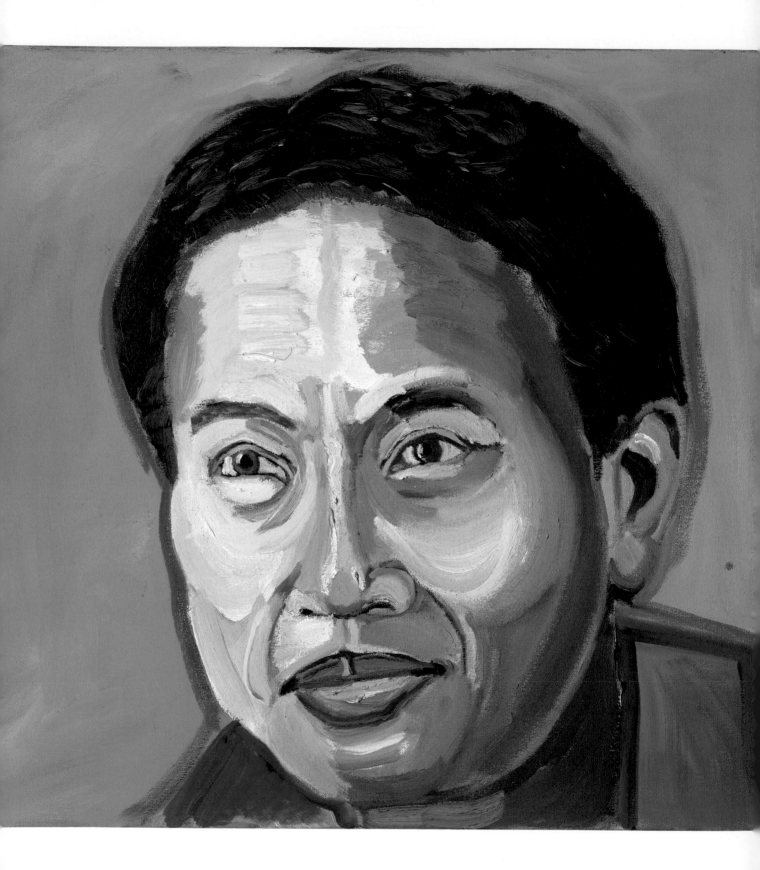

KIM MITCHELL

"America is the greatest country in the world,
but it comes with responsibilities."

"KIM MITCHELL" IS THE THIRD name she has had in her lifetime. No one knows the first, including her.

In May 1972, Kim's mother was killed when the Vietcong attacked their village. Later that day, an older man found the six-month-old clutching her dead mother, still trying to nurse. He placed her in his straw hat and carried her as far as he could before handing her off to a South Vietnamese Marine named Bao Tran. Tran carried her thirty-seven miles to the Sacred Heart Orphanage in Danang, where the nuns asked him the girl's name. When he said he didn't know, they told him, "You must give her one." He answered, "Tran Thi Ngoc Bich," which translates to "Precious Pearl."

Kim's second name only lasted a few weeks. One day, an American Air Force sergeant named James Mitchell came by the orphanage on one of his regular runs to deliver clothing and food. The nuns placed Baby Number 899 in his arms, and he instantly fell in love. He named her Kim, and her third name stuck. When asked to describe her journey, she says, "I was fortunate enough to be adopted and flown to the United States to start my new life in America."

Kim became a naturalized citizen at age five and lived most of her childhood on a farm in Wisconsin. "Growing up thirty miles south of Lake Superior was almost as rural as you can get," she says. "There wasn't much entertainment, so I kept myself busy by getting involved with every activity I could. From band, where I played the French horn and trombone, to choir, to basketball, running cross-country, playing softball, to community organizations with 4-H and church youth group."

She did well in school—"basically straight A's, because my father paid me ten dollars for each A I received," she says—and made friends with the twenty-one other students in her grade. The seventh grade was very hard for Kim. "For some reason, all of the students decided that was the year they were going to make sure that I knew I looked different from them. I know what it's like to be humiliated. There were days I didn't want to go to school, but I'm glad my parents made me," Kim reflects. "I learned a lot that year about how to treat people. The following year, when we came back to eighth grade, it was like nothing had happened. We were all friends again." She shrugged it off with her characteristic good humor. "Perhaps it was the water or too much snow that winter, and people got brain freeze," she says.

From the third grade on, Kim's dad had gently encouraged her to consider the Air Force Academy. In high school, she met a retired Navy admiral at a youth leadership conference and did an about-face. Kim attended the Naval Academy Preparatory School from August 1990 to May 1991. "I didn't know port from starboard or forward from aft," she jokes, but she managed to earn entry to the prestigious United States Naval Academy at Annapolis that summer. "Two weeks before reporting in, my father was struck by lightning and killed on our farm," she says. "A week after the funeral, I was taking the oath as a midshipman with the class of 1995."

By the fall, Kim wasn't sleeping well. Her family still struggled with the death of her father, and she realized she needed to be home. The commandant of the midshipmen allowed her to go back to Wisconsin and return to Annapolis the following year.

Kim completed her studies and served our country for seventeen years as a naval surface warfare officer. She capped off her career with a two-year assignment at the Pentagon working for Mike Mullen, a four-star admiral and the seventeenth chairman of the Joint Chiefs of Staff. "Admiral Mullen asked us to travel all around the country to find resources and services for our veterans, military families, and families of the fallen," she says. When I asked Mike about Kim, he told me he was struck by "someone who feels so blessed to be an American that she just keeps giving back, more than she received—from her military service to her continued commitment to helping veterans."

After leaving the military in 2012, Kim stayed true to that commitment. Kim is a graduate of the Bush Institute's Veteran Leadership Program, where

she honed her work to help veterans overcome post-traumatic stress, substance abuse, unemployment, and other obstacles in the transition from military to civilian life. After cofounding the Dixon Center for Military and Veterans Services and running Veterans Village of San Diego, she became senior vice president for military, veterans, and government affairs at National University in 2020. Kim says her work is a way not only to give back to her country but to honor her father, who struggled to "fit in" after retiring from the military.

"America is the greatest country in the world," she says, "but it comes with responsibilities. We must always take care of those who need our assistance. We must assist those seeking freedom. We should always take care of our service members, veterans, military families, and families of the fallen. To me, their smiles and hugs of thanks mean the world. As one Vietnam veteran told me, 'Thank you for bringing meaning to my service.'"

In late 2012, Kim heard from the family of a man who claimed to be the Vietnamese Marine who had saved her. At first, she thought it was a prank. But she eventually agreed to meet in Albuquerque, New Mexico, where Bao Tran had immigrated. When they reunited on March 29, 2013—Vietnam Veterans Day—Bao had on the same uniform he was wearing when he dropped Precious Pearl off at the orphanage forty years earlier. "I was emotionally overwhelmed," Kim remembers. "I barely got out the words, 'I just want to say thank you to a man who took the time to save a baby.'"

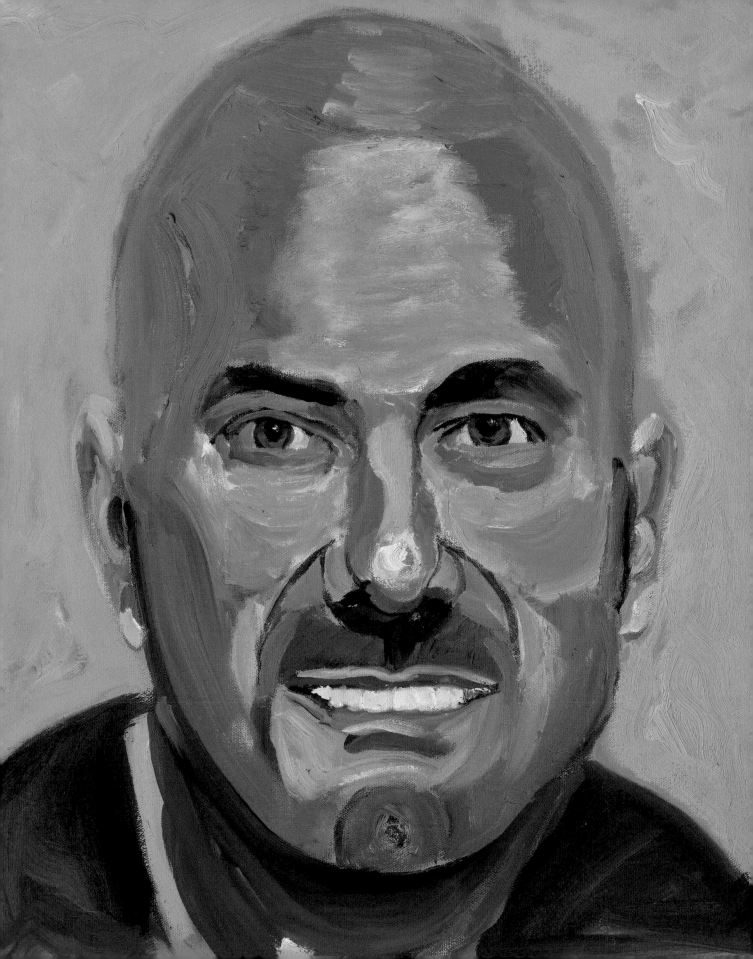

MARK HAIDAR

MARK HAIDAR COMES FROM a Shia Muslim family of mountain farmers. For generations, they grew wheat and olive trees on top of Safi Mountain in southern Lebanon. "Every other year, my great-grandfather would press the oil, load it on his donkey, and go to Jerusalem to sell his oil," he says.

In 1982, war broke out with Israel. The family escaped to Kuwait, and Mark was born a year later. Being proud Lebanese citizens, the family returned to their homeland as soon as they could. Their village had been leveled, so Mark grew up in a refugee area called Wadi El Zayni. "Although people came from different areas and had different backgrounds, we all shared a common struggle: poverty and lack of safety," he says. "Sewage water was flowing in the streets. We were fighting every day to make ends meet." The Haidars' home was a living room inside of an apartment they shared with other family members, with a makeshift kitchen and bathroom on the balcony. "My sister froze to death when she was five months old," Mark remembers. "We didn't have enough money to buy a tombstone for her grave."

Mark is a hopeful guy, and he found little joys where he could. He and his brother sold metal scraps and used the money to buy admission to a beach resort. "We would swim all day and spend the rest of the money to share a small box of French fries and lots of ketchup. I think up until today, this is the most delicious meal I've ever had." Still, these respites were often interrupted by the reminders of war. "F-16s would fly above our neighborhood and break the sound barrier and shatter all windows," he says. "There is nothing scarier than an F-16 flying low above a child. . . . But after midnight, it was peaceful. I would look up to the sky and count the stars. This was my daily reminder that there is a much bigger world out there."

Mark's curiosity and optimism found a new outlet when his school got two computers from the United Nations. "I had no control for what was going on around me," he explains. "But behind that computer, I was in charge. I felt empowered. And that's where it happened. I read the Declaration of Independence. It was the most powerful text I ever read, and still is. Imagine a young person living in a war-torn country. A person who feels there is no prospect for life." The unalienable rights to life, liberty, and the pursuit of happiness meant the world to Mark. "I became obsessed with America and what it stands for."

He also became determined. "I knew that in order to come here, I needed to speak English and be good at school." To learn the language, he watched hundreds of episodes of *Seinfeld* and *The Simpsons*—what Mark calls America's best "documentaries." Each weekend, he took the bus into Beirut to visit the library, where he devoured every book on computer programming he could get his hands on.

By the time Mark earned his bachelor's degree from Beirut Arab University in 2006, he had received six technical certifications and won several awards. Along the way, Mark faced obstacles. At one point, he was captured and interrogated by Hezbollah for building a website that helped displaced villagers network with one another. Then, just days after finally being granted a student visa to study for his master's at the University of Detroit Mercy in Michigan, Mark's plans were thwarted when armed conflict with Israel erupted.

"I witnessed bridges, buildings, power plants, roads just entirely destroyed," Mark remembers. "I saw and heard about the death of relatives. Everyone was prepared for death.

"A few days into the war, my dad came to me and said: 'Son, here is a debit card. I have a little over two thousand dollars in my bank account. This is my life savings. Leave three hundred dollars in the bank for us to buy groceries. I have an oil smuggler outside. He will find a way to get you to the Syrian border and from there you can leave to the USA.' I left right away with only a pair of jeans, a knockoff polo shirt, sandals, and my dad's old Samsonite briefcase."

The smuggler took Mark as far as he could. Mark walked the rest of the way, crossed the border into Syria, and caught a bus to Damascus. When he couldn't find a flight to the United States that he could afford, someone suggested he try for a cheaper flight out of Turkey. After a thirty-six-hour bus ride to Istanbul, a travel agent found him a flight to New York City for $500.

"I still remember seeing New York for the first time," Mark says. "It was majestic!" He visited the Statue of Liberty and read the words inscribed at its base: *Give me your tired, your poor, / Your huddled masses yearning to breathe free, / The wretched refuse of your teeming shore.* "I was in tears reading these words, as I could relate to every letter. For me, it resembled hope . . . a chance for a better future."

Mark recognized that it was a chance, not a guarantee. And the obstacles continued to mount once his Greyhound bus arrived in Detroit. "Reality set in when I realized that tuition was going to cost around thirty thousand dollars a year. I started working the night shift seventy hours per week at a gas station in Detroit, where I cleaned toilets, changed trash bags, and pumped gas in a high-crime area. During the day, I helped my school get a grant from the US Army, and in return they paid my tuition. For almost eighteen months, I didn't get more than four hours of sleep per day. I survived living off of eighty-nine-cent Taco Bell cheesy bean and rice burritos. Within two years I earned my master's degree in electrical engineering and authored numerous publications, all without accumulating any debt."

Mark has become a phenomenal success in business, using his talent and tenacity to cofound Dialexa, a technology research and creation firm in Dallas that has helped launch more than sixty products and incubate other technology companies. He is the CEO of automotive data startup Vinli and serves on the board of several organizations, including UNICEF's Great Plains Region.

Despite all his success, Mark's proudest moments have been among his family. "Without a doubt, they are when my daughter, Mariam, read out loud from a chapter book, and when my nine-month-old son, Cedar, stood on his feet for the first time. Nothing comes close to that." Mark and his wife, Claire, love to take their kids camping and explore the wilderness of Texas. At night, they use their telescope to "explore the universe" and look at the same stars Mark counted when he was a kid.

During a Presidential Leadership Scholars event, I asked Mark if he hated the Israelis for destroying his village and attacking his people. Without hesitating, he looked me straight in the eye and said, "No. Hate takes too much effort. I love. I love my family, and I love America."

ANNIKA SÖRENSTAM

———————

"I loved America from the beginning."

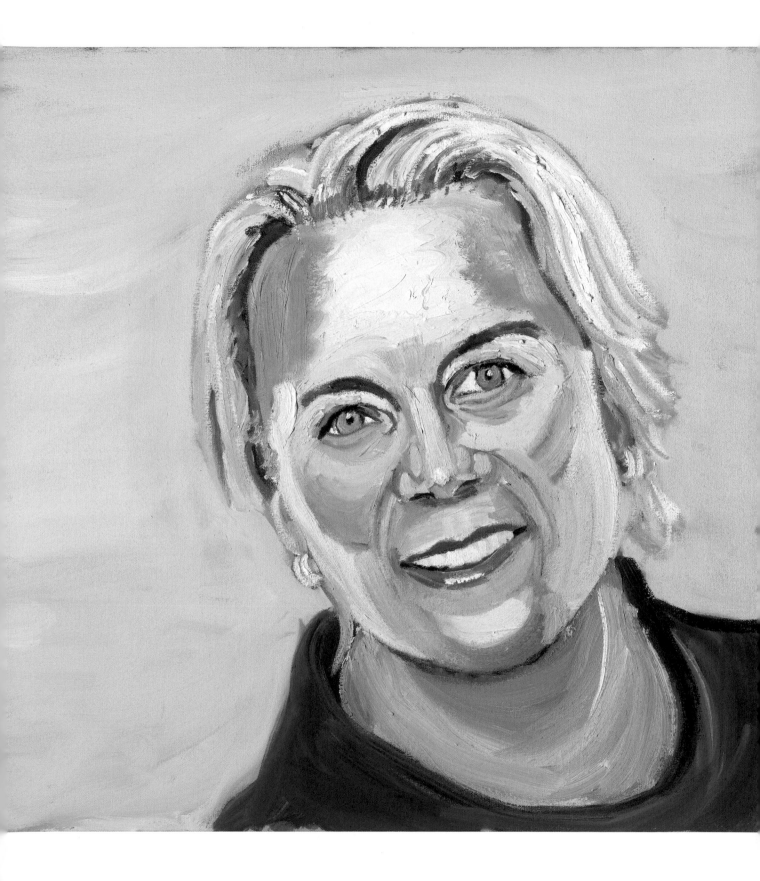

I MET ANNIKA SÖRENSTAM AT A 2011 clinic we hosted for young golfers. "I did the swinging, he did the talking," Annika later joked. She did a lot more than swing a club that afternoon. She inspired the 125 inner-city kids who had shown up to learn from one of the winningest female golfers in history.

We were there with First Tee, a nonprofit organization of which I am the honorary chairman. The program introduces children to golf and builds character by teaching the "nine core values" associated with the sport: honesty, integrity, sportsmanship, respect, confidence, responsibility, perseverance, courtesy, and judgment. As I watched Annika—a Swedish-American—interact with the kids at the clinic, I realized how fortunate we are to have her as a citizen of our country.

Annika was born in Stockholm in 1970 to a family who loved sports. Tennis, soccer, downhill skiing, volleyball, and (of course) golf were daily pursuits for young Annika and her sister, Charlotta. "We have a lot of gray, dark times in Sweden, so when the sun is up, Swedes go out," Annika says. And when the sun wasn't up, Annika still found ways to play. Her dad put a net in their basement, and she would hit shot after shot into it. Annika got good and stayed humble. As she puts it, "I wasn't the best golfer, but I was ranked. I got invited to play in some tournaments."

In the late 1980s, when Annika was finishing high school, a teammate from the Swedish national golf team invited her to visit at the University of Miami. "It was perfect," she says. Annika had learned English when her family lived in London from 1982 to 1984 ("I temporarily had a British accent," she jokes), and her friend's invitation gave her the chance to maintain her game in warm weather. "Imagine four women crammed into a dorm room," she says. "It was tight, so I got out and practiced a lot."

"I loved America from the beginning," she remembers. "I felt like it was the country of opportunity." This was particularly true for great golfers. "Beautiful courses, great competition, amazing facilities, and you can play year-round. The more you play, the better you get. I knew this was what I wanted to do and where I wanted to be."

A year later, Annika played a tournament in Japan representing the University of Stockholm—where, by the way, she studied chemical engineering. "I was paired with a player from the University of Arizona who said, 'You should come and play for us.'" When she got back to Sweden, her parents asked how the trip was. "It was great," she replied. "I'm going to play for the University of Arizona!"

Two years later, after winning several titles for the Wildcats—including the 1991 NCAA championship—she turned pro and signed with IMG, a top sports management agency. At the time, she was still playing on a student visa, so the agency helped her apply for what Annika simply refers to as "an O visa." The US Citizenship and Immigration Service puts it in more impressive terms: "The O-1 nonimmigrant visa is for the individual who possesses extraordinary ability in the sciences, arts, education, business, or athletics."

Annika dominated women's professional golf, winning ninety tournaments around the world, including seventy-two times on the LPGA Tour. One of her most important tournaments was one she didn't win. In 2003, she attracted record crowds at Fort Worth's Colonial tournament, where she became the only woman since 1945 to play in a PGA Tour event. At the height of her golf career, she was also pursuing her green card and then her American citizenship. "I had been in the US for eleven years. I was thirty-five years old; I knew this was where I wanted to start a family and make my home." She took her citizenship oath in 2006. "The following week I brought my red, white, and blue golf bag to the US Open, and I won. It was pretty cool to be a new US citizen and win the US Open," she says.

After the 2008 season, Annika retired from professional golf to focus on her family and her foundation. She and her husband, Mike McGee, are raising their children, Ava and Will, in Orlando, Florida. And they're helping other young people through the ANNIKA Foundation, which provides golf opportunities for girls in America and around the world.

"We have more than six hundred participants in our programs each year representing sixty different countries," Annika says. "I know these girls are not all going to be professional golfers, but I think golf teaches you skills—like with First Tee—to prepare you for the next chapter of life. They are going to be influencers and successful leaders at whatever they do." In 2020, President Donald Trump announced he would honor Annika with the Presidential Medal of Freedom, the highest civilian award a President can bestow. She is a fitting recipient. Annika's example and commitment to young people add to the character of our nation, and I am proud that this world champion chose America as the place to hang her visor.

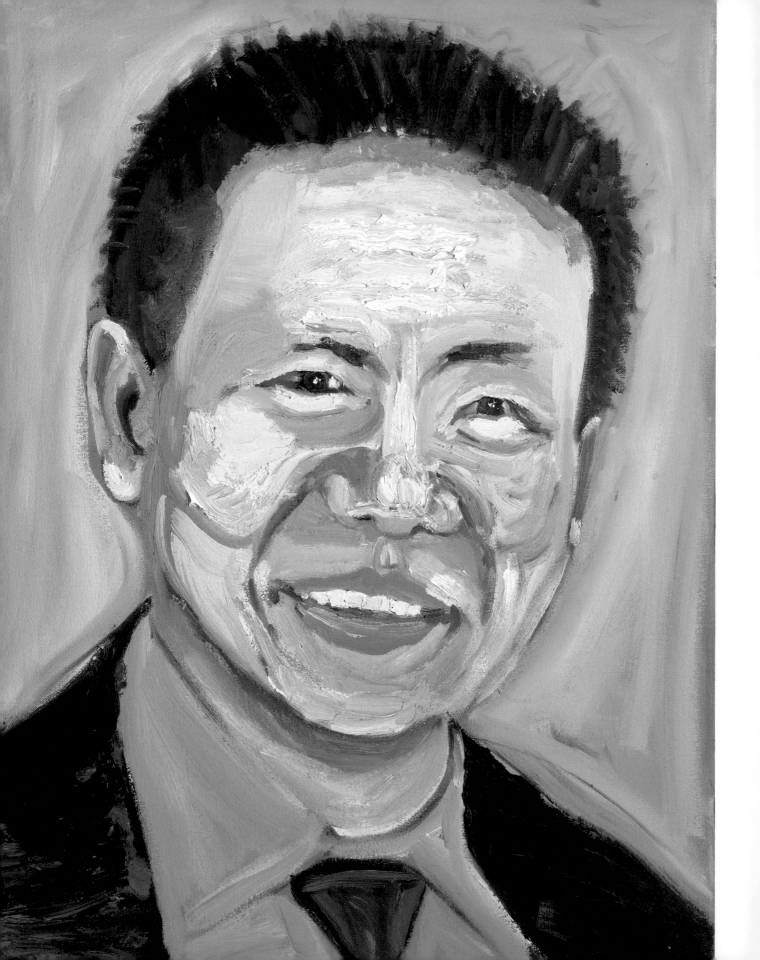

BOB FU

B OB FU GOT HIS ENGLISH NAME by drawing it out of a hat. Well, actually, it was a basket. He was in his early twenties, studying English literature at Liaocheng University in northern China. "It was hard for American teachers to remember our Chinese names," Bob explains, "so they put all the boys' names in one basket, girls' in another one." He got Joseph on the first draw but thought it was too complicated to remember. So he traded with his desk mate and became Bob. The girl sitting behind him drew Heidi.

College rules prohibited students from dating, and Chinese laws prevented students from marrying. Nevertheless, Bob had taken a shine to Heidi, and a romance developed. In 1989, they took a decidedly unromantic trip to join other students protesting the Communist government in Tiananmen Square. They left the protests just three days before the massacre that took untold lives. "I was really spared," Bob says.

As he continued his studies in English, Bob learned about a Chinese Christian whose faith had empowered him to overcome an opium addiction and begin helping others. Bob was struck by the healing power of the Gospel. "I became a radical little evangelist," he laughs. At one point, he proclaimed to his professor, "I believe in Jesus!" breaking a Communist Party rule. "At the time, I didn't know the distinction between a house church and the government-sanctioned church, and had little knowledge of the government policy of religious restriction. I just thought, *This is good news! I'm a changed man. I want to help others.*"

Heidi and Bob started a ministry to reach their fellow students, and they were in awe of the reception. People were starving for spiritual salvation. One night, they gathered four hundred students in a hotel for a worship service. "When I made the altar call, half of them right there stood up and accepted Christ,"

Bob says. After graduating, he and Heidi continued their ministry—and broke Chinese law—by starting an underground church.

It wasn't long before they learned about the government's restrictions on religious expression the hard way. "Prison theology is a must-take course for any faithful Christian in China," Bob says. "The pastor who married Heidi and I spent twenty-two years in prison. The pastor who baptized me spent seventeen years in prison. And we were imprisoned for illegal evangelism." He and Heidi spent two months in jail. When they got out in 1996, they were placed under house arrest. Heidi and Bob wanted children, but the government had assigned Bob a job teaching English at the Party School of the Central Committee of the Communist Party. That classified him as a civil servant, which meant they had to get a "special yellow pregnancy permission card" to have even one child. When Heidi became pregnant after their application was rejected, the doctor told them, "You have to run if you want to have the baby."

Heidi disguised herself and slipped past the guards of their apartment building. Bob was more recognizable and had to take a different route. He describes the escape in his book, *God's Double Agent*. "I entered a tiny toilet stall and climbed on the ledge of the window. . . . The jump was close to twenty feet and though I couldn't see the ground, I knew there was vegetation there to help break my fall. As soon as I left the ledge, I forgot all of my ideas about how to fall strategically. I flailed my arms and even though I was desperate to remain silent, a yell escaped from deep within me. . . . My glasses flew off and I vaguely remember reaching up to touch my face before everything went black." Bob described it as his "leap of faith." After he escaped, he vowed to get LASIK.

"We didn't have any plan, and we couldn't go back to our hometown," Bob remembers. Thankfully, they had the help of others. A local policeman they knew who was a "secret Christian" helped spirit them away to the countryside. Another fellow believer, who ran a travel agency, helped them fake documents and travel to Hong Kong. An American missionary hosted them for eight months while they looked for a new home—"any country that could provide us refuge, protection," Bob says. Finland said no. Australia said no. And the United States said no. As Bob and Heidi desperately searched, their son was born. They named him Daniel, "because he was born while we were still in the lion's den."

Fifteen days before Hong Kong was to be handed over to China—"my family's certain demise," Bob wrote in his book—he went to McDonald's for a

hamburger. A reporter approached him for a segment on *ABC World News Tonight* with Peter Jennings and asked him about the handover. "Actually, I'm a religious dissident from China," Bob replied, "and my family will be arrested again for our Christian religious beliefs unless the United States government will act on our behalf. Please, America, stand up for religious freedom."

This was before videos went viral, but America took notice. After an intervention at the highest levels of government, Bob, Heidi, and Daniel were granted asylum. On June 27, 1997—three days before Hong Kong was returned to China—the Fu family of three arrived in the United States. They went to Philadelphia, where Bob studied at Westminster Theological Seminary. After meeting pastors from my hometown, they put down roots in Midland, Texas. Along the way, they had two daughters, Tracy and Melissa. "We certainly broke the one-child quota," Bob says with delight.

In 2002, Bob founded ChinaAid, an organization that supports underground churches and Christian networks in China. They have provided legal advice to dissidents, helped refugees resettle, and shined a spotlight on the religious persecution taking place there. "My first press release was full of errors, plus the 'Chinglish' grammar mistakes. But the facts were so compelling, they always ended up in the *New York Times*, AP, and *Washington Post*," he says. "I want to bring the spirit of those who are being persecuted and share their testimony so we don't take our freedom for granted."

Before I went to the 2008 Beijing Olympics, I met with Chinese human rights and religious freedom activists at the White House. Not by accident, we scheduled the meeting on the same day the Chinese Foreign Minister was in town. That's when I met the founder of ChinaAid.

In preparing this book, I asked Bob why Americans in places like Midland, Texas, should care about religious freedom halfway around the world. Bob lit up. "This is the right thing to do! The founding fathers' families came here for the same reason I did—religious persecution. If you're a Christian, you know the teachings in the Bible about caring for the aliens, the strangers, the vulnerable, the elderly, the widows. They are our true fellow neighbors. Our voice is priceless, and that morality can never be bankrupted."

TONY GEORGE BUSH
and his mother, LAYLA

———

"I thank the American people for allowing me to have a beautiful life here among all of you."

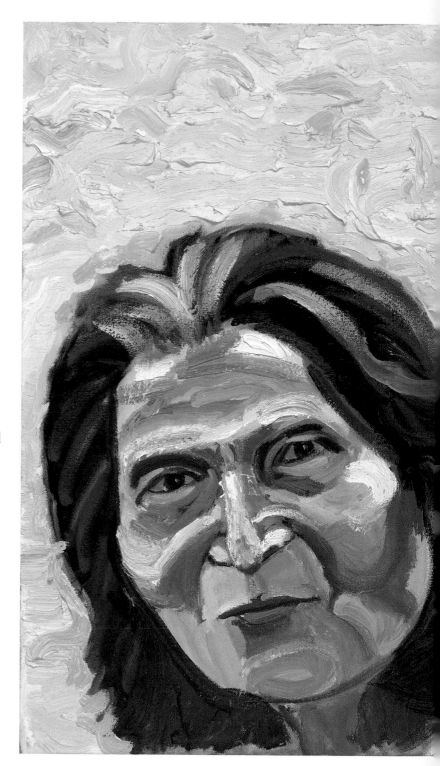

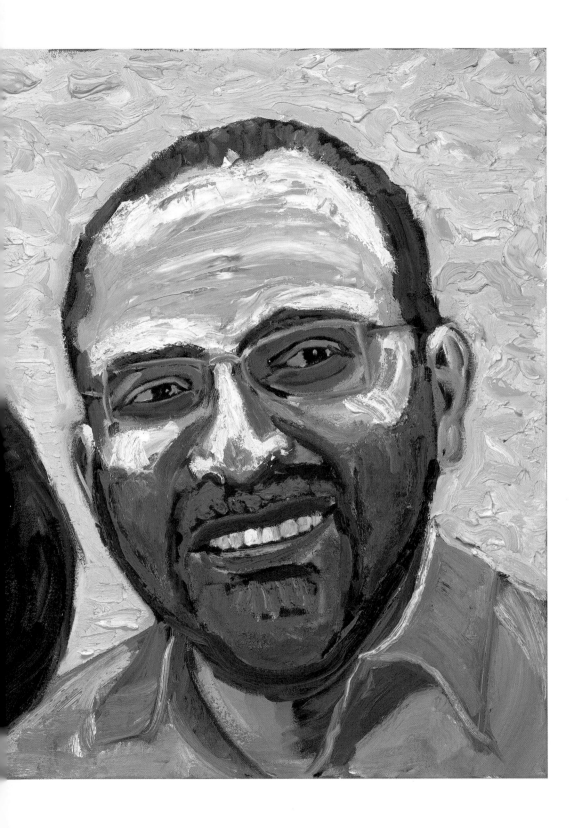

I N 2019, my office received an email from a curious sender:

Mr. President,

In this email you will find two photos. The first was taken in July 2003 in Baghdad after the liberation of Iraq. We will always be grateful to you and the US Armed Forces for everything they did for us. The lady in both photos is my mother, Layla. The second photo was taken in September 2019, when my mother received her US citizenship. She wishes to meet you in person and thank you on behalf of my family. We hope this email will find a way to you.

God bless America and God bless you,
Tony George Bush

We checked our Bush family tree. Sure enough, no Tonys. When we dug a little deeper, we learned the remarkable story of an Iraqi-American family.

When I started writing this book, I knew right away that I wanted to include an Iraqi or Afghan translator who had served alongside American forces in the war on terror. At great risk to themselves and their families, these brave souls stepped forward to aid our troops. My view is that anyone who has served our country and proved their loyalty should be welcome here. Unfortunately, the Special Immigrant Visa program for these brave linguists has been curtailed in recent years. Fortunately, groups like No One Left Behind are working hard to save this program and keep our country's promise.

Tony was born as Ali in Baghdad, Iraq, in 1986. When he was two, his father died in a car crash, leaving his mother, Layla, to raise their small Shia Muslim family by herself. "She became the mother and the father," Tony says. "She worked so hard to support my sister and me." Layla had gone to Switzerland for her education in the 1970s and became a hotel manager in Baghdad. When Saddam Hussein took power, the government seized the hotel—along with most everything throughout the country—and fired all the employees. Layla started cleaning houses to get by.

"Living under Saddam's regime was a disaster," Tony recalls. "I grew up in a bad economy. There was no fairness. We did not have freedom. The education was terrible. You can't attend college or get a job if you're not a member of the Ba'ath Party. We were not allowed to travel or even have a passport. Before 2003, it was the dark ages."

Tony liked to play soccer as a boy, but his mom kept him indoors out of fear for his safety. A lot of their neighbors had been arrested or kidnapped for inexplicable reasons. "If you were lucky, you got to leave with only one hand or one ear. But if you were not lucky, you got executed," Tony says. "We were living day by day, waiting for a miracle to save us."

Tony estimates that at the beginning of the twenty-first century, 20 percent of Iraqis had telephone lines. No one had a cell phone. There were two TV channels, and both belonged to the government. Tony's family would sneak onto the roof to listen to the BBC's Arabic news service on a small radio. "We had to do it secretly, because if anyone found out, we may get arrested," he says.

"In 2003, we heard President Bush give Saddam's regime forty-eight hours to leave Iraq," he remembers. "We were so happy. It was hard to believe, because Saddam had been President for thirty-five years. We counted every minute until Operation Iraqi Freedom started."

Tony describes the timing of the liberation as personally fortuitous. He was about to turn eighteen, the age at which he would be compelled to serve in Saddam's military—something he didn't want to do. "I felt freedom after seeing the US armed forces, how they protected us," Tony says. His mom started carrying a small American flag and even a photograph of me, which she pulled out whenever she saw our troops. "One time I said, 'Mom, you might get killed!' She said, 'These people risked their lives for us. I want to make them smile and show them that someone carries their flag.'" The photo Tony emailed in 2019 shows Layla holding my picture and flashing a thumbs-up at a US military police checkpoint.

"When the American forces came to my area, they used to give us chocolate," Tony explains when asked how he got the job that brought him to the United States. Having learned a little English when he was younger, Tony struck up conversations with the Americans. Before long, someone suggested he apply for a

position as a translator. Siding with the Americans meant he and his family could be targeted by insurgents. "But to see someone who never met you, who didn't even know your name, put his life on the line to protect you . . . that means a lot." As Tony waited to turn twenty-one, the minimum age to apply, he took English classes to hone his language skills. And he married an Iraqi woman named Luma.

After passing the language test and background check, Tony was hired. He remembers a young American Marine fitting him with protective gear before his first assignment, in Fallujah. He tightened Tony's bulletproof vest down against his chest and told him, "I have to make sure you're safe because you're my priority." "From that day on, I considered the US military my family," Tony says.

To protect his identity, he had to wear a mask and use an alias. "I used to eat a lot of Frosted Flakes," he laughs. The Marines he was embedded with told him, "We are going to call you Tony. Tony the Tiger." It stuck.

His next post was with the US Army in Baghdad. A staff sergeant welcomed him and asked about his family. When Tony told her that his wife was pregnant with their first child, the sergeant asked if he had bought anything for the baby. "I have to wait until next month, when I get paid," Tony said. His voice cracks with emotion when he recalls what happened next. "The next day when I came in, she said, 'Good morning,' and shook my hand. I felt something in my hand. The day after I met her, she gave me one hundred dollars for my baby."

After more than two years serving alongside American forces in combat, Tony learned about the Special Immigrant Visa program from an American soldier. He and Luma wanted to raise their family in peace and safety. His commanding officer provided a letter of recommendation, and three months later, his application was approved. Tony would move to the United States and bring his family after establishing a home. "My journey to the dreamland, the United States of America, was a beautiful adventure," he says. "I remember when I first arrived and gave my documents to the officer. When he saw that I worked with the military, he smiled and said, 'Welcome home.'"

The International Organization for Migration covered Tony's flight from Iraq, and he worked minimum-wage jobs to pay them back in two and a half years. Catholic Charities helped Tony get acclimated in Sacramento. He later

lived with a fellow translator in Spokane, Washington, then with his sister—who had also immigrated after serving as a linguist—in Newport, Rhode Island. He eventually settled down in Houston, Texas, where he got a security job at George Bush Intercontinental Airport. Due to bureaucratic delays, it took years for Tony's family's visas to be approved. But in 2013, Tony was finally reunited with his mother, wife, and children when they joined him in Houston.

Four years later, Tony became a naturalized American. "I didn't sleep the day before," Tony says. "I was too excited. I had waited my whole life for that moment." The next day, he legally changed his name to Tony George Bush and took the oath of allegiance as his family watched. "Being a citizen of this country and raising my family in a safe place where people respect us as humans is the best thing that ever happened to me," he says. "I thank the American people for allowing me to have a beautiful life here among all of you."

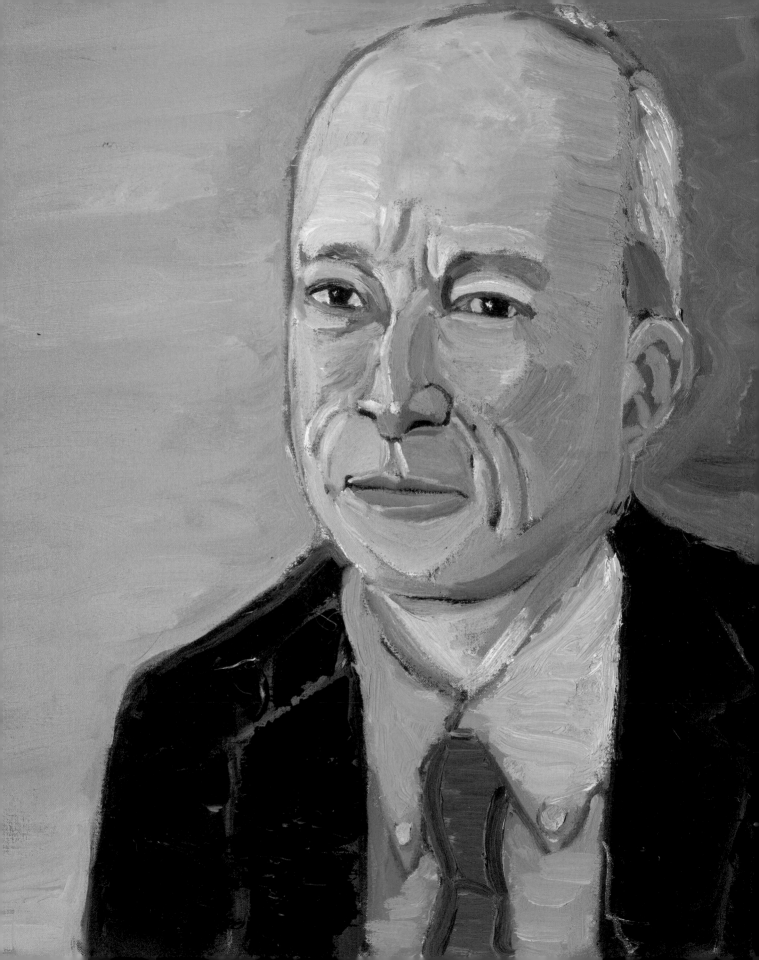

YUVAL LEVIN

Yuval Levin has been described by the journalist Steve Hayes as "perhaps the leading public intellectual on the center-right these days," an assessment with which I heartily agree. I got to know Yuval when he served in the White House during my presidency. He's a brilliant thinker, a compassionate soul, and a patriotic American committed to preserving our country's founding principles for all our citizens. I relied on his advice on a range of domestic issues. Along with advisors like Mike Gerson and Pete Wehner, he was part of the soul of my administration.

I included Yuval in this book because I want people to know the kind of brainpower and perspective that immigrants can bring to our country. So here's some of Yuval's story, in his own words:

I was born in the city of Haifa, in northwestern Israel, in 1977. My parents brought our family (the two of them, my two siblings, and myself) here in 1985, when I was eight years old. They left largely for economic reasons. My father had owned a small construction business in Israel, and the collapse of the Israeli economy in the eighties—particularly the completely out-of-control hyperinflation it involved—destroyed the business and my family's livelihood. My parents were left to start over, and an opportunity for my father to use his engineering and construction skills in the US led them to make the move.

Although escaping an economic disaster was key to what drove them to emigrate, my father in particular had also long been drawn to the promise of America. Even as a child, growing up in Israel, he had felt the appeal of American culture, of the economic freedom available here, and of the ideals this country represented. So they were responding to both a push and a pull.

My parents spoke some English when we moved—though we three children spoke none—but otherwise they had essentially no resources to draw on here. I certainly did not fully appreciate as a child how difficult the move must have been for them, let alone making it with three young children, and how much they had to bear to make it easier on us.

Leaving home was frankly excruciating. Easily the hardest part was leaving a close-knit extended family behind. I would see my grandparents or cousins pretty much every day, and that family environment had been my whole world. And now I faced a new reality in a country where I knew no one outside my nuclear family, did not speak the language, and had no grasp of the culture and its expectations. I had a couple of months to try to adjust a bit and learn a few words of English before starting the third grade at the local public school in northeast Philadelphia.

I had an amazing English-as-a-second-language teacher in that first year in America. She had the impossible task of teaching a class of about ten elementary schoolkids who not only didn't speak English but didn't have a common language between them. She was a young teacher, and I can only imagine how hard it was. But she opened a doorway to English for me, and through it to a new life in a new home that I went on to make my own. These days, I write and speak for a living. A command of English is how I earn my livelihood, yet I don't have the words to express my gratitude for the help she offered me in that first year in America.

My education and my work have frankly been a form of devotion to America. By the time I was a teenager, just a few years after moving to the US, I had become intensely interested in American history and politics. And by the end of high school, I was not only a political junkie but a committed conservative—committed, that is, to preserving the best of the American tradition and building on it. I was home and eager to contribute something.

I went to college in Washington, DC, earning a degree in political science. I was about as American as it was possible to be by the time I took the citizenship test in 1998, at the federal building in Newark, New Jersey. After we all recited our oath, the judge who had presided gave a very short speech. He said we should now start thinking and talking about America "not in the third person but in the first person plural"—we should say our

and we *and* us *when we talk about this country. I'm not a guy who gets emotional listening to speeches, but I'll never forget his words, and I'd be lying if I said there wasn't a tear in my eye.*

I have had the enormous privilege of devoting my working life to playing some small part in helping my adopted country flourish and renew itself. I couldn't be more grateful to be doing this.

We are in one sense a nation like every other—loyal and proud, and protective of our own. Yet we are in another sense a nation like no other—defined by aspirations and commitments that enable us to welcome into the fold anyone willing to share in them.

As Abraham Lincoln put it in 1858, not every American is descended from the people who wrote the Declaration of Independence. Many came later or had ancestors who did. "But when they look through that old Declaration of Independence they find that those old men say that, 'We hold these truths to be self-evident, that all men are created equal,' and then they feel that that moral sentiment taught in that day evidences their relation to those men, that it is the father of all moral principles in them, and that they have a right to claim it as though they were blood of the blood, and flesh of the flesh, of the men who wrote that Declaration, and so they are."

And so they are. To be an American is to feel a tingle down your spine at reading those words, and to know they speak of you.

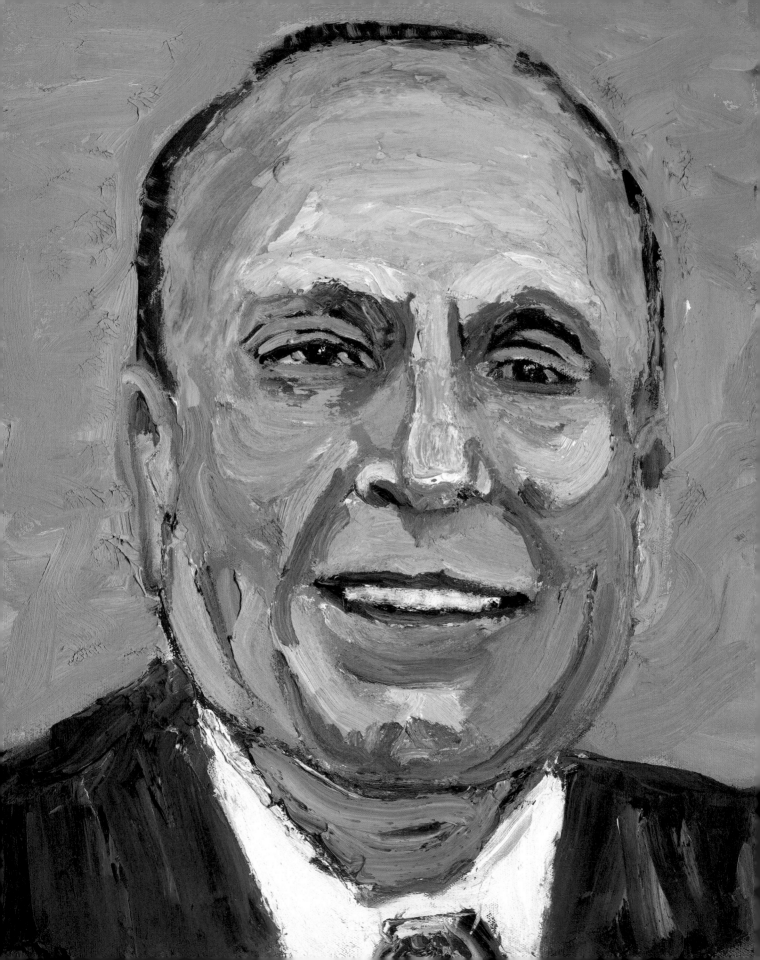

JAVAID ANWAR

ONE OF THE MOST GENEROUS MEN I know learned to be charitable before he had anything to give away. Javaid Anwar grew up in Karachi, then the capital of Pakistan, in the 1950s. "We had a lot of beggars in our country; it was a poor nation," he explains. "My mother wanted me to help whomever I could. Sometimes people would knock on our door and ask for food, and we'd pack up our dinner and give it to them. 'Oh, we've eaten,' she would say—and then go to bed hungry."

Javaid's parents separated before he was born, so he and his mother lived with his grandparents. "That's the only reason I survived," he says. His mom worked as a telephone operator. She put 80 percent of her income toward Javaid's school tuition, hoping that he would become a doctor. "I want you to help the poor who cannot afford medical treatment," she told him.

Javaid says he's fortunate to have gone to the best schools in Karachi, but eighth-grade biology got in the way of his medical career. "The names were so big, I couldn't remember or pronounce them," he jokes. "I decided I would never become a doctor." He didn't lower his sights, though. He settled on nuclear engineering.

After finding out he could access the "humongous" library at the new US embassy, he spent hours there researching his options. He learned that one of the few schools that offered a degree in nuclear engineering was the University of Wyoming, some 7,800 miles away. "My mother's exact words were, 'Have you lost your mind?'" he says. "'How am I going to afford your tuition and airfare all the way to the United States?'" Desperate but determined, Javaid took a train to Multan, where he met his father for the first time. His dad agreed to pay for tuition, but the money never came. "I never heard a word from my dad again. Nothing. I was pretty depressed. I had already applied and been admitted. I had worked so hard," he says.

Four weeks before he was supposed to start classes, Javaid had given up. That's when his mother and grandmother surprised him. "They said, 'We love you very much. We're going to give you a one-way ticket and one semester's tuition.' Sink or swim," he says.

In 1971, Javaid boarded his first airplane and flew to Laramie, Wyoming. He says the temperature felt like negative thirty degrees when he landed. "It was the shock of my life," he says. "I was raised in a tropical climate. I thought, *Oh my God, what a mistake I've made!* The cowboys were used to it, but those first six months were horrible for me."

Javaid was short on money, so he took a job at the university cafeteria. It only paid a dollar or two an hour, but it included three meals a day Monday through Friday. At midnight, he punched in at the lumberyard—and again every thirty minutes to prove he wasn't sleeping. In the summers, he went to big cities like Denver and New York to work better-paying construction jobs and save for tuition.

Incidentally, Javaid's flight from Pakistan to the United States was the same year as Henry Kissinger's (page 31) secret flight from Pakistan to China. "I had absolute admiration for Henry Kissinger," Javaid says. Decades later, Javaid bought a private jet and hired a retired Air Force pilot named Charlie Bond to fly him. It was the same pilot who had flown Henry Kissinger from Karachi to Beijing.

One summer, Javaid visited a friend in Vallejo, California, who had already graduated with a nuclear engineering degree. "Do you want to see where I've worked for the last six months?" the friend asked. "And he took me into a submarine," Javaid remembers. "I said, no way." Just like that, Javaid decided to become a petroleum engineering major.

He had always planned to return to Pakistan after his education. "Then I saw that in America, if you work hard, and you're honest, you get rewarded. You are respected. I was never respected in my own country," Javaid says. "In Pakistan, if you don't have a father, a lot of people look down on you. If you're a woman and you're not married, people put you down. It's a cultural thing."

Not long after graduating, Javaid was hired by Roy Williamson, an oilman in Midland, Texas. Roy respected Javaid's talent and work ethic, and Javaid adored him. "This is the man who gave me a chance. I was so impressed with him. I wanted to be Roy Williamson," Javaid says. Roy's private plane, red sports car, and impeccable clothing may have been part of the allure. The job with Williamson led to other work in Houston, Amarillo, and the small town of Pampa, Texas. "It gave me a chance to go to the oil field and learn a lot."

While in Amarillo, Javaid met a wonderful woman from Maine named Vicki. They married in 1981 and eventually had twins, Leslie and Ryan. They soon learned the ups and downs of the industry Javaid had chosen. When oil prices plummeted in the early 1980s, Javaid saw men in their forties and fifties get laid off. He thought about their families, and he thought about his family.

"I decided back then, I'm not going to be a victim when I'm that age. I'm going to start my own oil company," he says. One skeptical investor told him, "You know, I can do two things. I can give you the money, or I can just put hundred-dollar bills in a briefcase and open it on a windy day." "We did the first one," Javaid laughs. In his words, "The bucket of sh*t turned to gold," and he paid his investors back in just two and a half months—almost three years ahead of his projections.

Javaid found success through hard work, innovation, risk-taking, and, as he puts it, a lot of luck. He once visited his mom in Karachi wearing an expensive suit, probably styled after Roy Williamson. She wasn't the least bit impressed. "Have you ever thought about how poor people live?" she asked. "Have you thought about where you were at one time?" So he did. "I thought about where my success came from. It came from education. So I started giving to the University of Texas, where my kids had been through the engineering and business schools," he says. And he just kept giving, to charities in Midland, across Texas, and throughout the country. "I overcommit sometimes, but I always fulfill my promises. It gives me a lot of pleasure deep down."

Much of Javaid's generosity goes unrecognized. That's the way he likes it. Unbeknownst to Javaid, his longtime assistant Deneen Wooten has observed some of his quiet kindness. "Javaid always stops to put gas in the rental car, even if we've only used thirty-two cents' worth," she says, recalling one trip to Dallas. As Javaid filled up the tank one day, he saw an elderly black woman digging around in the trash. He asked her if she had lost something. She said no, she was looking for food. Deneen watched Javaid reach into his suit and hand her an envelope. "She walked away, and she didn't know what it is yet. So I watched her. And that lady's face when she opened it, it was just priceless." The envelope contained ten thousand dollars in cash. "She sat down on the curb and started crying," Deneen says. "He probably changed her life right there."

"That's what America did for me," Javaid explains. "It changed my life. It gave me chances I can never repay. The only way I can try is by helping other people out in this country. Not only am I living the American dream, but I'm fulfilling the dream my mother had for me."

ZUNITA
CUMMINS

"I would like Americans to understand
that becoming an American citizen
is not as easy as they would think."

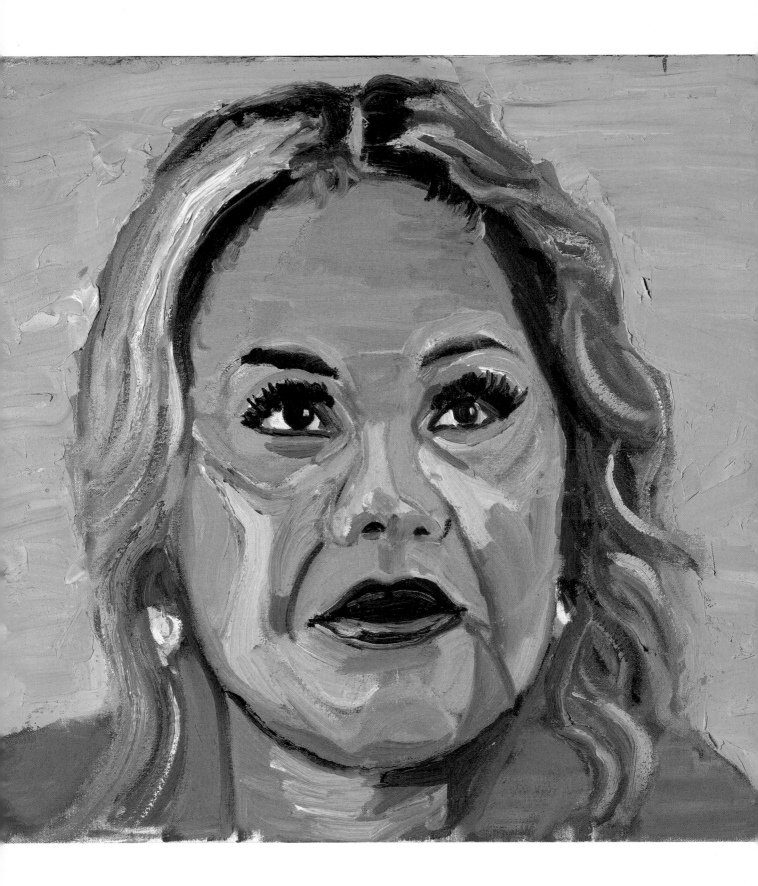

Lik e many, Zunita Cummins came to the United States for a better education. She studied at Richland College in Dallas with the goal of teaching preschool. Unlike many who come on a student visa and are sent home after receiving an education here, she was able to stay and become a citizen.

That wasn't always Zunita's plan. She had a happy upbringing in Panama and intended to return. "I didn't have much growing up, but I never went to bed hungry," she says. "My dad has been a pastor since I can remember, and I was raised Baptist with a strong faith, good values, and to be respectful to others." To make ends meet, her family opened a bakery in their coastal town of Colón. "I remember getting out of school and going door-to-door with my brothers to sell the cakes that my mom baked. It never felt like a chore. It was more like an adventure."

When Zunita graduated high school in 2001, she asked her parents for help to continue her education in Dallas, where her aunts and cousins had immigrated. "If you learn English really well—writing, reading, and speaking—you can get good jobs in tourism or as a bilingual teacher in a private school. Those are good jobs in Panama," she explains.

When asked why she decided to change her plans and stay in the United States, Zunita laughs. "I met my husband in college," she says. She fell in love with Jonathan Cummins, a fellow student who grew up in Michigan and Texas. She also fell in love with the United States.

Through friends at New Life Baptist Church, she found a job working as a nanny "for a very special family." Amy and Brandon Harris had a little boy, with another baby on the way. Zunita recalls how the interview went. "Amy said, 'Well, I'm looking for someone older who has more experience with babies.'" At the time, Zunita was only eighteen, but Amy offered to try her out for a month. It must have gone all right, because Zunita stayed for eight years.

With support from the Harris family, Zunita continued her education. She raised two daughters of her own, Natalee and Naomi, and became a preschool teacher and a nanny to other families. Anne Wicks, who directs education reform programs at the George W. Bush Institute, relied on Zunita to help watch her son and describes her fondly. "She never just babysat Duke—she read to him, did art projects with him, and taught him. It was such a big help for me to be able to rely on her to be responsible with my child in a really personal setting," Anne says. "That enabled me to be a better mother and a better employee at the same time. Her being so family oriented helped my family, too."

While caring for other families, Zunita saved money to help bring hers to Dallas. The biggest expense was paying immigration lawyers to help her and her parents navigate the complicated process of becoming citizens. It is slow and competitive, as it should be. "I would like Americans to understand that becoming an American citizen is not as easy as they would think," she says. "It is very difficult, and it required a lot of money that not everyone is able to afford. I would also like Americans to know that most immigrants are here to help make this country better every day for us, for you, and for your children."

In December 2018, Zunita started a business. Launching Dallas Baby Whisperer LLC was a big step toward the American dream. And Zunita took another step three months later, when she and forty-eight other immigrants became naturalized American citizens at the Bush Center in Dallas.

"The most emotional part—I cried a little bit—was when they called a group up to the stage, and Mrs. Bush said to bring my daughters up as well," Zunita says. "I was very proud they could be at the end of the long journey with me after eighteen years. It was very important that they were there with me, and they were very proud of me."

Laura and I were proud to stand with Zunita and her girls as we recited the Pledge of Allegiance side by side as equal citizens. And Anne Wicks watched proudly from the audience. "I knew how hard she had worked at that," Anne says, "and how thrilled she was to be here. It had been a goal for her. She is very clearly someone who is contributing to our society in lots of ways—faith, community, family—someone I'm excited to be able to call my fellow American."

I am, too.

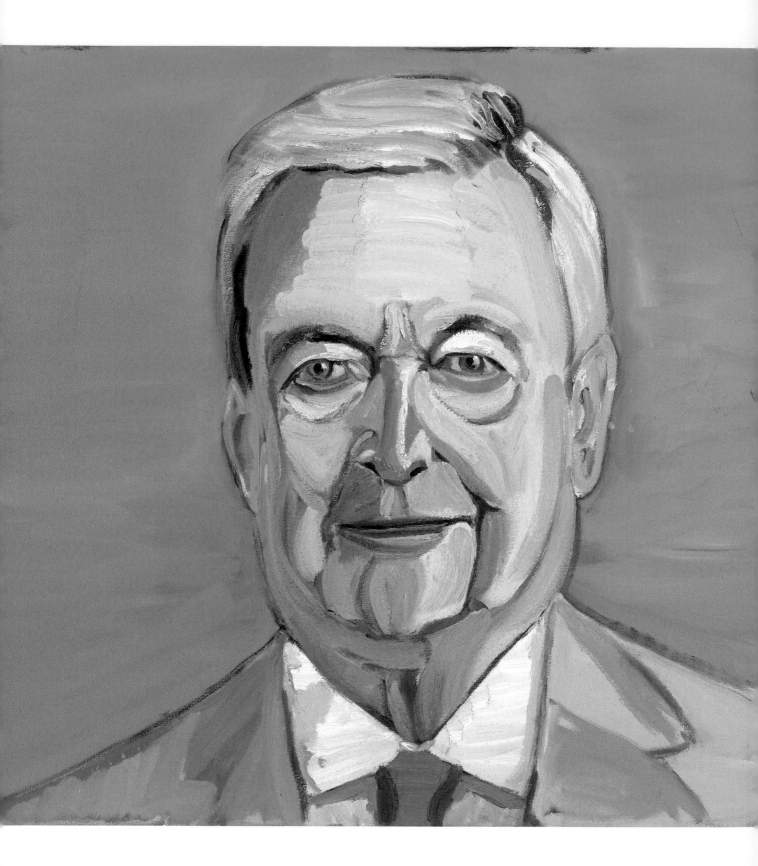

ARMANDO CODINA

E VEN BEFORE THE BAY OF PIGS INVASION and the Cuban Missile Crisis, the early 1960s were a terrifying time to be a parent in Cuba. Communists seized private schools, closed secondary schools, and opened agricultural "youth camps" where students were forced to work the fields. Rumors about compulsory military service swirled—and were later proved true when Fidel Castro sent troops to Angola.

Years earlier, Armando Codina's father had served as Speaker of the House and President of the Senate in Havana. "He was exiled during Batista and then a second time shortly after Castro took power," Armando recalls. His parents divorced when he was young. "In 1961, I was sent by my mother to the United States to flee Castro's Communist Cuba. I was fourteen years old at the time. Later on in life, when you have kids, you learn that's the greatest sacrifice a parent can make: to separate from a child in order to save them."

Armando evacuated through a remarkable underground rescue operation known as Operation Pedro Pan (or Peter Pan). With the knowledge and support of the Eisenhower administration, Father Bryan Walsh of the Catholic Welfare Bureau organized the exodus of fourteen thousand Cuban minors from 1960 to 1962. I view it as one of the greatest displays of American altruism ever. It was smart, too. Operation Peter Pan brought us great future Americans, many of whom I am fortunate to know. US Senator Mel Martinez was my Secretary of Housing and Urban Development and the first Latino to chair the Republican National Committee. Hugo Llorens was a career foreign service officer who worked in my White House and ran the American embassies in Honduras and Afghanistan. Eduardo Aguirre served as my Ambassador to Spain. Reverend

Luis León was the rector of St. John's Church across from the White House, where Laura and I worshipped during my presidency. Miguel "Mike" Bezos came to the United States alone in 1962; thirty-two years later his son, Jeff, founded Amazon. And Armando Codina, a dear friend to my father, my brother Jeb, and me, is a tremendous success in business and a generous American philanthropist.

"When I arrived in Miami," he says, "I was sent to Camp Matecumbe for a short time, then to an orphanage in New Jersey, and to foster homes." Armando describes those as some of the worst days of his life. "The hardest part about leaving home was leaving my mother behind." Like most Cuban parents, Rosa expected Castro's reign to be brief and her separation from her son temporary. Instead, Castro became the longest-ruling dictator in modern history. Armando wasn't reunited with his mother until she made it to Jacksonville, Florida, three years later.

Rosa didn't speak English, so Armando skipped college and worked to support her. He bagged groceries at a Winn-Dixie during the day. At night, he drove a truck around town to pick up checks from businesses and deliver them to a computer center for processing. "That's when I became fascinated with computers," he says.

After a couple of years, Armando and his mother moved to Miami, where he got a loan from the Small Business Administration and started a company that pioneered data processing and financial services for doctors' offices. In 1978, Ross Perot Sr. and Clint Murchison Jr. bid against each other to buy the company. When Armando closed the deal with Murchison, who owned the Dallas Cowboys at the time, he celebrated by buying a boat. Its name: *What a Country*.

He went on to invest in and develop office buildings, homes, apartments, and industrial projects. "My real estate company eventually became the largest full-service commercial real estate company in the state even though we only went up to Dade, Broward, and Palm Beach counties," Armando says. When his mother was alive, he limited his investments to those three counties so he could have lunch with her each day. He has served on the boards of major companies like American Airlines and Home Depot. And he has more awards than shelf space, including the United Way's Tocqueville Award for Outstanding Philanthropy and Humanitarian of the Year from the American Red Cross. But Armando speaks most proudly of his family: "I married above myself, and Margarita and I have four daughters and nine grandchildren."

When I asked Jeb about Armando, he described him as "one of Miami's great community leaders. . . . He is a loyal and caring friend to hundreds. It is an amazing group that ranges from waiters to Presidents." The first President he met, Gerald Ford, spoke at Armando's naturalization ceremony in 1976. A few years later, he was invited to the same auditorium for a Cuban Independence Day speech by President Ronald Reagan.

"I'm looking at the teleprompter, and all of a sudden I see my name," Armando said. President Reagan introduced Armando and told his story to the crowd: "It took courage for this little boy to begin his new life. But now, at thirty-five, he has a string of business accomplishments of which any individual many years his senior would be proud."

For a time, Armando thought he might like to go into politics like his father. He chaired one of my dad's presidential campaigns in Dade County and Puerto Rico, grueling work for which our family remains grateful. "After a year serving as a volunteer, I got cured of the political bug," he laughs. That—along with Rosa's Cuban cooking—might explain this 2001 *Miami Herald* article: "On this very day, news reports have him attending George W. Bush's inauguration in Washington, D.C. He's not. He's coming to lunch at his mother's." Armando recently made it up to me, complimenting me as "an underestimated President who is now an underestimated artist." *Mis*underestimated, I reminded him.

"I was fortunate that Cuba was ninety miles from this great nation that has given me everything I have," Armando reflects. "If I lived for a hundred years, I could never repay what this country has done for me. With all our challenges, we are still the country with the most hope and opportunity in the world."

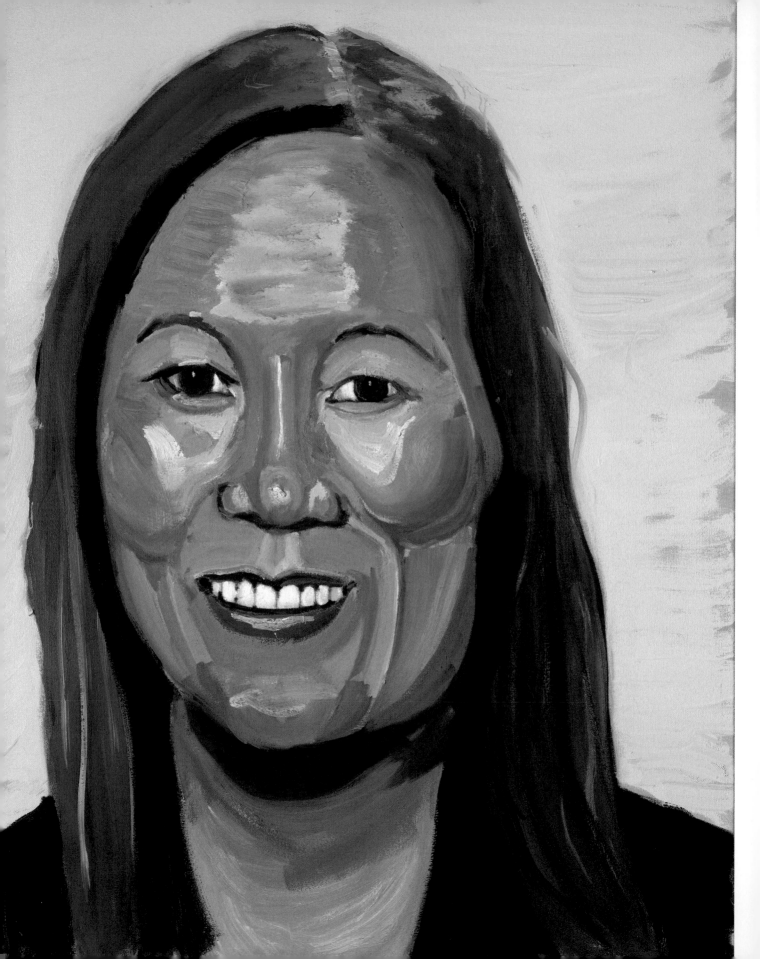

THEAR SUZUKI

––––––

"COURAGE IS A LEADERSHIP ATTRIBUTE that I need for myself and want for others," Thear Suzuki says, describing the work she does in the business world. "According to Mark Twain, 'courage is resistance to fear, mastery of fear—not absence of fear.'" As a child in a war-torn country, Thear had plenty to fear. Throughout her life, she has resisted it, mastered it, and mustered a courage few could.

Thear was born as Sokunthear Sy in Phnom Penh, Cambodia, in either 1972 or 1973—she doesn't know. "The first eight years of my life were spent in war and refugee camps," she explains. "Upon their victory of the civil war, the Khmer Rouge, a Communist regime led by Pol Pot, drove millions of people out of cities and into the countryside, where men, women, and children were forced into labor camps." The crazed, craven dictator tried to reset time to "Year Zero" when he seized power. By year four, he had presided over the deaths of two million of his people. "The Khmer Rouge wanted to turn the country backward into a socialist, agrarian society where all citizens were expected to work for the common good, living arrangements were communal, and meals were rationed," Thear says. "They persecuted the educated, outlawed schools, and targeted Christians, Buddhists, and Muslims."

Thear's family of seven managed to survive the genocide, which took place on sites across Cambodia now known as the Killing Fields. They worked in forced labor camps and lived in the jungle for years before escaping to a Thailand refugee camp in 1979. After two years bouncing from camp to camp, they found support from the United States Conference of Catholic Bishops' Migration and Refugee Services, which sponsored their move to the United States. "They helped us find housing, secure food stamps, find jobs for my parents, and register us into school in Dallas."

––––––

Thear's family only needed the food stamps for three months before becoming independent. "My father and mother worked minimum-wage jobs to support our family," she remembers. Her dad spent twenty-five years working as a janitor at Bradfield Elementary. Her mom took jobs at a local restaurant, Highland Park Cafeteria, and as a maid at the Mansion hotel. She learned English by watching *The Price Is Right*. The five kids pitched in by rooting through trash and redeeming cans for a nickel and bottles for a dime. They wore clothing donated by Bradfield Elementary families and dresses sewn by their mother.

Like so many immigrants, Thear struggled with the new language and the strangeness of the food. She remembers repeating a grade to get a better grip on English and scraping the toppings off of her pizza. Eventually, she mastered the language and even took a liking to fried chicken.

The family initially lived in housing projects in West Dallas, where they feared for their safety. "We often received phone calls telling us to go back to our country," she says. "We moved out as quickly as possible." Others in their new community were more welcoming. Thear's parents had "heard the Good News" in a Thailand refugee camp and converted to Christianity. In Dallas, they found a church that embraced and supported them. When Thear was a teenager, Ron Cowart, a police officer who patrolled their neighborhood, got her involved with a scouting group he had started for Southeast Asian students. The program, Exploring, taught Thear about community service and helped her study for her citizenship exam. She aced it and became an American on June 16, 1992.

Thear credits her third-grade teacher, John Gallagher, as another inspiration. "He helped me through my formative years and helped my family rebuild our lives. Through his kindness and advocacy for my education, my life was completely transformed." When Thear graduated from Skyline High School in 1992, after serving as student body president, Mr. Gallagher nominated her for a scholarship to Southern Methodist University. "I have been able to achieve some level of success because so many have helped and took a chance on me," Thear says.

With her degree, Thear went on to work as a technology consultant at Accenture for sixteen years. She's currently a principal and talent leader at Ernst & Young. She serves with more community organizations than there's room to list, including the boards of directors of the Texas Women's Foundation, the Dallas Holocaust and Human Rights Museum, and the Boy Scouts of America—whose Exploring program helped young Thear become a naturalized American citizen.

As a Presidential Leadership Scholar in the 2019 class, Thear took on a personal leadership project, "engaging men in the conversation about invisible gender differences, and how women and men can work together to solve the gender equity issue." She and her husband, Eric, are raising four boys who, no doubt, value and respect women and girls.

Thear says, "We have come full circle, from receiving help from others when we were in need, to now serving others in need. My father has dedicated his life to sharing God's Word and building disciples. He led the efforts to translate the first Cambodian study Bible. My mother has built water wells and churches in Cambodia, and at age eighty-one, she still goes on mission trips.

"Being an American means I am free," she concludes. "I have rights. I can believe what I want and make choices for my family. I can use my skills and resources to help others improve their lives."

When I painted Thear, I thought of her Mark Twain quote, and it brought to mind another remark from that same author: "It is curious—curious that physical courage should be so common in the world, and moral courage so rare." It is curious and fortunate that one of America's own has the combination of both.

DIRK NOWITZKI

———

"The people of Dallas took me in from the beginning
and made me part of their community.
I'll never forget that for my entire life."

In his twenty-first and final NBA season, Dirk Nowitzki surpassed Wilt Chamberlain to become the sixth-ranked all-time scorer in league history, just behind Michael Jordan. Dirk scored each of his 31,560 points as a Dallas Maverick, breaking Kobe Bryant's record of twenty consecutive seasons with one team. Every time an opportunity to play elsewhere arose, Dirk stayed firmly put, no matter what it cost him. "The people of Dallas took me in from the beginning and made me part of their community," he says. "I'll never forget that for my entire life."

When Dirk came to the United States after being picked in the 1998 NBA draft, he was fulfilling his childhood dream. "I grew up in Würzburg, Germany, in a sporty family," he says. As a boy, he tried everything from handball to tennis to soccer to basketball. "I basically grew up in a gym." Dirk spent his summers honing his skills on the court with his coach and mentor Holger Geschwindner, painting homes for his parents' small business, and daydreaming about "coming to the US and playing for the best league in the world.

"The hardest part was leaving my family, leaving my friends," Dirk says of his journey to Texas. "And the unknown. Not knowing if I was going to make it in my new profession in the NBA." The twenty-year-old was living on his own and getting used to a new language. "Lisa Tyner with the Mavericks helped me with everything. She basically took me under her wing and helped me get adjusted to living in another country. I will never forget it and will always be grateful to the Mavericks for helping me get settled and eventually feeling comfortable off the floor as well as on the floor." Dirk didn't spend much time off the floor. His work ethic was legendary. He practiced so much that at one point, the coaches had to lock him out of the gym to force him to rest.

One thing the Mavs didn't provide was a style consultant. Dirk keeps a photo of himself with former teammate Steve Nash from the 1998 press conference introducing them to Dallas. "I had an earring and a brutal bachelor boy 1990s haircut," he says. I like Dirk because he can laugh at himself. I almost painted him from that picture, but I respect him too much. "Every time I see that photograph now, it makes me smile because that's where the journey started," he says.

That journey has been one for the record books. Dirk's signature one-legged fadeaway jumper was a game-changer. Defying physics, he could launch his already-seven-foot frame high enough into the stratosphere that it was nearly indefensible, inspiring imitation shots from high school gyms to NBA arenas. He also

changed the game by raising the profile of international players and paving the way for more to follow him. Dirk was named the league's most valuable player for the 2006–7 season and the NBA Finals' MVP in 2011. That year, he delivered one of the grittiest performances in playoff history, leading the Mavericks to their first NBA championship. And in 2017, the fourteen-time All-Star earned a less notable but most fitting recognition: the Twyman-Stokes Teammate of the Year Award.

Throughout his career, Dirk was beloved in Dallas and respected across the league. In his final season, 2018–19, Dirk got a standing ovation during almost every appearance. In Los Angeles, Clippers coach Doc Rivers called an inexplicable time-out with nine seconds left in the game. He walked over to the microphone and asked the crowd to join him in cheers for "one of the greatest of all time." Dirk's final game was in San Antonio, whose Spurs had been his rivals for decades. They sent him off as if he were one of their own, and Dirk broke down in tears when they welcomed him onto the court for the last time. LeBron James called him "unstoppable." Kobe Bryant tweeted, "I loved and hated competing against you."

Dirk appreciated all the tributes, but he's most proud of his family. He and his wife, Jessica, have three young children: Malaika, Max, and Morris. "They had to sacrifice a lot these last few years while I was still playing and traveling. Now it's mostly about family time," he says.

The lanky and lovable star picked up more than one nickname while he was playing. The Blond Bomber. The Dunking Deutschman. But in Dallas, many children have a more endearing name for him: Uncle Dirk. For more than a decade, Dirk has been a frequent visitor to Children's Medical Center—especially at Christmastime, when he arrives with more gifts than he can carry. He has spent hundreds of hours there wandering from room to room, playing Guitar Hero, and bringing joy and laughter, the best medicine, to kids who need it most. He has insisted on doing so in private—no press coverage.

When asked about the former Maverick, the team's owner, Mark Cuban, says, "For all his accomplishments on the court, it is Dirk the person—the dad, the philanthropist, the friend—that makes Dirk so special to me and all of Dallas."

That, even more than his remarkable career, is why I included Uncle Dirk in this project. The Dirk Nowitzki Foundation has been as generous and loyal to the children of Dallas as its namesake was to the city's NBA franchise. His dedication to our community and our country represents the greatness of America. We are fortunate to have Dirk Nowitzki on our team.

SHINHAE OH

S HINHAE OH AGREED TO BE part of this project on one condition: that her story would be shared not as a credit to her, but as a testament to God and the people who have helped her throughout her remarkable journey.

"I was born in North Korea in 1991 and grew up during a time frame called the Arduous March," Shinhae says. Shinhae was raised by her mother, who enlisted her help after school to keep up with housework and tend the crops that the family relied on for sustenance. At night, they huddled side by side under a lantern. Shinhae studied while her mom sewed her clothing.

"The dictatorship is the dominant national religion that North Korean citizens must practice," Shinhae explains. "We were made to worship Kim Il Sung and Kim Jong Il as supreme gods. I was exposed to that kind of brainwashing since I was a child. My mother would always encourage us to hope for a life outside of North Korea. In the last year of high school, I started to realize that the reality in which I lived was very different from the wonderful things about the government that we learned in school. And my mother masterminded the plan for my escape."

Shinhae's sister had escaped to China six months earlier. So in the spring of 2009, Shinhae's mother encouraged her to reunite with her. She followed the trail her sister had taken toward the Yalu River, roughly fifteen hours north on foot. For the next month, she studied the border crossing and the patterns of the guards. Then, with the protection of a loving God she wasn't yet aware of, she crossed safely into China.

Shinhae describes the next two years in China as a very dark time. "The word *hard* can never represent how painful it was to leave my mother, knowing I would likely never see her again. The fear of being caught and sent back to face imprisonment or death, and having nowhere to go and no one to tell about

my situation, were all part of my daily experience," she says. Shinhae felt guilty for leaving her mom behind and started to question her meaning and value as a human. She reunited with her sister but still felt vulnerable and alone, as if the world had turned its back on her.

When Shinhae needed it most, she was introduced to a South Korean couple who worked as underground missionaries helping North Korean defectors. Shinhae calls them her "spiritual parents." She says her spiritual father helped her rebuild her identity and reinvent her inner self. "He offered help and told me that I was not useless; I was a person who deserved to be loved." Shinhae stayed with the missionaries while they developed a plan to liberate her. In 2011, they helped her slip into Thailand after multiple bus trips. She spent a year there in immigration detention facilities while the American embassy in Bangkok processed her refugee documentation with support from the South Korean government.

"On September 1, 2012, I arrived in San Jose, California," she says. "The confidence my mother had in me and the encouragement from my spiritual parents allowed me to choose the United States as my destiny, without fear." The International Rescue Committee provided a caseworker who helped her navigate mountains of immigration paperwork, enrolled her in English classes, and advised her as she looked for work. Shinhae credits the IRC for making her feel welcome in a new land and empowering her to become independent in just ten months.

Still, she faced challenges. "Having choices was one of the hardest adjustments," she says. "Where I grew up, everything was controlled by the government. My new reality overflowed with so many options."

Shinhae found support from the Korean community in the area. "Being able to meet people like me brought me a sense of comfort," she says. Shinhae quickly learned to embrace her newfound freedom and make the right decisions. She loves running, biking, and playing squash, Ping-Pong, and badminton with her friends. And in 2014 she moved to Chicago to learn English at a boarding school for North Korean refugees called Emancipate North Koreans, or ENoK. Three years later, she enrolled in the master of divinity program at McCormick Theological Seminary.

"I am interested in pastoral care, which is an important factor in the inner healing of defectors who have been through so much," she says. "My experience as a defector has opened my heart to care for other people who have overcome so

many hardships to obtain their freedom yet are still in pain. I believe each one of us, no matter where in the world we are born, deserves a life full of happiness and peace." In 2019, Shinhae married Luke, a Korean-American PhD student at the University of Chicago who volunteered with ENoK.

I met Shinhae that year, during a breakfast for recipients of the Bush Institute's North Korea Freedom Scholarship. She had been encouraged to apply by Sheena Greitens, a scholar whose focus includes North Korean resettlement, and the staff at ENoK. I was moved by what seemed like an unlikely decision to attend a seminary, so I asked Shinhae how she became a Christian.

"When I met the South Korean missionary, he approached me without expecting anything in return," she said. "I had never met someone who just loved me unconditionally. So I asked him, 'Why do you love me so much without any expectations, unconditionally?' He told me that it was because he believes in Jesus. I said, 'Who the hell is Jesus?'"

The entire room burst into laughter.

"I told him, if his religious belief is truly the source of loving others and upholding their dignity, I want to practice the same religion he does." It was the moment Shinhae decided to start reading the Bible and what eventually led her to study theology.

As Shinhae's faith has grown, so have her plans to give back to others following in her steps. "I found myself, peace, and safety here. My goal is to share all the grace that I have received from countless individuals with everyone who feels they have not yet encountered the opportunity."

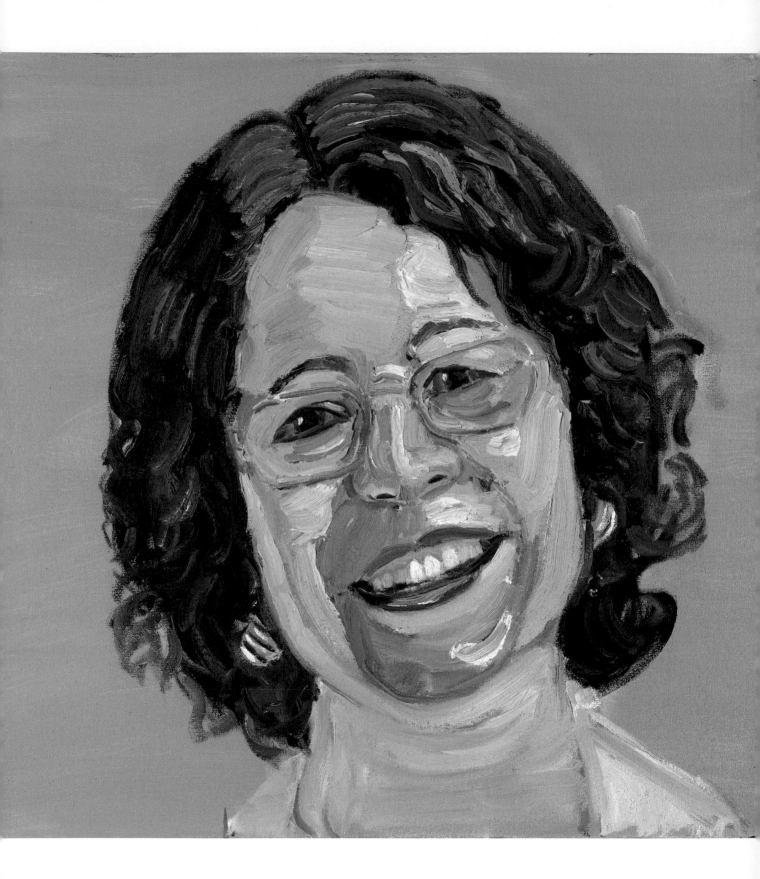

AMY EBSA

"Our children make even more of an impact
since they combine the good values from their
parents' culture and those of the United States."

For ten years, I had the privilege of being greeted and uplifted by Amy Ebsa's joyful smile at my office in Dallas. Amy has been the gatekeeper of the building's parking garage since arriving in America thirty-five years ago. She says her joy comes from her gratitude to God and to her fellow Americans.

Amy grew up in Addis Ababa, Ethiopia, a country in the eastern horn of Africa that's home to a beautiful people with a proud and complicated past. Six years ago, while checking up on the Bush Institute's work on cervical cancer there, Laura and I had the chance to get out of the capital city and explore the country as tourists. We visited villages along the Omo River in the south whose way of life hasn't changed in hundreds of years. The residents invited us into their bamboo-thatched homes and painted our faces. We also traveled north to see places of worship that were carved into stone by hand about nine hundred years ago. (My favorite was the Church of St. George in Lalibela. Google it, and you will see why.) Ethiopians take great pride in their Christian heritage and in the fact that theirs was the only country in Eastern Africa that resisted European colonization.

Sadly, Amy's experience in her home country was entirely different from ours. While Ethiopians avoided foreign rule in the nineteenth century, they suffered under brutal leaders in the twentieth. From 1974 to 1991, a military junta called the Derg killed hundreds of thousands of innocent Ethiopians during the Red Terror. Even more died of starvation during a devastating famine.

"It was disgusting," Amy says. "Whether there is a reason or not, they see you, they shoot you. We very much lived in fear." Amy lost many family members, and in some cases never found out what happened to them. As a young girl, she saw a pregnant woman shot in the street. "It was raining, and water was just running over her. That is forever in my memory."

Amy's husband, Seifu, worked as an Ethiopian diplomat. Their family found a reprieve from the Red Terror when the government posted him to Germany and then Belgium, for a total of eight years. By the time Seifu was ordered back to Addis Ababa from Brussels, the situation had only worsened. Killing was indiscriminate, and going home would be a death sentence, so he and Amy applied for political asylum in the United States. Amy had a sister in Dallas who assured them it was a "calm place to raise a family." They were granted asylum and brought their young son and daughter to the city in 1984.

Amy started work at my future office building a week after arriving. Meanwhile, her husband studied for his MBA while working in the library at

Southern Methodist University, home of my future presidential library. "Those transitional years were difficult for us," Amy says. While she missed home, she was also haunted by it. "The scars are still there. I like my country, but it still scares me to death. For so long in my dreams, I would wake up and think I was still there. But we were happy because we found Ethiopians, and we worshipped with them and established friendships. We were also fortunate to find Americans who were kind to us and helped us out."

Amy's faith sustained her, and she sustained her faith. Today, if she's not in her parking booth, you'll find her at St. Michael Cathedral, where she is a founding member and active participant on the board. She's proud that their Ethiopian Orthodox congregation has grown from just a few members to more than a thousand and recently opened a school. And she's especially proud of her son and daughter. "Our children make even more of an impact since they combine the good values from their parents' culture and those of the United States," she says, expressing a sentiment held by many first-generation immigrants. Her son, Desta, helps lead a tutoring program at the University of Texas at Dallas, and her daughter, Tizita, is a professional counselor for Harmony Community Development Corporation. Tizita volunteers as a missionary in her spare time. "She works for God," Amy says.

Anyone who has ever visited my office remembers Amy. When a car pulls up, she puts down whatever she's reading—usually the Bible—before leaping to her feet and throwing open the window. She greets each and every person with an enthusiasm that makes paying for parking feel like winning the lottery.

One day I noticed Amy reading a book by Timothy Keller, one of my favorite preachers. I thought of his 1997 sermon "An Immigrant's Courage." It was about the Book of Ruth, in which a desperate Moabite leaves her country to find hope and favor in Israel. "It takes tremendous courage to leave the land you've always lived in and to permanently move to another land, another country, another nation, another culture. It's a death-defying feat," Dr. Keller said. I'm joyful that Amy had the courage and the faith in God to accomplish that feat.

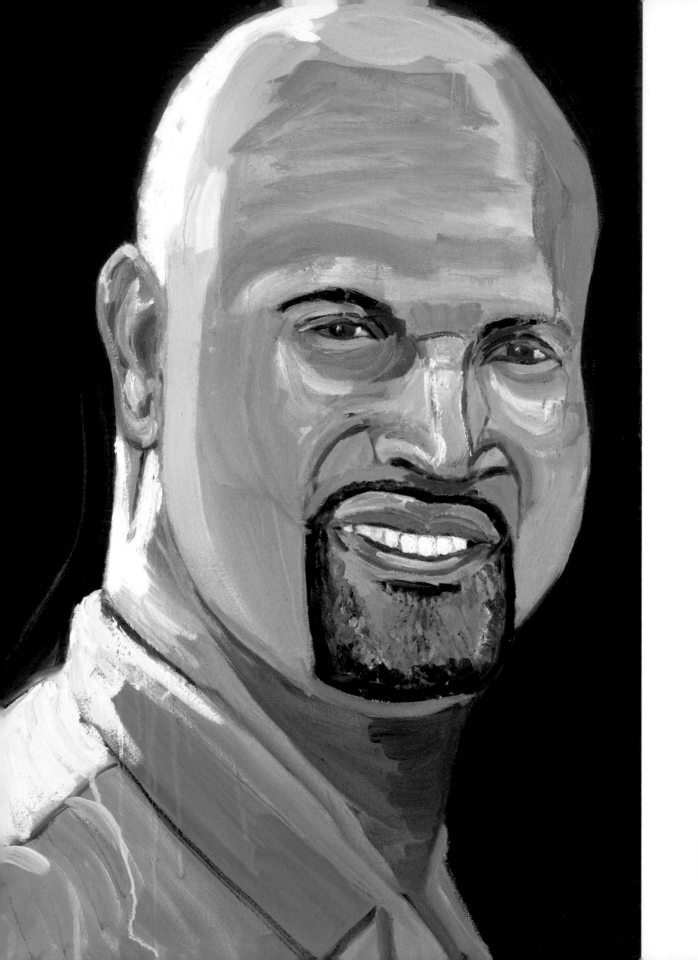

ALBERT PUJOLS

IN FALL 2011, the Texas Rangers—the ball club where I was once part of the ownership group—faced the St. Louis Cardinals in the World Series. We headed into the first game at home tied with one win apiece and a shot at the Rangers' first championship. Dirk Nowitzki (page 102), who led the Dallas Mavericks to their own championship that spring, set the stage by throwing out the ceremonial first pitch, a sixty-seven-mile-per-hour fastball.

I knew the Cardinals' first baseman was a great player, but I had never seen Albert Pujols play in person. That night, Albert hit three home runs, batted in six runs, and powered his team to a 16–7 romp over my Rangers. Sportswriter Matthew Leach called it "the greatest individual hitting performance in World Series history." The next night, I threw out the first pitch to Nolan Ryan. We won that one, but eventually the Cards went on to win in game seven, dashing any hopes of the Rangers' winning the Commissioner's Trophy that year.

"Most people talk about my numbers first," Albert says. "Six hundred fifty home runs. Two thousand RBIs. Three thousand hits. Two world championships. Three MVP awards." But when he shows people his trophy room, he breezes through the impressive collection and heads straight for his Roberto Clemente Award. He received it in 2008 when fans and reporters chose him as the player who "best exemplifies the game of baseball, sportsmanship, community involvement, and the individual's contribution to the team." Albert says, "Without question, that is the award that I'm most proud of, and that is what I would like to be remembered for."

Albert was selected for that award because of his work with the Pujols Family Foundation. Through it, he celebrates and supports people with Down syndrome in the United States and provides humanitarian aid in his native country, the Dominican Republic. He was born there in 1980 and grew up in one of the

poorest and most desperate areas of Santo Domingo, the capital city. Albert's dad—his hero—traveled the country playing baseball while his grandmother raised him and eleven of his cousins in her small apartment. To pitch in, Albert collected bottles and shined shoes. His grandmother encouraged him to focus on his education instead. "Earn your degree," she told him. "That's something they can never take away from you."

When Albert was sixteen, his dad decided to bring him to America for a better education and a chance to make the most of his God-given baseball talents. Other members of their family had immigrated to Kansas City, Missouri. In 1996, the father and son joined them. Albert only knew Spanish, and he missed his grandmother and the cousins he'd left behind. But his Kansas City family and the community there embraced him. "I had amazing support at Fort Osage High School," he says. "The teachers, administration, and coaches went above and beyond, teaching me English and helping me acclimate to the United States." In turn, Albert went above and beyond for them. He immersed himself in the language, studied night and day, and led the Fort Osage Indians to a state title in his first season, as a sophomore. He did well enough in school to graduate in December 1998, a semester early, and accept a baseball scholarship to nearby Maple Woods Community College.

At age eighteen, Albert allowed one distraction: a date at the Cheesecake Factory with a Kansas City beauty named Deidre Corona. She told him that night that she was a single mother with an infant daughter who had Down syndrome. Albert quickly became enamored with a second beautiful distraction: Isabella, whom he later adopted after marrying Deidre.

A few months after meeting Deidre, Albert Pujols entered the 1999 major league draft with high hopes of being picked early. When he didn't get selected until the thirteenth round, he was devastated. (Deidre is a little more explicit; she told *60 Minutes* that he cried like a baby.) The St. Louis Cardinals sent Albert to play in the A-league for the Peoria, Illinois, Chiefs. They paid him $252.50 every two weeks. He worked hard and stood out, and the Cardinals called Albert up after just one season in the minors. "I surpassed all my dreams the day I walked onto a Major League Baseball field in 2001," he says.

Albert's career statistics tell the story of a player who is a shoo-in for the Baseball Hall of Fame (if he ever stops playing). A more telling set of statistics reveals a man whose passion for baseball is surpassed only by his passion

for others. After Albert signed a contract to play with the Angels in 2012, Todd Perry, executive director and CEO of the Pujols Family Foundation, shared a few of those stats with the *Los Angeles Times*. From May 2005 to 2006, Albert participated in twenty-two events for people with Down syndrome. In the twenty-two games he played after each of those events, he batted .527 with twelve home runs and twenty-five RBIs. "It uplifts the kids, but I think it uplifts Albert even more," Todd told the paper.

Since 2005, Deidre and Albert have dedicated their time and resources to their foundation's work. Some of their hallmark events are the proms they hold for teens and young adults with Down syndrome. (Albert is usually one of the last people on the dance floor.) He returns to the Dominican Republic at least once a year, where the foundation sends doctors, mattresses, clothing, and other necessities. When his World Series championship team came to the White House in 2006, Albert missed the trip because he was serving the poor in his native Dominican Republic. He believes it is what God has called him to do.

Albert, who became an American citizen in 2007, is a religious man. He does not drink or smoke, and he has never failed a drug test. As I write this in 2020, Albert is celebrating his twentieth wedding anniversary and preparing to start his twentieth season in Major League Baseball. His grandmother taught Deidre her Dominican recipes, and Deidre makes Albert's favorite dishes for him and their five children. "I am very proud to be Dominican-born, and I will never forget where I came from. However, becoming an American was one of the greatest accomplishments of my life," Albert says. "America is truly the shining city on a hill." And Albert is a shining example to Americans.

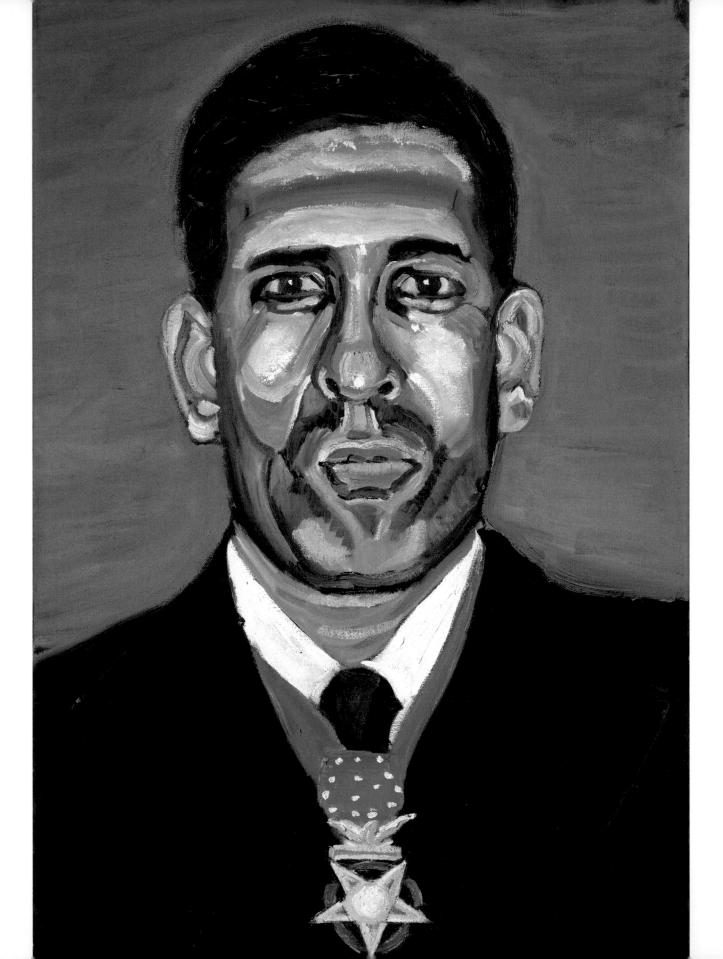

FLORENT GROBERG

ON NOVEMBER 12, 2015, President Barack Obama presented Army captain Florent Groberg with the Medal of Honor, our nation's highest military distinction, for "acts of gallantry and intrepidity at the risk of his life above and beyond the call of duty." The recognition didn't come as a surprise to those who fought, trained, or grew up with him. Florent—I call him Flo—jokes that he learned to fight at an early age.

"I grew up in Achères, France, just outside of Paris," Flo says. "The French newspapers called it the ghetto after I received the Medal of Honor, but to me, it was home. My adoptive father, Larry, would bring me back random gifts from the US, and I would usually have to fight to keep them." It was a decidedly European upbringing. "My mom used to give me a list of groceries that included cigarettes and wine, and I would go pick them up."

The trajectory of Flo's life changed forever at age eleven, when his dad suggested moving to the United States. "I remember that moment clear as day," he says. "I stopped playing video games, turned around, and wondered what was going on. That's when my father said, 'If we move to the US, you can eat at McDonald's and you will meet Michael Jordan.' Just like that, my allegiance to my country was sold for French fries (irony) and this magical creature called MJ."

In 1994, the Grobergs moved to Palatine, Illinois—a suburb not too far from where the Bulls play—and eventually settled in Maryland. "I remember looking for the metro, buses, and people. I found none of them, and it felt weird to me," Flo says. "The other challenge was that I didn't speak English." It was hard for him to leave behind his friends and his way of life. "But honestly, the intrigue and the unknown was much more exciting to me."

Flo learned English quickly and excelled in academics and athletics. In 2001, he became a naturalized US citizen, graduated high school, and went to the University of Maryland to run track and cross-country. There, he earned a bachelor of science in criminology and criminal justice.

In 2008, Flo enlisted in the United States Army. "It had been my goal since my uncle was killed by a terrorist organization called the GIA in 1996," he says. "Following the 9/11 attacks, there was no other choice for me."

Before long, Flo distinguished himself as an exceptional soldier. He completed the rigorous Airborne and Ranger schools, was assigned to the Fourth Infantry Division as a platoon leader, and rose through the ranks to captain.

Flo is a reminder that many of our most distinguished service members were not born in the United States. Some 3,500 individuals have been recognized with our highest military honor since it was first awarded in 1863. More than 700 of those medals have gone to immigrants. "There is a whole world out there of folks who might not have had the opportunity to be born in the United States," Flo reflects. "Once given an opportunity, we will earn it and we will put our lives on the line for the United States of America and everything she stands for."

Captain Groberg did just that on August 8, 2012, when a suicide bomber approached his formation, which included several high-ranking military officials. His instincts and training kicked into action. He charged toward the threat, pushing the bomber away from the group before the bomb could detonate. Flo's selfless act of courage saved the lives of members of his group, including the colonel he had been assigned to protect. But the explosion severely wounded him and several of his comrades.

To this day, Flo wears a bracelet with the names of his brothers who didn't survive the attack: Command Sergeant Major Kevin Griffin, USA; Major Tom Kennedy, USA; Major David Gray, USAF; and Ragaei Abdelfattah, an Egyptian-American immigrant and USAID foreign service officer. When Flo received the Medal of Honor at the White House, he asked President Obama to recognize those individuals and invite their families. "I wake up every morning and think about them. I go to sleep every night and think about them. I would trade places with them at any second. My goal in life is to remember them and speak about them . . . and be a better person, because I get to live for them," he told Stephen Colbert on *The Late Show*.

The injuries Flo sustained that day put an end to his running days, but they haven't slowed him down. He recently served as chief of staff for Boeing Commercial Airplanes and deputy vice president for Boeing Commercial sales and marketing, two jobs he says he was selected for because of his "military background in succeeding in austere environments." In 2020, he became a principal program manager for Microsoft Azure. He is married to Carsen, whom he describes as his "best friend and the most important person in [his] life." When asked what he is most proud of, he doesn't mention his Medal of Honor. He says it's her. "She is everything that I want to be. My dream is to be a good husband, a good father, a good friend, a good person for my community, and a good American." By those measures, it's safe to say that Flo epitomizes the American dream.

As an aside, I asked Flo if he ever got to meet Michael Jordan, his inspiration for coming to the United States. "He walked past me one time!" Flo replied. So, Michael, if you're reading this: let's make it happen.

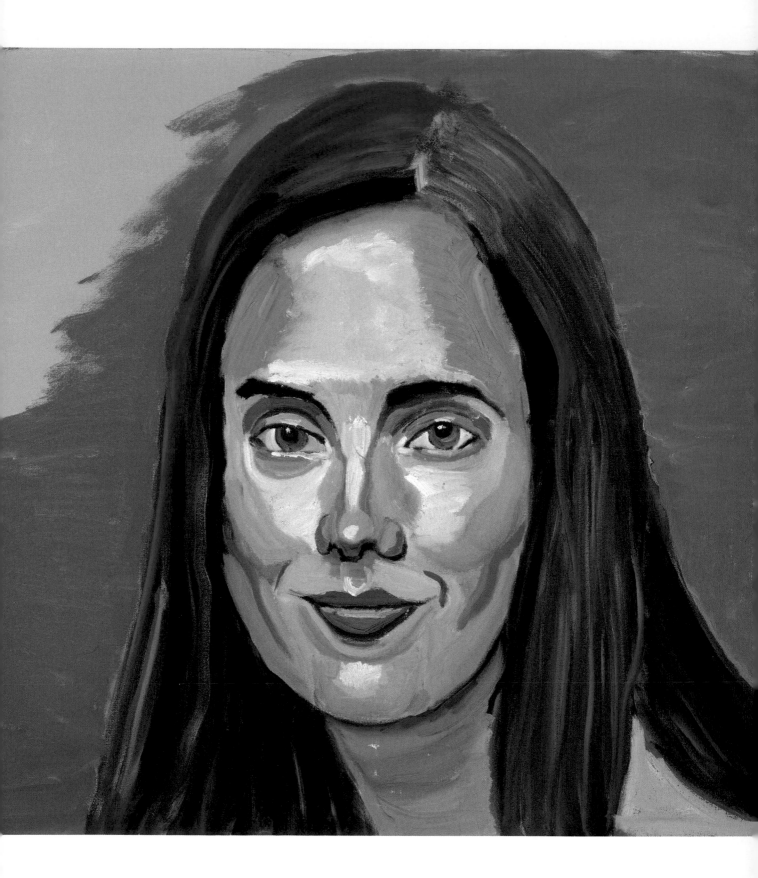

ALFIA ILICHEVA

"Random acts of kindness, from showing someone how
to get on a school bus to teaching someone English,
can alter the course of someone's life in a big way."

ALFIA ILICHEVA WAS RAISED outside of Moscow, Russia, in a Muslim Tatar family—a Central Asian ethnic minority who trace their roots back centuries to the Mongol Empire. "As a child of the perestroika era, I grew up in a time of economic and political instability, which meant that I often turned to my family, my community, and my interests for a sense of security and comfort," she says. "Some of my first memories are connected to the rustic magic of our Rybushkino village—chasing geese, gathering wild berries, going on hikes with my cousins. I was immersed in my culture, spending time with my grandparents in our native Tatar village."

That all came to a crashing halt in 1997. It was a turbulent time in Russia, and significant assets were being transferred from control of the state to the private sector. Alfia's father, one of Russia's best and brightest, had been a successful business executive and entrepreneur. She was eleven years old when he was assassinated. His killing remains unsolved to this day. "My father's death took away many things from us," Alfia explains. "Financial freedom. Political rights. Our home. The day he died, I promised myself going forward that I will never take anything in life for granted.

"My mother was committed to fulfilling one of my father's last wishes: a Western education for their two daughters. With help from our father's friend Mikhail, a Russian Jew, we moved with one suitcase for the three of us and big hopes for a new life on the other side of that Atlantic," Alfia says.

Alfia wants Americans to understand two things about immigration: one, how hard it is; and two, how much it helps when Americans welcome a family like hers. "Immigration left us rootless, vulnerable, and alone. No friends. No family. No meaningful connection to a culture that I understood, that understood me. It took all my security blankets away, and the isolation was challenging in a big way."

Alfia still remembers waiting for the bus on her first day at Lewis F. Cole Middle School in Fort Lee, New Jersey. She spoke only a couple of words of English. Unbelievably, the other student at the bus stop spoke Russian. Her name was Maria. She helped Alfia get on the bus, find her way around the school, and open her locker. At gym class, Alfia's new classmates patiently taught her how to play baseball. Her teachers helped her learn English. And the local Jewish community welcomed her Muslim family and helped them get settled at every turn.

"I was touched by the efforts of my classmates and teachers to welcome me to a new environment, to make me feel at home," Alfia says. "Random acts of kindness, from showing someone how to get on a school bus to teaching someone English, can alter the course of someone's life in a big way. Looking back, the people who supported me and took a chance on me have shaped who I am today."

Alfia honored her father's wishes by graduating from Georgetown University and later earning an MBA from Columbia University. In between, she worked on Wall Street while studying for the citizenship exam. "I was a first-year analyst on a trading floor and had naively planned to quietly prepare for the exam after my long work days. My plan was broken when someone on the team spotted the books and discovered my plans to become an American citizen. Suddenly I found myself surrounded by all my colleagues, excited for me to become American and even more excited to turn into US history teachers for the day." Alfia's fellow traders took delight in schooling and quizzing her on Native American tribes, constitutional amendments, and the dates of obscure events in American history.

When Alfia came back to work after passing the exam and becoming a naturalized American, action on the hectic trading floor screeched to a halt. Alfia's fellow citizens brought out an apple pie with a candle and serenaded her with "The Star-Spangled Banner." "It was an unforgettable feeling," she says. "Looking back, this is what I love the most about my adopted home—the American people as individuals and as a collective are incredibly inclusive and welcoming to others, regardless of their background and origin, with open arms."

Mikhail, the friend of Alfia's father who helped their family immigrate to the United States, passed away in 2019. Alfia says his gesture—a Jew helping Muslims—will always stay with her. Many of her mentors have been accomplished Jewish Americans who helped her along the way, from applying to college to getting her first job, launching a nonprofit, and navigating career decisions. She credits her success to their generosity and support.

Alfia is a hardworking, talented, contributing American. She cofounded a nonprofit organization called Women in Innovation, and she and her husband, Oleg, are raising three daughters. No doubt, they will follow their mother's example, flourish in America, and become contributing, innovative women.

DAVID FEHERTY

───────────

"It wasn't so much the country that attracted me first;
it was more the people."

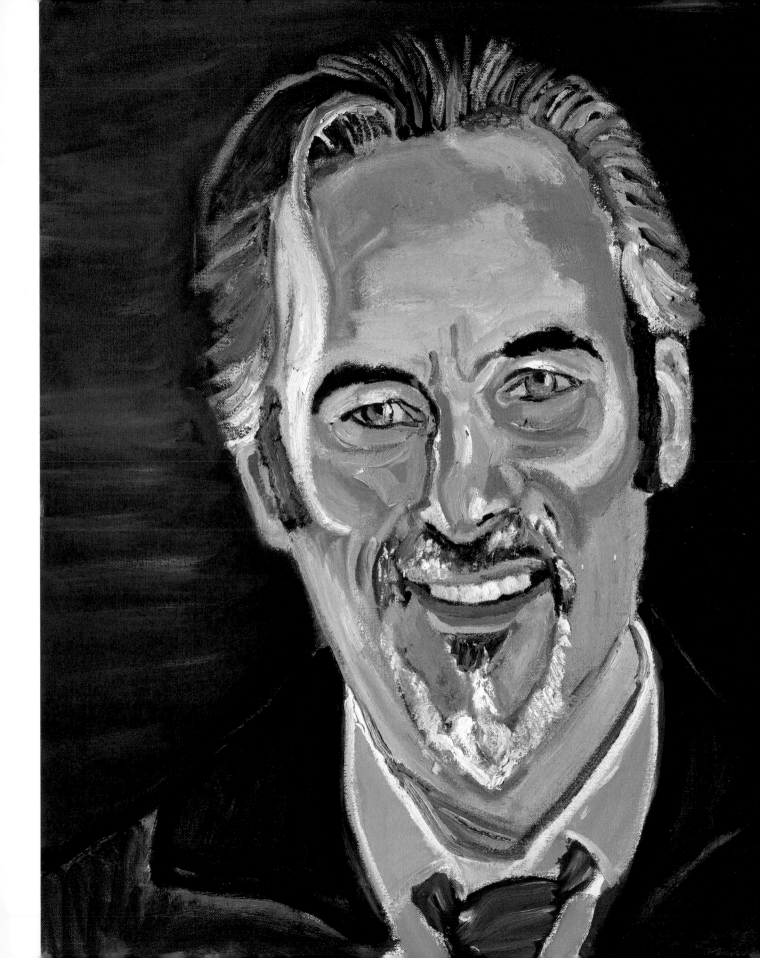

I CAN SAY CONFIDENTLY that David Feherty is the only person who has ever asked me whether I wear boxers or briefs. Even worse, he did so on national TV. When I refused to answer the question on his eponymous Golf Channel show, trying to cling to any remaining hope of sounding "presidential," he didn't miss a beat: "It's a thong, obviously."

The fact that Donald Trump, Barack Obama, Bill Clinton, and I have all given interviews to one of the most predictably unpredictable personalities in television is a testament to this good man's humor and heart.

David grew up in Northern Ireland during "the Troubles" of the 1960s and '70s. "Although my hometown of Bangor was a relatively safe place (about twelve miles from the main trouble spot, Belfast)," he says, "parts of the province were an urban war zone, with sectarian murders, bombs, troops on the streets, roadblocks, riots, and protests." David turned to golf as an escape from both the big Troubles and the ones he was having in the classroom as a teenager.

Though he claims he wasn't any good, he turned pro at age seventeen and spent the next sixteen years playing the PGA European Tour. "I had no plan B," he says. He won five tournaments on that circuit before deciding to compete in the United States.

"I first thought about coming to the US after I played on the European Ryder Cup side at Kiawah Island in 1991. It wasn't so much the country that attracted me first; it was more the people. It was my dear friend the late Payne Stewart who told me that this was where I should be. Initially I came here to play the PGA Tour to make a better living, but I fell in love with the country," David says.

In 1993, he immigrated to the United States with his family. Hall-of-fame golfer Lanny Wadkins picked him up from DFW airport and helped him get set up to practice at Preston Trail Golf Club. "I will always be grateful for his friendship, and the members at the Trail," David says. "Coming from Ireland, I was used to people telling me how much they loved the place and how friendly the people were, but I have to say I felt exactly the same about America from the start, and in particular, Texas."

The next few years were rough for David, to put it mildly. "I was at the lowest point of my life in a foreign land," he remembers, "pretty much penniless after a bitter divorce." Since then, he has spoken out about his struggles with substance abuse and mental health. "I was a drug addict and an alcoholic, suffering from

bipolar disorder," David admits. "But the silver lining in my cloud was Anita, who saved me in more ways than one."

David met the interior designer from Mississippi on a blind date in 1995 and married her in 1996. With Anita's support, David sought treatment for his problems and overcame them.

Around the same time, CBS Sports was looking for a color commentator who knew the players and the caddies. And there's no commentator more colorful than David. Dismissing his talent and hard work, he says, "I was lucky enough to be in the right place at the right time when the TV job came along." For more than twenty years, David has brought his energy, enthusiasm, and irreverence to some of the most significant moments in golf. "I think it's an indication of how great a country this is. I found Anita, I found my place, and the American dream came true for me."

In 2007, David went to Iraq with the USO. "Having grown up in an urban war zone, I wanted to do something for American troops in the Middle East," he says. "I thought then, as I do now, that the average American serviceman or -woman was the finest human being I had ever had the privilege of being around. I went there an Irishman, and I came back an American. The first thing I did was apply for citizenship."

Our mutual friend Jim Nantz worked with David at CBS at the time. Jim told me, "I've never been around anyone who took the responsibility and honor of citizenship more seriously than he did. For a guy who finds humor in everything, the day he became an American citizen was one of the greatest days of his life. He was downright giddy and emotional about it."

He still is. "As a Northern Irishman, I had two passports, Irish and British," David recently said. "When, on the twenty-third of February 2010, I got my American citizenship, I tossed them both. I love my homeland, but I know that Texas is where I belong. Yee-f***ing-haw, baby!"

David has traveled back to war zones several times with the USO to thank our troops. And in 2008, he cofounded Feherty's Troops First Foundation to support those who were injured on the front lines. "I saw how they had my back downrange and felt the least I could do was try to have theirs when they came home," he says. I'm grateful for David's support of our finest citizens, and I'm proud that he's one of them.

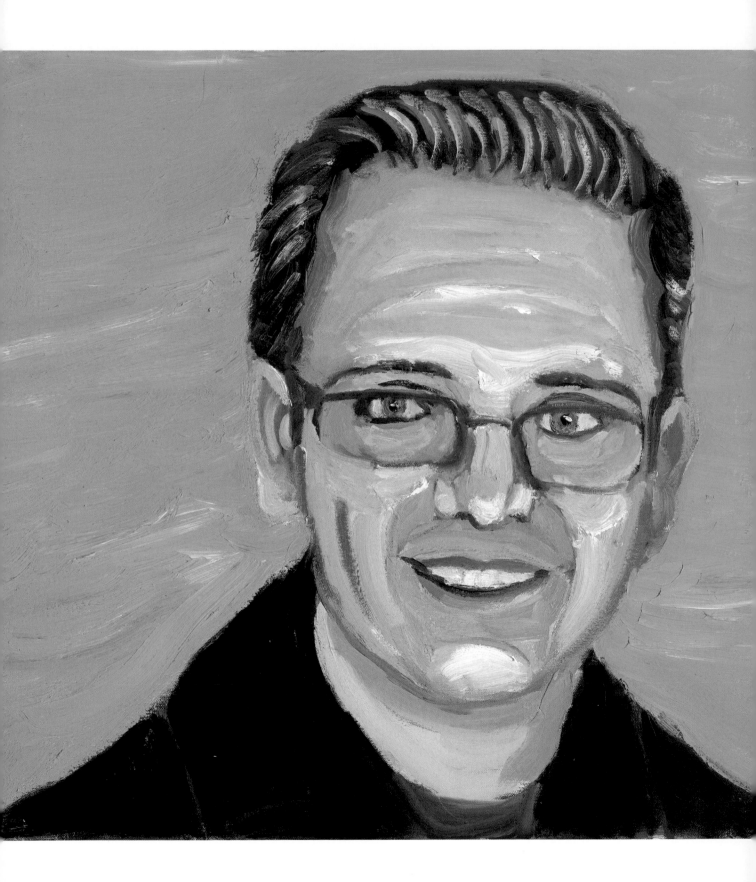

CARLOS MENDEZ

CARLOS MENDEZ DIDN'T CHOOSE to come here illegally. "The thought never crossed my mind," he says. He was only nine years old when his mother got on an inner tube, put Carlos on top of her, and floated across the Rio Grande. He is one of more than eight hundred thousand people known as "Dreamers," who crossed the border as minors and grew up in the United States. Their legal status here, along with their identity, their dignity, and their future, is in limbo until Congress acts. I wanted to share Carlos's story to illustrate the contributions Dreamers can make to the only country they know as home.

In the town of La Tinaja, Mexico, Carlos grew up the very definition of *dirt-poor*. There were no paved roads, and his toys consisted of old cans and marbles. "I remember my mother would build a small bonfire to keep me warm when I showered," he says. "Although we always had a meal to eat, it typically consisted of beans, eggs, and soup. We would have meat once a week if we were lucky. My parents tried to have their own business several times, but things never seemed to work out."

In 2000, Carlos's dad decided he had to do better for his family. He went to Dallas and worked multiple jobs in restaurants, saving every penny he could. After about a year, he sent word for Carlos and his mom to head north.

"I remember traveling to the border, and I could see in my mother's face how worried she was," Carlos says. "She knew the danger we were facing." After they crossed the river, smugglers had them quickly change into dry clothes and start walking. "We continued on our journey—I can't remember how much we walked, but as a child, it seemed like forever." After spending the night at someone's house and another night in a hotel, they finally made it to Dallas to reunite with Carlos's dad.

"One thing that surprised me was the gas station we stopped at on the way to

Dallas," Carlos says. "I had never seen a store where you could just walk in and grab what you needed. The other thing that surprised me was the air conditioner. It felt really cold." Carlos enjoyed these new American luxuries and settled in at a Dallas elementary school, where he learned English quickly and excelled.

Both parents worked multiple jobs until tragedy struck on their way to work one morning. Another vehicle ran a red light, severely injuring Carlos's dad and killing his mother. "I was so attached to her," he says. "My mother was the glue that kept the family together."

Carlos and his dad moved to northeast Texas, where Carlos enrolled at Mount Pleasant High School and started working at age fourteen. When asked if it was hard to get a job because of his legal status, Carlos demurs. "That's a different story. It was a challenge; you could say that." Henry Cisneros, the former mayor of San Antonio, described Carlos's living arrangements in an article for the *San Antonio Express-News:* "They lived in an aluminum garage with a concrete floor, slept in their car, and showered at a local gym. Despite working long hours in a restaurant, Carlos became a straight-A student."

After graduating from high school in 2010, Carlos was accepted to the honors program at Northeast Texas Community College. One of the program's benefactors, Karen Harmon, had been impressed by Carlos. "I didn't know her, but she wanted to help me," Carlos says. "She took me out to eat, took me to the mall, and bought me clothes—all those little things that made a difference in my life."

As an assignment for school, Carlos chose to write about Henry Cisneros, and the paper made it back to the mayor himself. "It was the best analysis of the economic development strategy I tried to execute as mayor written by any journalist or any analyst at any level," the San Antonio leader wrote. When they met in 2012, Henry told Carlos he predicted a bright future for him as a writer. Carlos surprised him by replying that he had no interest in writing; he was going to be an engineer. He just needed a plan to transfer into an engineering school.

The dean of the University of Texas at San Antonio's engineering school told Henry that Carlos was "clearly qualified," and Carlos transferred in that fall. He stayed in the Cisneroses' guesthouse, taking a bus to campus when Mary Alice Cisneros couldn't drive him. "He has one hell of a brain," Henry says. "He took five engineering courses the first semester—thermodynamics, materials science, all that stuff—and he had straight A's. Next semester, straight A's. The following

semester, he came into the house almost crying. 'What's the problem?' I asked. 'I got a B!' Carlos said."

In 2012, President Obama announced Deferred Action for Childhood Arrivals, or DACA, a temporary executive action to safeguard Dreamers like Carlos from deportation. The Cisneros family helped Carlos secure an immigration attorney to arrange for his DACA protection. "One day, he came into our house, and—as opposed to the time he got a B—he was beaming," Henry remembers. "He showed us his green card, and on the top, it said, 'United States Government.' I have never seen another human being more excited. And what excited him was not so much the status, but the United States' people sanctioning his presence."

"Before DACA, I always lived in fear of what would come next," Carlos says. "I felt that no matter how hard I tried, I would never be a successful person in this country because I was an illegal immigrant. I was lost, and the future seemed foggy. When I received my work permit, I felt free. I felt that I was worth something and that I belonged."

Another happy thing happened to Carlos that year. He met Jessica, a Latina from San Antonio who was also studying mechanical engineering. They graduated in 2015, married in 2017, and had a daughter in 2019. (Karen Harmon was at Carlos's commencement, their wedding, and the baby shower.) Today, Jessica is a manufacturing engineer at Boeing, and Carlos is a production manager at Avanzar, which produces interiors for Toyota vehicles made in San Antonio. On top of working, raising a baby, and volunteering at Living Stone Church, Carlos has gone back to school—this time to earn his MBA.

To me, Dreamers who were raised in our country should be granted legal status. Many, like Carlos, have grown up and are contributing to America's economy and society. I oppose blanket amnesty, and I oppose illegal immigration. I also oppose punishing children for their parents' decisions. Dreamers deserve the opportunity for their papers to reflect their American upbringing. I hope we reach a permanent legislative solution that achieves this for them.

When I think about Carlos, I marvel at what he overcame in life and the joy with which he did so. I think about his parents and what they risked to give Carlos a better life. And I think about people like Henry, Mary Alice, and Karen, who helped Carlos thrive in this new land. I look forward to the day when Carlos becomes a citizen and I can thank my fellow American for his contributions to our country.

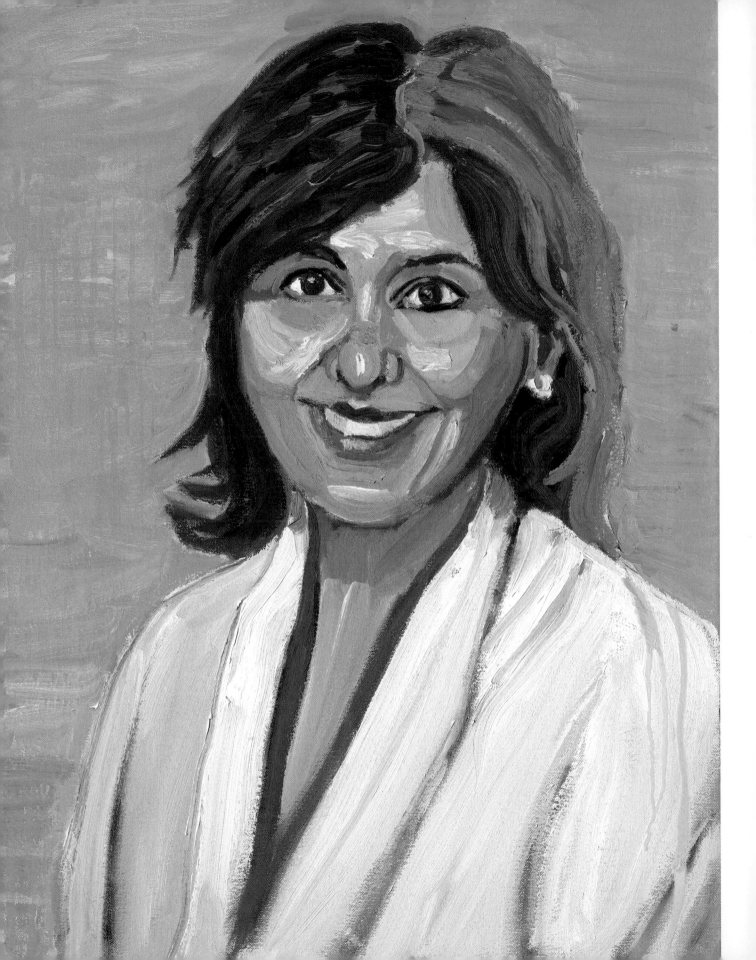

DILAFRUZ KHONIKBOYEVA

"America is a nation built on opening our hearts to our neighbors and the belief that human life is sacred."

Khorog, Tajikistan, sits at the foot of the Pamir Mountains near the northern border of Afghanistan. Formerly a part of the USSR, the town can only be accessed by a two-lane road, which is blocked by snow for six months out of the year. It is home to the Pamiri people, a small population of indigenous Ismaili Muslims who speak their own languages and follow the Aga Khan, a spiritual leader who teaches peace and pluralism.

After the USSR fell in 1991, a civil war broke out in the country. Ethnic animosities boiled over, and the Pamiris were targeted. The road to Khorog was cut off by militias, beginning a years-long blockade.

This is where Dilafruz Khonikboyeva was born in 1988. And the war was why her family had to flee. "Little children started dying from malnutrition and infection," she says. "My mom sold her jewels to buy my brother and me carrots."

Dilafruz says her parents tried to shield her from the desperation. "I played marbles, visited my grandparents' farm, and loved Russian cartoons. I didn't know about the food shortage. But by the winter of 1994, people were starting to lose hope. We did not know if the world knew what was happening to us or cared."

That's when they saw America at our best. "Trucks broke through the front lines and were approaching. They were food aid, with the USAID logo on the side emblazoned with 'From the American People,'" she recalls. "That aid ensured the Pamiri people did not starve—and with them the culture, language, and religion." USAID, the Aga Khan Foundation (which helped distribute the food), and a man named Davlat Khudonazarov (who advocated for the intervention) would prove to play outsize roles throughout Dilafruz's life.

With the food also came word that Dilafruz's family had been granted green cards through a lottery called the Diversity Immigrant Visa Program. Dilafruz likened it to winning Willy Wonka's Golden Ticket. Her family sold everything they had and set out on the long journey—first across the front lines to the capital, Dushanbe; then into Moscow, where Mr. Khudonazarov helped them obtain their papers; and finally on to America. "My parents did a fantastic job of making the whole thing an adventure," Dilafruz says.

On November 25, 1995, Dilafruz arrived in Washington, DC, with her brother, her parents, and a single small suitcase among them. "My first memory of the US was seeing all the twinkling lights as we landed," she says. "We had not only lived with food shortage for years, but electricity and heating shortages as

well. The beauty of the twinkling lights and the warmth they gave off filled my heart and took my breath away."

The family eventually made their way to Atlanta, Georgia. Logic would dictate that leaving behind danger, persecution, and starvation would make resettling in a safe land all the easier. In fact, for many refugees, it presents a new conflict—in Dilafruz's family's case, a kind of survivor's guilt. "We were leaving our homeland of millennia and were not sure if our family and friends would survive the war that was forcing us to leave," Dilafruz says. "In that sense, every good thing that happened to us, every time we ate a meal, it was always with deep feelings of guilt and sadness that we had this opportunity when others didn't."

Her parents resolved to make the most of the opportunity. They initially worked multiple menial jobs before finding positions in their professions, automotive engineering and journalism. The family dedicated themselves to "learning the language and the culture, building friendships, and trying to ease the pain in our hearts for those we left to an uncertain destiny."

Dilafruz thinks a lot about the sacrifices her parents made along the way. "The older I get, the more I am amazed at their selflessness. They made the choice to immigrate for my brother and me—so we would not grow up in war. I was humbled and in awe when I later read what they wrote at the time: their lives were over, they lived only for their children."

Dilafruz never took that, or her newfound freedom and security, for granted. She earned two degrees from George Mason University's School for Conflict Analysis and Resolution and spent eight years doing disaster assistance relief around the world with USAID. Today she works as a global lead for the Aga Khan Foundation, providing development support to communities in twenty countries around the world. "America is a nation built on opening our hearts to our neighbors and the belief that human life is sacred," she says. "My existence is an example of the profound impact that development and international aid can have in the life of a person, a family, a community."

When Dilafruz graduated from the Presidential Leadership Scholars program in the summer of 2019, I had the privilege of meeting her mother, whose dreams were realized in the strong, beautiful, accomplished American whose portrait adorns these pages.

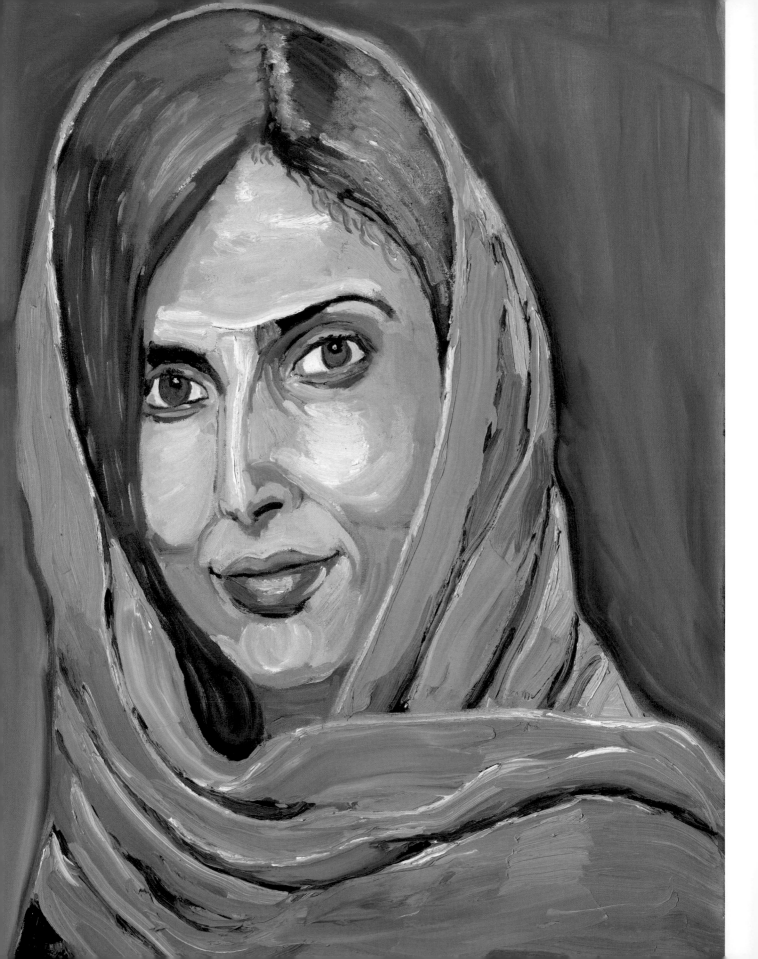

ROYA
MAHBOOB

"The hardest part for me was leaving my family, my friends, and my cousin, whom I love more than anything else. But now I have the ability to keep my business without fear of someone taking it away from me."

O<small>N</small> N<small>OVEMBER</small> 17, 2001, First Lady Laura Bush became the first woman to deliver the weekly White House radio address. It was two months after the attacks of 9/11 and a month after American forces began strikes on Taliban and al-Qaeda targets in Afghanistan. Laura wanted to speak up for the women of Afghanistan who had suffered under the terrorists:

> *Afghan women know, through hard experience, what the rest of the world is discovering: the brutal oppression of women is a central goal of the terrorists. . . . Women have been denied access to doctors when they're sick. Life under the Taliban is so hard and repressive, even small displays of joy are outlawed—children aren't allowed to fly kites; their mothers face beatings for laughing out loud. Women cannot work outside the home, or even leave their homes by themselves. . . . The fight against terrorism is also a fight for the rights and dignity of women.*

At the time of that address, Roya Mahboob was a fourteen-year-old Afghan refugee living in Iran. Her family had fled the same oppression Laura described. "During the Taliban, we lived in the darkness," Roya says. "There was only one reality for girls: to marry at a young age. I lived in fear. Fear of the Taliban who came and burned our books. Fear of an unknown future. Fear of never escaping the colorless, hopeless life that was all I knew."

With al-Qaeda and the Taliban in retreat, Roya's family was able to return to their home in Herat, Afghanistan, in 2003. "Through the support of my family, I did go to school and learned about computers," she says. "My studies took me to university, where I learned and grew even more—feeding my passion for technology and desire to change the world. After I graduated, I became the IT coordinator of the same university."

Roya started a software development company in 2010, making her one of the first female tech CEOs in the country. The company grew quickly, fueled by the female programmers and bloggers she hired. In 2013, Sheryl Sandberg highlighted Roya's efforts in *Time* magazine's "100 Most Influential People in the World." "She is building 40 free Internet-enabled classrooms across Afghanistan to allow more than 160,000 female students to connect to the world," the COO of Facebook wrote. "She also founded a multilingual blog and video site to give these women a platform for telling their stories."

Unfortunately, the Taliban still loomed large, and Roya's success caught their attention. "They sent threats, warned us to cease and desist, and followed us," Roya recalls. "It was time to leave Afghanistan."

An American business partner sponsored Roya's work visa, and she came to New York City in 2014. "The hardest part for me was leaving my family, my friends, and my cousin, whom I love more than anything else," she says. "But now I have the ability to keep my business without fear of someone taking it away from me. I have the ability to make decisions about what to do and have access to the same opportunities without fear of persecution due to social status or gender."

In 2019, I had dinner with Roya during her trip to Dallas as a Presidential Leadership Scholar. She told me that she has used her freedom here to continue growing her businesses and start the Digital Citizen Fund. "My passion is building digital literacy for women and children in developing countries, and bridging the gap between education and job markets by offering practical skills," she says. Her nonprofit helps women and girls in oppressive parts of the world gain independence through access to technology.

Roya believes that the United States and our allies helped bring "light to the lives of millions of people who lived in darkness." More than 3.5 million Afghan girls are enrolled in primary schools today, up from only 5,000 in 2001.

As policymakers in the United States and allied countries make decisions about our future in Afghanistan, it is important to remember the stories of people like Roya and what life was like for them prior to 2001. We all benefit when women and girls are empowered to realize their full potential and become contributing members of society. And Laura and I will always stand behind them.

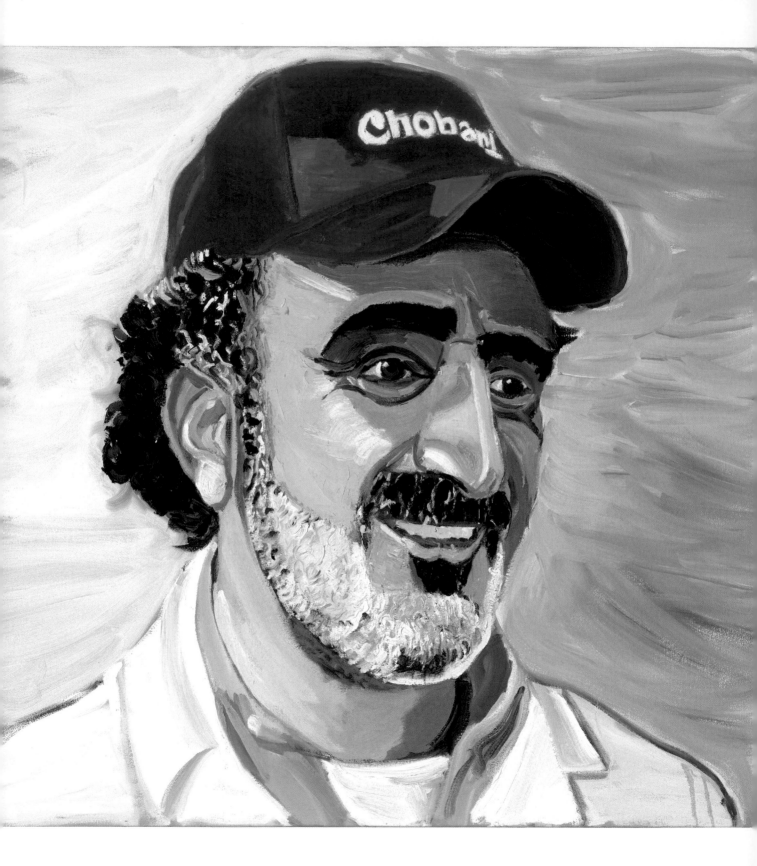

HAMDI ULUKAYA

A S A CHILD, Hamdi Ulukaya had a simple life, a happy life. "I grew up in Iliç, a small town in a province called Erzincan in the very northeastern part of Turkey," he says. "My ancestors—my father, my mother, their fathers and mothers, as long as you can go back—were Kurdish nomads. And they were master shepherds. They would do cheeses and yogurts, make clothes from the wool, and shepherd lambs for meat. In the winters, my father would go to the big cities to sell the cheese that we made during the summer. We were six brothers, and our mother was extremely active in our lives."

Hamdi always had a curious mind, and he wanted to learn more about the world. In the early 1990s, he enrolled at Ankara University in Turkey's capital city, working toward a degree in politics. He started a student newspaper there and often wrote about rights for the Kurdish people, an ethnic group of approximately thirty million living in parts of Turkey, Iraq, Iran, Syria, and Armenia. By nature, those pieces included the occasional criticism of the Turkish government.

"One day, I was walking on the street with my cousin, and a police car stopped and picked me up," Hamdi says. "They took me to the interrogation center, which was infamous. People would go and wouldn't come back alive. Or if they did, they would come back half that." After fifteen or twenty hours, Hamdi was released—to his own surprise and relief. "No one who comes into this police station leaves in your condition," the police told him. "You're very, very lucky."

Hamdi decided not to push his luck. He started talking with friends and family about leaving the country. A stranger overheard Hamdi and referred him to an agency that helped him apply for American colleges and a student visa. That turned out to be the easy part. The hard part was telling his family.

Hamdi was very close to his mother, and he dreaded telling her he was leaving. "I knew she would say yes," he says. "She always wanted the best for me. But we had to talk about it. I think the hardest thing I have ever done was leaving her behind in that village." With his mother's blessing, Hamdi arrived in New York City on October 15, 1994, at the age of twenty-one. Adelphi University picked him up from the airport and took him to the campus on Long Island. He had $3,000—what he called "big money"—but school cost over $1,000 a month.

As his finances dwindled, he learned of a community center in Brooklyn with cheaper housing. Hamdi moved in with other Turkish students and transferred to Baruch College in the city. "I had a teacher who was this very loud, very smart lady whose profession was actually in theater," he remembers. "She gave us a homework assignment: write something, in English, that you know how to do, how to make. So I chose to write about making cheese, because that's what I knew." A week later, the professor stopped Hamdi after class. "I wasn't sure if I wrote something that offended her, or if she was happy," Hamdi says. Not only did the professor love Hamdi's paper, she asked him to visit her farm in upstate New York. "I couldn't believe it," he says. "I never thought New York had farms. I never thought they had cows."

The visit showed Hamdi a new side of his adopted country. "My childhood in the mountains was raw and natural. It was stars and fires, stories told by shepherds, long walks, horses, dogs, and singing. When I got out of New York City, I could breathe again. The air smelled the same. The animals, the farm, the river, the people—it was like going home," Hamdi says. When the weekend ended, he didn't want to leave. So he convinced his professor to let him move there and work the farm. He milked their fifty cows, cleaned the manure, and took care of the land while taking business classes at the State University of New York at Albany, sixty miles away.

"I got to know real America on that farm. I got to know the people. I got to see America completely differently than other immigrants do, especially Turkish people who settle in big cities." He didn't know how yet, but he knew that this region of the country would play a defining role in his future career. He decided to stay and applied for a green card, which he received in 1999.

Later that year, Hamdi's mother developed cirrhosis as a result of hepatitis B. He brought her to New York for treatment, but she died six months later. Hamdi was heartbroken. "She had a very magical way of teaching of life, of being a human being, being a member of society. . . . Now she was gone, and I wasn't sure

how to hold on to that in a very distant country. Growing up, she always had this green scarf. So when she passed, I held on to that."

With his father's encouragement, Hamdi had started his own cheese business—a decision he says led to one of the most challenging periods in his life. As he struggled to grow the company, Euphrates, he saw a real estate listing for a nearby yogurt factory that Kraft Foods had shuttered. Against the advice of everyone he consulted, Hamdi bought the factory in 2005 with a loan from the Small Business Administration. He named his new company Chobani, after the Turkish word for "shepherd," and it didn't remain a small business for long.

Hamdi's first move was to paint the factory red, white, and blue. He rehired many of the plant's former employees who had lost their jobs, as well as a number of refugees looking for work. They started producing the thick, tart Greek-style strained yogurt that his family had made for generations.

Through word of mouth and creative, low-budget advertising, they began to penetrate the market. After groceries and warehouse stores like Costco began selling their product, Chobani started doubling their sales every year. In 2012, Hamdi expanded by opening a second factory in Twin Falls, Idaho, and Chobani became the number one Greek yogurt brand in the United States.

All the while, Hamdi has kept up his practice of hiring a mix of local workers and refugees. "I loved seeing how beautifully this came to life. These refugees have contributed massive amounts in business, in society, in art, in politics. They have survived through the most catastrophic times, and they are ready to contribute and pay back," he says. "Having refugees in this society is a beautiful, beautiful thing." Hamdi has vowed to give away the majority of his wealth in support of refugees and launched a coalition of businesses, the Tent Partnership for Refugees, to promote refugee integration.

In 2019, Laura and I met Hamdi for lunch after Southern Methodist University bestowed on him an honorary PhD in humane letters. He told us about growing up in Turkey and his experience founding Chobani. He talked about his wife, Louise, the daughter of respected French-American chef Jean-Georges Vongerichten. ("She's a foodie," he says.) Hamdi spoke proudly of his sons, Aga and Miran—and of course, his mother. "It has been a beautiful, beautiful journey," he says. "This only happens in America. It's magical."

I painted Hamdi Ulukaya with his trademark grin and green hat. "Every time I wear a Chobani hat, my mother's green scarf is in it," he says. "You think I'm the one who made all these so-called amazing things? All the credit goes to her."

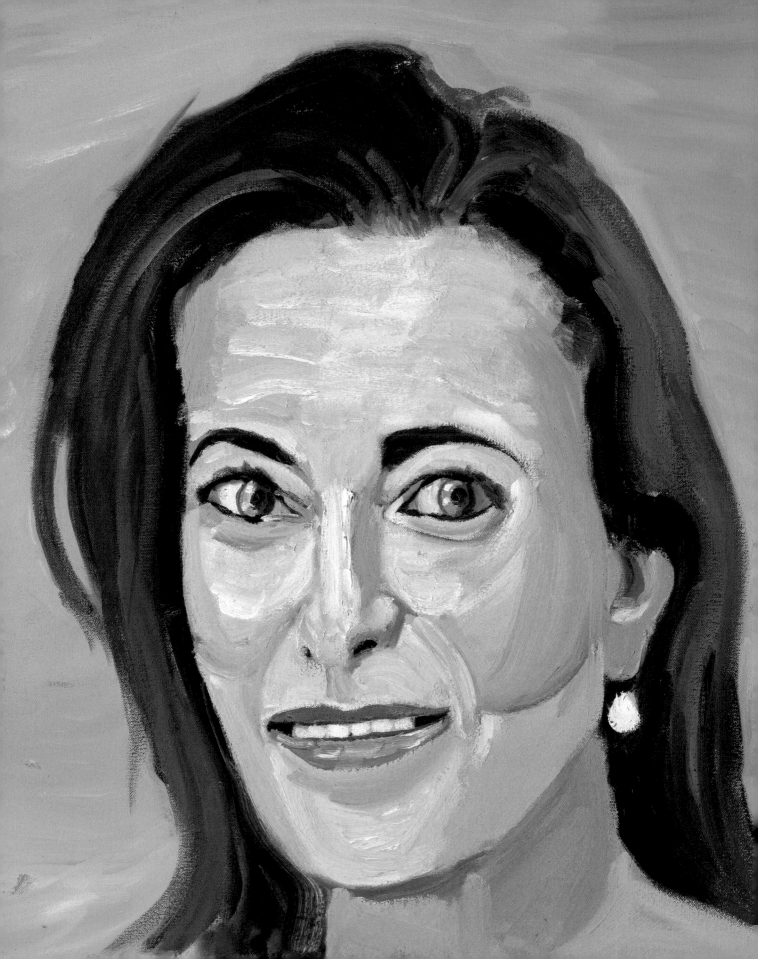

DINA POWELL McCORMICK

As President, I smiled when the Senate unanimously confirmed my nomination of Dina Powell as an Assistant Secretary of State, responsible for public diplomacy. The thought of an Egyptian-born Coptic Christian promoting American interests and values around the world reminded me what an unusual country we have. In an era when Coptic Christians faced violence and persecution—as many Christians in the region still do—Dina had risen to the highest ranks of American foreign policy. And she would go on to do a marvelous job.

Dina's father had been a captain in the Egyptian Army, and her mother was a graduate of the American University in Cairo. The parents of two young daughters wanted a brighter future for their children. Girls didn't have the same opportunities that boys did, and being a religious minority created additional challenges. So in 1977, the Habib family immigrated to Dallas, Texas. "They just knew that their girls would reach their potential if they took this huge risk," Dina says.

Dina was four years old at the time and didn't speak English. She remembers struggling to fit in with her classmates and begging her mom to pack her an American-style lunch. Hummus and grape leaves made her stand out in a cafeteria where turkey sandwiches and potato chips were more common. "My parents were so proud to be Americans, but they did teach us that retaining our heritage was important. Only God would have known that years later, after 9/11, when I worked at the White House and ultimately the State Department, I would feel so blessed that I did retain both my language and my understanding of the region of my birth and the culture," she says.

Dina's parents worked hard to afford the best schools for their daughters. Her dad, Onsy Habib, drove a bus and mowed lawns before ultimately becoming a successful real estate entrepreneur. Her mother, Hoda Soliman, received a master's degree from the University of Texas at Dallas and became a respected psychologist and social worker. Their efforts allowed Dina to attend Ursuline Academy for high school. The school's motto is *Serviam*, "I will serve." "It really instilled in me that of those to whom much is given, much is expected," Dina says. That value has guided her decisions ever since.

Dina jokes that her parents told her what a lot of young immigrants hear: "You can be anything you dream of, as long as you're a lawyer, a doctor, or an engineer." After graduating from the University of Texas, where she waitressed at an Austin restaurant while working full-time at the state capitol, Dina was admitted to Southern Methodist University's law school. When she informed her father she was going to Washington, DC, to work for the House Republican leadership instead, her dad said, "What was the point of even moving from Egypt?" "They didn't understand politics or government," she explains, "because in a lot of these countries, citizens don't participate."

I'm fortunate that Dina made the move, because she ended up working on my 2000 presidential campaign. On a team of talented people, she stood out as hardworking, diplomatic, and efficient. Prior to my inauguration, we asked her to join the White House Office of Presidential Personnel, a thirty-five-person operation tasked with placing about four thousand high-level jobs across the federal government. In our weekly meetings, I was impressed by Dina's intellect and confidence. When I promoted her to head the office in 2003, she became the youngest person to hold the position, at just twenty-nine years old.

One afternoon, I saw Dina through the window of Marine One as I landed on the South Lawn. She was standing there with a man I knew must have been her father. Rather than heading into the Oval Office, I made a beeline over to them. "You must be Mr. Habib," I said. "I just wanted to tell you that you raised a great girl. She's a very important advisor to me."

"It's a lot to take in," he told her after I walked away. "As proud as I am of you, there really is no other country in the world where a man can bring a four-year-old daughter who doesn't speak a word of English and watch her one day serve the President of my adopted country." Dina says it was the first time she ever saw her dad cry.

Her parents would have many more opportunities to take pride in Dina's accomplishments. During Dina's time as Assistant Secretary of State, Condi Rice honored her alongside people like PepsiCo CEO Indra Nooyi (page 39) with the Outstanding American by Choice award. In 2007, she was recruited by Goldman Sachs to build their impact investment business and serve as president of the Goldman Sachs Foundation. At Goldman, Dina built an initiative called 10,000 Women, the largest private-sector effort to empower women entrepreneurs globally. In addition, she developed 10,000 Small Businesses, a program that helped small business owners—many of whom were immigrants—and created new jobs and growth nationwide.

When Dina made partner, Executive Vice President John F. W. Rogers suggested that she bring Mr. Habib to dinner as her date during a board meeting in Dallas. As they pulled into the driveway of my friend Harlan Crow's beautiful Highland Park home, Dina's dad told her, "I've been here before."

"Okay, Dad, I love you," she remembers saying. "But you have never been to Harlan Crow's house before."

"Yes, I have," he said. "I mowed this lawn for two years when we first moved here from Egypt. I never imagined I would go inside as the guest of my daughter. That's America for you."

From 2017 to 2018, Dina left Goldman Sachs to return to the White House. As a Deputy National Security Advisor, she developed the Trump administration's National Security Strategy. Today she is back at Goldman, where she serves on the management committee and is responsible for the firm's largest global banking clients. Dina and her husband, Dave McCormick—the CEO of Bridgewater Associates, who also served in my administration—are raising six daughters. One thing is sure: they can become lawyers, doctors, engineers, or whatever else they dream of.

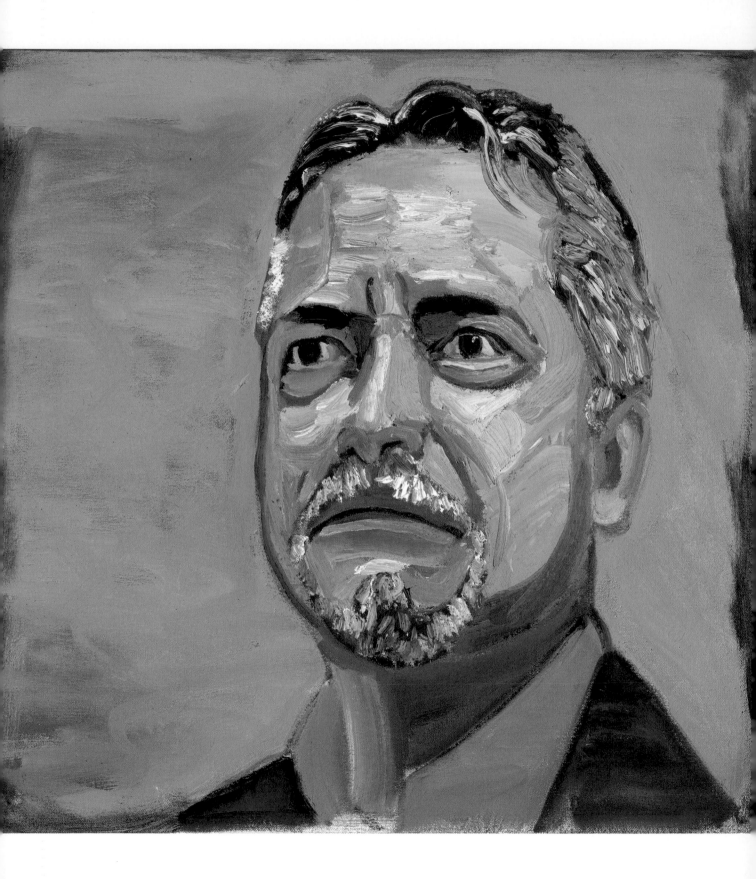

CARLOS ROVELO

I MET CARLOS ROVELO at an art exhibition just as I was beginning to work on this book. Our mutual friend Jim Woodson introduced us and told me that Carlos had immigrated from El Salvador during a civil war that displaced more than a million people from 1979 to 1992. As we talked, I was impressed by Carlos's background, his energy, his patriotism, and his success as a college professor.

I asked Carlos if I could take his photograph—a role reversal for me—and asked if he would write up some of his story. As I read Carlos's account, I decided I would share it here in his own words. Then I pulled up his photo, reached for my brushes, and got to work.

When I came to America, my only dream was to be safe from harm. My home country was experiencing a civil war where life held little value. Forty years later, I am a proud American citizen.

I was born in Santiago de María, a town famous for coffee plantations. My parents, dreaming of a better future for my sister and me, moved us to the capital, San Salvador, where my dad became a business owner. For over a decade, my father's financial success allowed me the opportunity to experience private education and two visits to California. I attended Colegio García Flamenco, a rigorous boys' school, where I excelled in academics and sports. I was a class president and school leader. I was a practicing Catholic and was deeply rooted in the traditions of the church.

Prior to the war, I never saw myself leaving my culture, my family, and my childhood memories. But over the course of a decade, more than eighty thousand people lost their lives, including some of my personal school friends. My father was sequestered

and tortured. My family was forced to pay a ransom for his release. A few months later, Archbishop Óscar Romero was assassinated while conducting mass just a few blocks from my house. My grandmother was attending the mass and witnessed the entire thing. These violent experiences as a young teen impacted my life tremendously. I began to question my future and was deeply worried about our safety. I was scared of the sounds of bullets and political violence in the streets.

Growing up, I enjoyed listening to American music. I followed American teen fashion and admired all that America represented, such as innovation, creativity, diversity, opportunity, and great universities. During my high school years, my father befriended a member of the US Peace Corps, and I began to dream about one day attending a US university. With the support of my parents, I applied for an I-20 student visa. I was accepted to Wichita State University in Wichita, Kansas.

The day I left El Salvador and arrived in Kansas, I began to question my identity. I became quite homesick. The void of family and the familiar was difficult to bear. I remember arriving unprepared both physically and emotionally. The cold winter weather was something new for me and difficult to adjust to. Meanwhile, the political conditions in El Salvador worsened. The assassinations and kidnappings of religious leaders and businesspeople increased. I was fearful my parents and sister would be killed. I began to look for ways to help them come to America with an asylum visa.

At the invitation of friends at Wichita State, I soon began attending First Presbyterian Church. I was truly blessed to meet compassionate Christians who were sensitive to the safety of my family. The church leadership decided to initiate the visa process to bring them to America. They hired an immigration attorney and wrote letters to the appropriate immigration and embassy officials in El Salvador. The church practically adopted my family.

My family was reunited on Christmas Day 1980. The church provided us with an apartment, furnishings, and food. It was truly miraculous to be together again as a family in a new land. We will forever be indebted to the families of this church who so lovingly cared for us. I am emotional even now as I think of it.

The joy of our family's reunification was challenged by deep sadness. My father was struggling in the aftermath of torture. I remember him crying one day and asking me to help him carry our family's flag. In that conversation I realized my sense of responsibility. I gathered the strength to not look back and, instead, set my eyes on the future.

At Wichita, I was quite surprised as to how little knowledge my new college American friends had of El Salvador. It was impossible for them to relate to my circumstances. However, these new friends did what they could to cheer me up. They invited

me to their farms. I met their parents and shared meals with them. I began to learn about the American family, American values, and American heritage.

In 1984, my family decided to move to Dallas to pursue wider opportunities—and a warmer climate. I transferred my credits and received my bachelor's degree in political science from the University of Texas at Dallas and my master's degree from the University of Dallas.

My naturalization ceremony took place at SMU on September 17, 1987, the bicentennial celebration of the United States Constitution. I still have President Ronald Reagan's welcome letter I received as a new citizen of the United States, along with a new sense of belonging.

For the last fourteen years, I have worked as a community college professor. I was the first Hispanic hired to teach government at my college, Tarrant County College South Campus. I teach federal and Texas government to first- and second-year college students. I also teach Mexican-American studies and art history. I tell my students that America's best days are yet to come and that they represent America's bright future. My wife, Dr. Sherry Dean Rovelo, is a professor of communication studies at Richland College in Dallas. We are both passionate advocates of the two-year college system and our students.

I have been part of this country for over four decades. I have lived under six Presidents and experienced times of abundance and limitations. However, one constant has persisted throughout: the belief in America the Good. In my undergraduate studies, I read Alexis de Tocqueville. I felt personally connected to his observations of my adopted homeland. My own story, like those of millions of immigrants before me, is the result of American values and opportunity.

Through reading and studying American history, I have learned about the peoples that have preceded us, how they built our nation through sacrifice, discipline, and faith in a superior power. I value America by being an active participant rather than a passive bystander. I value America by not taking it for granted. We must learn about each other and the power of our diversity. We must be open to listening and learning from others.

I have tremendous gratitude and admiration for America and for the opportunities she has given me. Today, my dreams are realized in the sharing of blessings with my wife, my children, my parents, my students, and with those who need America's inspiration. I am most proud of my four beautiful children, Gabriella, Charlotte, Fabienne, and Stephane—all college-educated professionals. I love to see them flourish. The hard work and sacrifices of the past are blessings reflected not only in their lives but also in the lives of my six grandchildren. I want to honor the immigrants that have preceded me by establishing my own family history in this great nation.

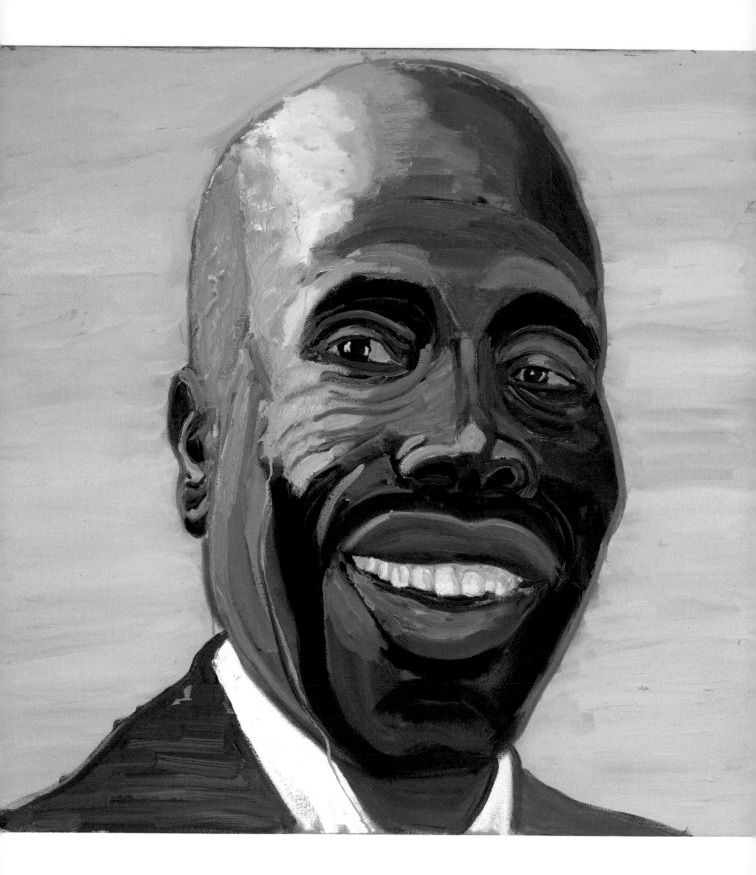

PHILIP ALIER
MACHOK

———————

PHILIP ALIER MACHOK observes his birthday on January 1, along with some 3,800 other Sudanese refugees who came to the United States in 2001. More than a decade earlier, they had been orphaned and forced to flee a brutal civil war in their home country. They became known as the "Lost Boys and Girls of Sudan." Today, when Philip rings in the New Year, he celebrates both his new life in the new world and the birthday that the US government assigned upon his arrival.

"I grew up in what is currently called Bor, Jonglei State, Republic of South Sudan," Philip says. "As Muonyjang, or Dinkas [a Sudanese ethnic group], our lives revolved around farming and cattle-keeping along the Nile River. My father worked for a British cotton firm, and my mother owned a local beer brewery. My hobbies involved singing, traditional dances, and wrestling." That all changed when the decades-long Second Sudanese Civil War broke out. Schools were closed, and the Islamist government began systematically targeting Christians and indigenous people in the south.

"It was in November 1989 when the government of Sudan sent troops to attack our villages and cattle camps in the rural Bor area," Philip says, "burning villages, killing innocent civilians, and destroying valuable materials." Like twenty thousand other children, Philip ran, fleeing the genocide. "I was too young to carry any food with me, and I lost track of my parents and siblings." For the next month, the ten-year-old boy headed east toward Ethiopia on foot, barely surviving on wild berries. "It was a very difficult trek. I saw young boys about my age who were eaten by wild animals. I saw them abandoned along the

way because they gave up due to hunger and thirst. They were never heard from to this day."

Philip spent the next twelve years living in refugee camps. His family became the boys and girls who were sharing in the harrowing experience. Like his new brothers and sisters, Philip was living in limbo, without a home, a country, or a future. "Bor was where everything dear to me was, including the grave sites of my ancestors," he says.

When the Ethiopian government fell in 1991, Philip began another perilous trek in search of a new place to live, walking hundreds of miles to Kakuma, Kenya, by way of Sudan. Hundreds of thousands more children are thought to have died during this exodus—some from starvation, others lost to beasts of the wild, and many drowned crossing rivers.

Around this time, aid workers at the refugee camps started to call the group the Lost Boys, named for Peter Pan's band of orphans. Throughout the 1990s, groups like UNICEF worked with Catholic Charities, World Relief, the International Rescue Committee, and others to resettle as many refugees as possible. Many came to the United States, but Philip was one of thousands who remained stuck in a far-from-idyllic Neverland.

By 2000, the Office of the UN High Commissioner for Refugees and the US government put together a plan to bring 3,800 to the United States. "I still didn't believe it was a reality until I saw the first batch of people leaving Kakuma Refugee Camp in Kenya," Philip says. "I landed at DFW airport on January 31, 2001, at the estimated age of twenty-one. I never, ever thought I would have the chance to come here.

"My coming to the United States of America was an act of compassion and kindness," he explains. "I felt so fortunate to have a second chance to better my life, get an education, have religious freedom as a Christian and political freedom to do what I want in life." Philip was too old for high school, so he enrolled in classes at Richland College in Dallas and got jobs washing dishes at a hospital cafeteria and bagging groceries at a supermarket.

He recognized right away that to succeed here, he would need to learn English. "It was very important for me to assimilate, integrate into American culture, and learn the language," he says. "It would have been like being a stranger in a strange land if it weren't for Americans' hospitality. Generous people opened their doors to us, oriented us to basic daily living, and welcomed us to houses of

worship, which was important. Some even went out of their way to organize rallies and raise awareness about the conflict we were fleeing."

Philip earned two associate's degrees before graduating from the University of Texas at Dallas with a bachelor's in finance. Today, he works as a pharmacy technician at Medical City Dallas. He hopes one day to become a banker. As he puts it, his American dream is "a work in progress." But, he says, "any future obstacles are minor compared to what I went through already."

Philip's dream is rapidly becoming a reality. He is a naturalized American citizen, and in 2019 he and his wife named their baby boy after Philip's father. "Being an American to me means having the freedom I was denied in my birth country and the human dignity I had lost in refugee camps," Philip says. "I donate to charities as a way to show compassion to those who need my help, just like I was shown compassion when I came here." He also volunteers his time with nonprofit organizations, including the Bush Center.

In 2016, Laura and I surprised Philip and a group of seventy Lost Boys and Girls while they were touring the museum. We told them how proud we were to call them fellow citizens and how grateful we were for their contributions to our community and our country. We talked about our shared hopes for the future of South Sudan, which found peace from the civil war in 2005 and gained its independence in 2011, but whose young democracy is going through tough times. We reminded them that our own democracy isn't perfect, either. Forming a more perfect union takes commitment, participation, and time. In South Sudan's case, it also takes help from the United States and like-minded allies.

"I want my fellow Americans to know that we can't take democracy for granted, like not voting in an election," Philip says. "Democracy is what the rest of the world is lacking, especially nations in turmoil like my country of birth. Many Americans don't understand why many people flee their lands for the land of the free. America chose me and gave me the opportunity to be here, and I am unapologetically an American. And if we continue to open our doors to other refugees, they too will be unapologetically Americans."

EZINNE
UZO-OKORO

"The privileges we are afforded in this country
are abundant beyond measure."

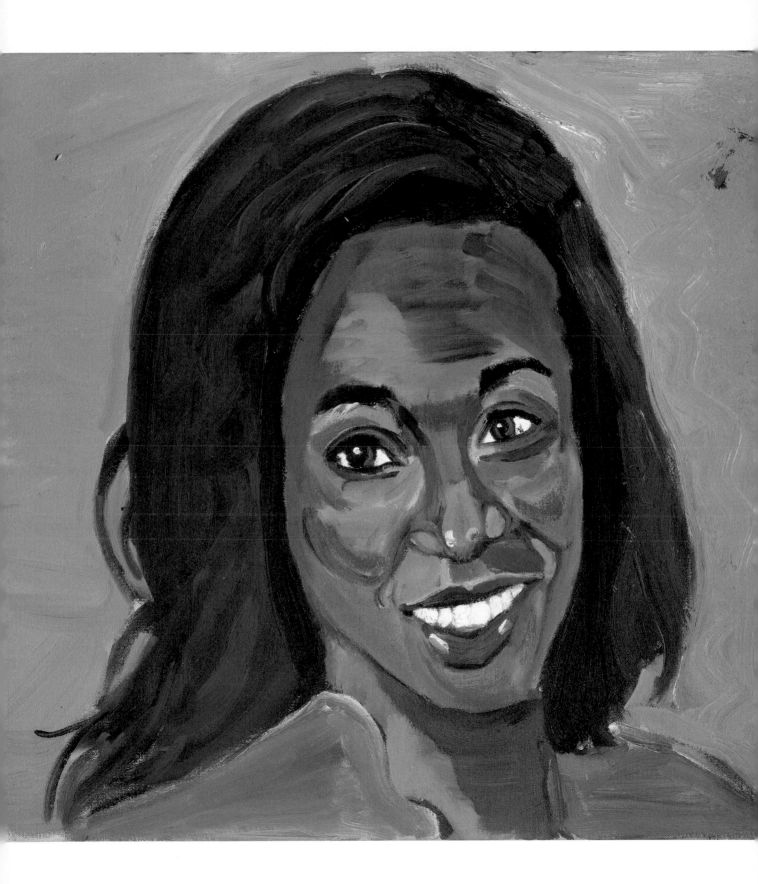

EZINNE UZO-OKORO'S SIXTEENTH BIRTHDAY was sweeter than most. She didn't get a car or a fancy party, but she got exactly what she'd wished for. "On November 29, 1999, my sixteenth birthday, I arrived in Washington, DC," Ezinne says. "It was the most important and best birthday gift I have ever received."

Ten years earlier, the perceptive young girl had observed something in Owerri, her small eastern Nigerian province, that didn't sit right. "I attended gatherings where the less fortunate focused on eating, while the well-fed socialized. It is my first memory of seeing people who were perpetually hungry versus those who were not." Ezinne's father had been educated in the United States during the 1970s, and his stories of America inspired her. "The lack of promise in Nigeria made it easy for me to start dreaming of a better life," she says.

Well-paying jobs were scarce in Owerri, and Ezinne's family moved to the crowded city of Lagos, then Nigeria's capital, trying to improve their situation. "My two siblings and I attended elementary and secondary schools," she remembers, "but given the teacher strikes and unemployment rates, it was clear to me before the age of ten that leaving the country was the only chance at a decent life." She was both intellectually curious and bored. She liked reading but didn't have access to a library. She was fascinated by the power of technology but didn't have a computer at school. "The typewriting class was the only course that appeared applicable," she says. "So I learned to type using a typewriter, hopeful that one day, I would be able to use my typewriting skills to type on a computer keyboard."

Ezinne's mind constantly generated questions and ideas. She recorded them in a notebook she always kept handy. "I had decided I wanted to migrate to the United States, and I was writing down all the inventions I would create. I aspired to study computer science and create software that might solve all the problems in my notebook."

Once Ezinne made up her mind to come here, the wait was excruciating. Though her dad had earned a green card while studying in the United States, the process took close to a decade for Ezinne. She asked him for a progress report every month. Meanwhile, she practiced her English with her grandmother, "who had taught English and always perfected our grammar," she says. Ezinne's dream came true in November 1999, and the family settled in Silver Spring, Maryland. "The hardest part was leaving my grandmother. I comforted myself knowing that

I could command the English language thanks to Grandma Matilda, so I felt I was taking a piece of her with me."

Within six weeks of coming to America, Ezinne started taking computer science classes at a nearby junior college. "No teacher strikes got in my way. Just endless opportunities," she says. "It was refreshingly simple. I was impressed by how much value I was given as a person and the value placed on meritocracy. No bribes were required. My parents did not need to know the president of the school. It was incredible!"

Ezinne took every advantage of her access to education, books, and computers. She majored in computer science—just as she'd dreamed she would—at Rensselaer Polytechnic Institute. And, only four years after immigrating to the United States, she was hired by NASA as a twenty-year-old computer scientist. Over the last sixteen years, she has skyrocketed through the ranks to become chief of the Small Spacecraft Mission Design Division. Along the way, she picked up a master's from Johns Hopkins and another from MIT, where she is currently pursuing a PhD as well as a third master's from Harvard. She is an expert in "building complex spacecraft systems and flight software," and her sixth spacecraft launched in 2018. "I am proud of being able to serve my new country to show my gratitude for changing my life and giving me opportunities," she says.

As a Presidential Leadership Scholar, Ezinne combined all of her skills in computer science, software engineering, space systems, and more to tackle one of the biggest problems in her notebook: food insecurity. With the hungry people in her Nigerian hometown in mind, she founded Terraformers, a venture that develops agricultural systems to better feed communities around the world. "I dream of continuing to invent and one day ensure healthy food access for everyone," she says.

"The privileges we are afforded in this country are abundant beyond measure," Ezinne concludes. "I married an American, Andrew, and now have one son, Augustus. I ran twelve marathons in twenty-four months. I mentor middle school girls, and it's mind-blowing when the American-born girls think I'm an inspiration. I only got here twenty years ago! Living and thriving in America is indeed a glorious experience." I believe people like Ezinne are what make the American experience glorious, and I can't wait to see what problem in her notebook she solves next.

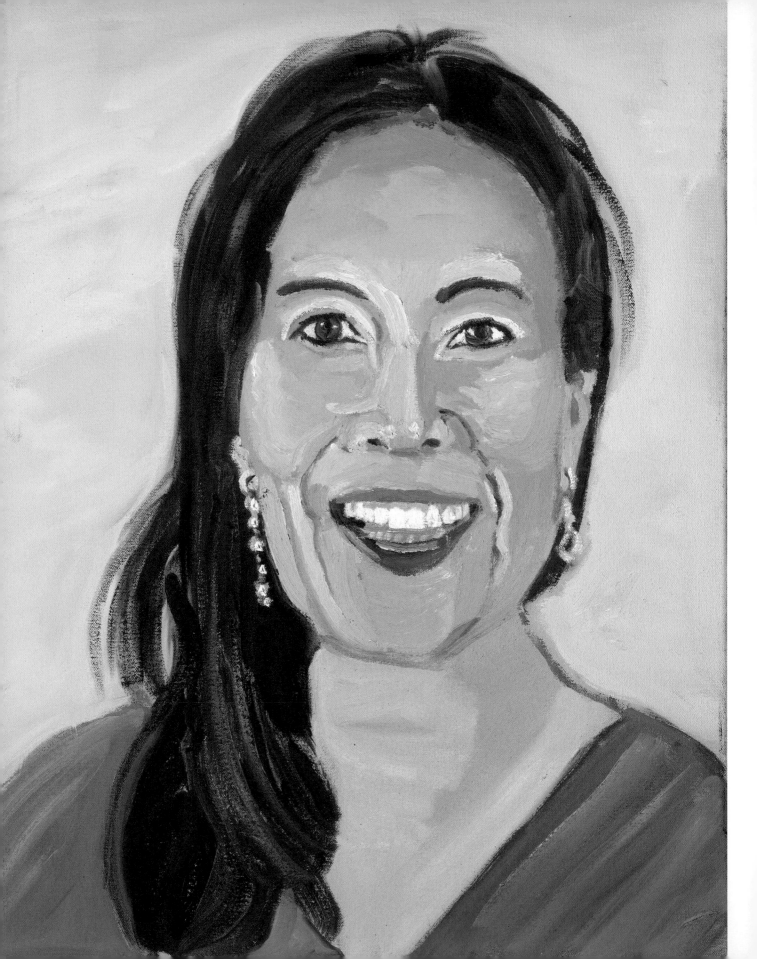

TINA TRAN

———

WHAT IS YOUR EARLIEST MEMORY? The sound of your mother's voice, or the smell of her cooking? Opening up a new toy on Christmas morning? Tien "Tina" Tran told me that her first memory in life is being handed over to a machete-wielding pirate and "trying to keep it together" somewhere between the South China Sea and the Gulf of Thailand. At the time, she was three and a half years old.

Tina's birthplace, Saigon, had fallen to Communist forces months before she was born. Her parents had sided with the Americans in the war and knew it wasn't safe to stay. They waited, Tina says, until they "could come up with a plan to escape." In 1979, she, her mother, her brother, and 383 others crowded onto a rickety fishing boat with a capacity of 120. They set sail for Malaysia, joining hundreds of thousands of other South Vietnamese "boat people" who fled their homeland. For many, and for Tina, the journey was perilous.

"Our boat was stopped by two pirate ships, one on either side," Tina recounts. "The people on the boat decided that a good peace offering would be to hand over a small young girl, and they chose me. My mom later told me that I instinctively knew not to cry. They were actually quite kind to me, and our boat was okay." *Okay* is a relative term. They held Tina's brother over the side of the boat until everyone onboard surrendered their possessions. But no one was harmed or kidnapped, and the group made it to a Red Cross refugee camp on Bidong Island in Malaysia.

Tina's next memories are of hunger and hardship. "I did not feel safe, and I was constantly afraid of being abandoned. Food was a big part of survival. The moms stood in line every day for milk and other provisions, and the kids stood in line every day for our one-cookie allotment," she says. Upon receiving their ration, the kids were given a black X mark on the back of their hands. One day,

when Tina was particularly famished, she found some Borax soap and, as she puts it, scrubbed off the top layer of her skin and got back in line for a second cookie.

"When I sat down to eat it in our little dirt encampment, my mom looked at me and said, 'I thought you already had your cookie.' I told her what I had done. Then she said, 'Whatever happens, you're going to be just fine.'" The confidence and resourcefulness Tina showed as a young child would serve her well throughout her life.

After living in that camp for a year, Tina flew to California with her mom and brother. "My mom's siblings, who had left in 1975 with the help of the American Army, sponsored us. When we arrived, they were there with big stuffed teddy bears. We took over one room in their home, and they dropped me in kindergarten without any English skills. I was able to adapt and quickly blend in," she says.

Tina's father joined them in Los Angeles two years later. He had worked as a lawyer in Vietnam but couldn't practice in the United States. So he became a landscaper. "He went from using his intellect every day to cutting lawns in the hot Southern California sun. People did what they had to do," Tina says. "My parents went to community college at the ages of thirty-four and thirty-two to learn English, and my mom, who never had a job before, found work as a data entry clerk. We had friends who were judges in Vietnam and became busboys in the US. It was really about the opportunity to work, to have your kids go to school, to be safe and together. I am so grateful for my parents' willingness to sacrifice and adapt so that my brother and I would have the opportunity to thrive."

Because she came to America at such a young age, Tina learned English quickly and without an accent. "In school, I didn't feel any different. I knew we were poor, but I excelled in school and was active and outgoing. I felt American. My teachers were kind, and my classmates just saw me for what I could do in the classroom and how I played outside of the classroom," she says. She only remembers one time when a boy picked on her for looking different. "My reaction was to kick him. I'm not saying that's what one should do," she laughs, "but nobody bothered me again."

After graduating from UCLA in 1997, Tina looked for jobs as a management consultant. "My parents didn't know what that was. I barely knew myself. But I knew I wanted to start my career in New York City." She applied for openings at multiple firms. The Manhattan office of Coopers & Lybrand—

now PricewaterhouseCoopers—initially declined to interview her. Ultimately, because of her tenacity and talent, they made a wise choice and hired her.

After later moving to Europe for an international job, Tina settled back in California in 2015. She led business development at innovative tech startups before landing at Facebook and eventually Microsoft, where she manages strategic partnerships. Tina is raising a son, Finn, whom she describes as "an affectionate kiddo who makes friends easily and loves to eat and play sports—just like his mom!" And she's helping people understand the perspectives of refugees and immigrants through her work with a nonprofit called Hello Neighbor (started by her friend and fellow Presidential Leadership Scholar Sloane Davidson). "Hello Neighbor runs a mentorship program that connects neighbors who live in the community with refugees who have recently resettled to help them adapt and thrive in the US," Tina explains. "You will find very patriotic people in immigrant and refugee communities. We know what we've been given by being able to come here because we know what we didn't have."

About a month before my mother died, Tina met her at my dad's presidential library in College Station, Texas. She told the Silver Fox, "We came here as refugees when I was very young, and I'm very grateful to be here." From her scooter, Mom replied, "I am so glad you're here with us."

"I couldn't tell if she meant welcome in the United States or with her there at the time, but it was just the warmest, most welcoming greeting," Tina says. My first memories are of my mother's welcoming voice, and I'm sure she meant both.

SUMERA HAQUE

"We worked hard, but America has provided us security and opportunities since we landed here. We are living examples of the American dream."

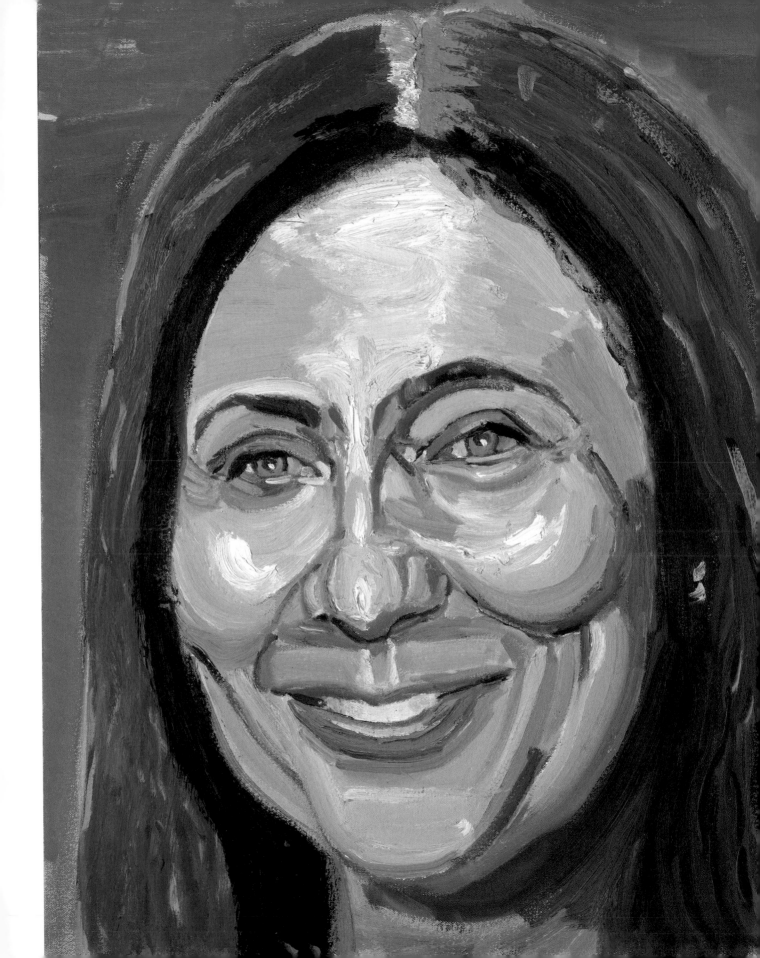

At a Presidential Leadership Scholars event in 2019, Sumera Haque stood up in front of the group, thanked me for my immigration policies, and told a story from 2004. "At the hearing for our asylum, the judge asked us to come forward. She said, 'If we allow you to stay here, promise me you will serve women here and around the world.' I said, 'I promise.' My boys were twelve and nine at the time. The judge said to them, 'Promise me that like your mother, you will both work hard.' My boys said, 'Yes, ma'am.' And the judge said, 'You're not going back to Pakistan. Welcome to America.'"

In the years since then, Sumera and her boys have kept their word, and America is better for it.

Sumera grew up in Pakistan and got married while she was in medical school. The day after the wedding, she discovered that her husband was not only a heroin addict but a brutal bully. When he hit her that day, it was the first in a series of daily mental and physical abuses. She stayed in the marriage for seven years for the sake of her children and because of the cultural stigma of being a single woman in Pakistan. "I left him in 1997 when I saw him doing drugs in front of my sons," she says. When she confronted her husband, he went into a rage that put Sumera in a hospital.

She was no stranger to hospitals. Her mother had been diagnosed with a brain tumor when Sumera was in the seventh grade, which inspired her to pursue a career in neurosurgery. "I wanted to save lives and prevent the suffering that my mother endured," she said. She entered another marriage, this time to a Pakistani man who worked at the World Bank in Washington, DC. Sumera moved to the United States in 1999 and earned a master's in public health at George Washington University to complement the medical degree she had gotten in Pakistan. "I came here thinking that now I have security and peace of mind," she explains. "But my second husband mentally tortured me, saying I only married him for financial reasons, and he refused to legally adopt my sons."

In December 2002, her husband planned a "family vacation" back to Pakistan. Once they were there, he disappeared with the passports of Sumera and her two sons and filed for divorce. She felt deceived, trapped, and afraid.

With help from a friend, Sumera and her boys returned to the United States in January 2003, only to be denied reentry at Dulles airport. Fortunately, a lawyer named Debi Sanders approached them at that moment. She explained that she was there with the CAIR Coalition, a group that gives legal aid to immigrants.

Debi told Sumera that she had the right to apply for asylum—which the judge later granted—and connected Sumera with a prestigious law firm that took on her case pro bono. "Every day, women like Debi embrace women in trouble like me," Sumera says. "They are empowering other women and their children whose destinies would have been destroyed if left at the mercy of their abusers. They are changing the world."

As Sumera built a new life in our nation's capital, she never forgot the commitment she made at her asylum hearing, she never forgot the friend who helped her return, and she never forgot the friends, family, and strangers—people like Debi Sanders—who helped her along the way. She leads Johns Hopkins Women's Health Center in Washington, DC, to meet the health care needs of women. As director, Sumera has established the center as a leader in academic training and teaching for other women's centers in developing countries around the world. She also serves on the US-Pakistan Women's Council and volunteers with organizations that support battered women and immigrants.

"I am most proud of raising my two beautiful sons as feminists," she says. "Yes, we worked hard, but America has provided us security and opportunities since we landed here. We are living examples of the American dream." Her younger son graduated from George Washington University and is pursuing his MBA from the University of Maryland while working in cancer research at Johns Hopkins Medicine. And her eldest, a University of Maryland graduate, works for a nonprofit in the UAE that expands educational opportunities in developing countries.

As I painted Sumera, I tried to capture her pride in her sons, her joy in her work, and her gratitude for our country. America is only as strong as the strength of its citizens, and we are fortunate that Sumera Haque is one of us.

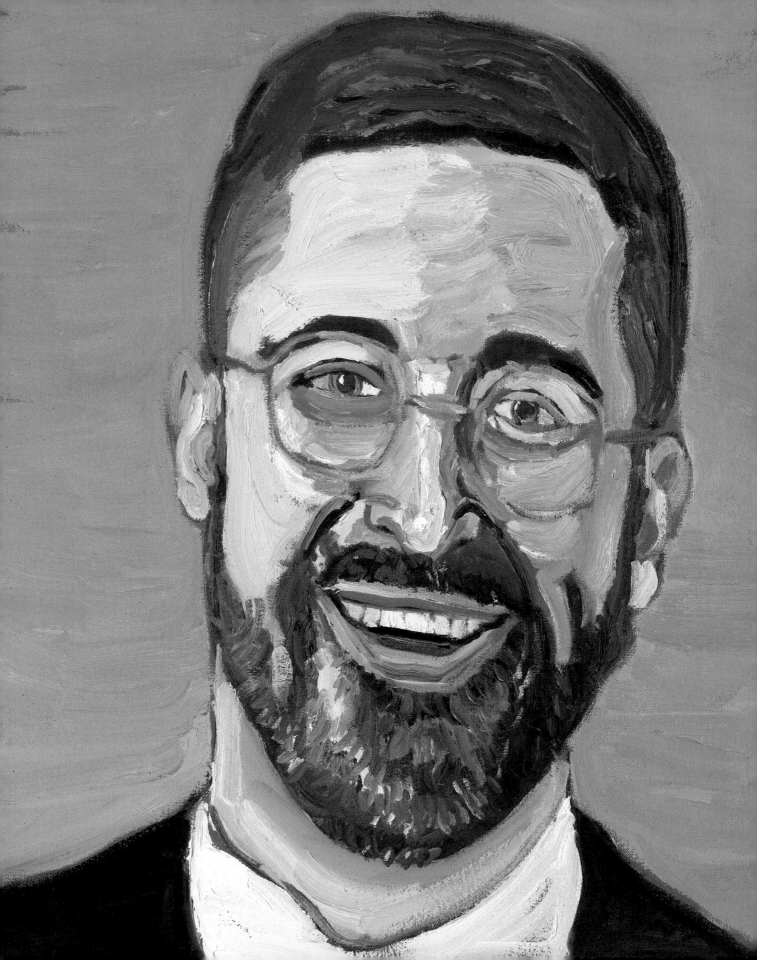

LEV SVIRIDOV

ON HIS FIRST MORNING in the United States, eleven-year-old Lev Sviridov woke up early. It was April 1993 in Burlington, Vermont. "At four a.m., I looked out on a foggy pasture filled with cows and small homes. I couldn't believe my eyes and thought that we must be in the wrong place," he says. "I ran and woke up my mother. She looked at my panicked face and asked what was wrong.

"I said, 'Mom, are we in America?' She nodded her head and said that we were. I yelled out, 'But where are all the nukes?'"

Lev and his single mom had just arrived from Moscow, Russia, and were staying with friends. Lev was born near the end of the Soviet era and grew up doing "duck and cover" drills to prepare for nuclear attacks from the United States. Communist propaganda had shaped his image of America as a faceless, futuristic empire packed with nuclear warheads all aimed at him. "Things I took to be the norm on the Russian side turned out to be the exact opposite of reality as it was," he explains.

As a young boy, Lev had spent his summers in Ukraine with his grandmother, a Holocaust survivor. The rest of the year, he'd lived with his mom in a communal apartment in Moscow. "I loved waddling to school in my overcoat," he remembers. He attended the first grade at age seven, then the second grade, before skipping all the way to fifth. He says they "studied Russian, a bit of history, math, and nuclear preparedness."

The last years of the Communist era were marked by food shortages, and the Soviet government had struck a trade deal with the United States to import surplus chicken. Lev remembers lining up with his mom to receive their weekly rations of two chicken legs, each of which seemed as large as an entire Russian bird. They became known as "Bush Legs," named for the American President, my father.

Lev's mother, Alexandra, was a filmmaker and journalist. When the USSR crumbled, she started a popular television show called *Top Secret*. "It exposed former members of the KGB to make sure they would never have access to the halls of power within the new democratic state of the Russian Federation," Lev says. "Every week for close to two years, her reporting resulted in the resignations of state deputies and even the head of the Russian Central Bank."

Alexandra was blacklisted for her provocative investigative journalism, and at least two attempts were made on her life. After she survived a gas attack exiting the subway near their apartment, a colleague advised her to take a "long vacation" with Lev. She arranged a series of research fellowships in Canada and the United States, and the two of them flew out in April 1993. "When entering the United States for the first time, I remember a member of the US Customs Service asking me what I would do while my mom was working," Lev says. "I proudly responded with a phrase I spent a long time learning: 'I want to eat.'"

Later, just as Lev's mom was finishing her last research fellowship at NYU, the family's "long vacation" was unexpectedly extended. A constitutional crisis led to a violent military standoff in Russia. "When it came time to return, my mom watched in horror as the second coup erupted in the streets of Moscow, and I rejoiced at the prospect of staying in America. As I said to Mom at the time, no mother would take their child into a war zone." Overstaying their visas, however, meant Alexandra was no longer able to work.

Soon, the mother and son found themselves homeless in New York City. They stayed with friends when they could but spent many nights wandering the streets. At the peak of their hopelessness, just as they considered returning to Russia, Lev and his mom heard about the Lawyers Committee for Human Rights—now Human Rights First, where Lev is a board member with Sanja Partalo (page 189). That's where they met my friend Tom Bernstein, an attorney and businessman who has been involved with the organization for decades.

"Tom invited us to celebrate Thanksgiving with his parents," Lev recalls. "To this day, it was the most food I have ever seen in my life." The Bernsteins went on to help the Sviridovs with their immigration paperwork and support them financially for years. "Tom and the Bernsteins changed the course of my life," Lev says. "I am eternally grateful."

Lev became an American citizen in 2004. The following year, he graduated from the City College of New York summa cum laude. "I am most proud of the

public university system that gave me a superb education," he says. "No other place would see me for who I could be versus what I was in the moment. It is a uniquely American outlook on opportunities that led to my being nominated and selected as a Rhodes Scholar." That scholarship led him to the University of Oxford, where he earned their equivalent of a PhD in inorganic chemistry. Lev and his brilliant mind have published papers with titles I cannot even pronounce, like "An In Situ Synchrotron Study of Zinc Anode Planarization by a Bismuth Additive," "Magnetic Properties of Fe_2GeMo_3N: An Experimental and Computational Study," and "A Manganese-Doped Barium Carbonate Cathode for Alkaline Batteries."

Lev is a lot like the Energizer Bunny. He just keeps going. At the CUNY Energy Institute, he helped develop large-scale batteries for backup power and renewable energy delivery. For the last seven years, he has directed Macaulay Honors College at the City University of New York's Hunter College. "Our students meet the highest academic metrics and go on to fantastic professional and academic careers," he says. "The vast majority are either the first in their families to go to college and/or are immigrants or children of immigrants. I have done my best to make the most of every opportunity afforded to me. The opportunities themselves are what I am most proud of and what I try to pass on to all of my students."

I had the privilege of meeting Lev and his mother in New York City in early 2020. For such a brilliant man, Lev is down-to-earth and humble. And his mom, a brilliant person in her own right, is a force of nature. I walked away feeling uplifted and fortunate to call them both my fellow Americans.

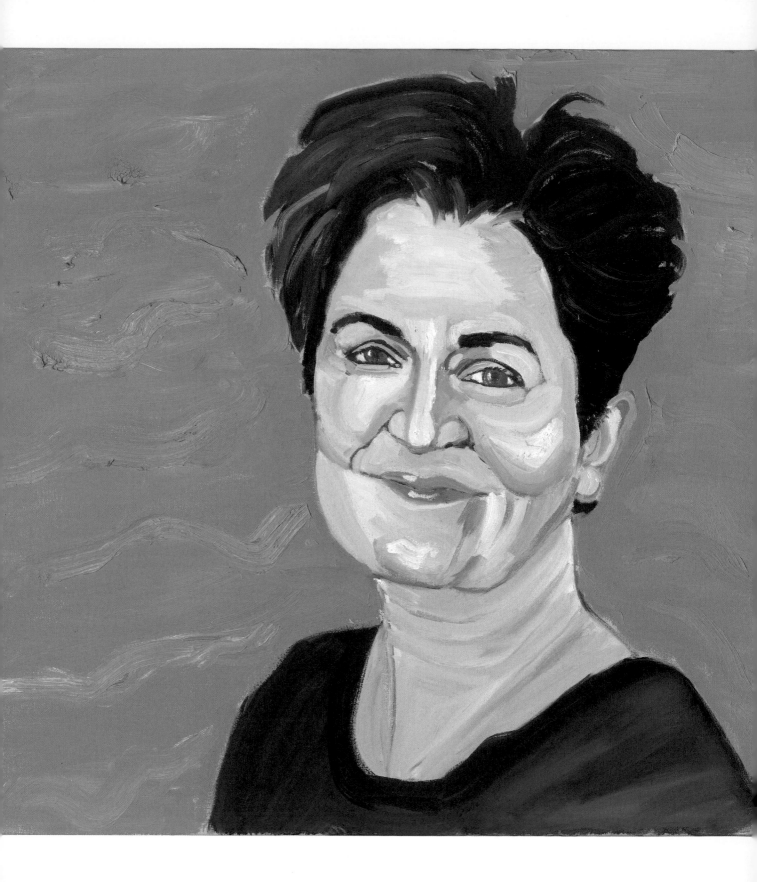

MARIAM MEMARSADEGHI

"We have a moral obligation to listen to our conscience and help others so that they can be free, empowered, and able to create a future."

The Iranian Revolution of 1979 changed Iran and the entire Middle East. During a time of relative peace and prosperity, the Shah of Iran was overthrown and replaced with a new Islamist government led by a Grand Ayatollah. Since seizing power more than forty years ago, the "Supreme Leaders" and unelected mullahs have plunged a beautiful country into economic and social ruin.

Mariam Memarsadeghi lived through it. "I was seven years old when the Iranian Revolution happened, and my family had no plans whatsoever to leave the country. My parents had, in fact, created a very good life. My dad was a successful young architect with a lot of promise and potential," she says.

"When the revolution happened, one of the first targets of the Islamists was our private school. In their minds, it was a symbol for westernization, or as the revolutionaries called it, West Toxification." Mariam's teachers, whom she adored, were thrown out and replaced. "Our new teacher was just downright violent," she says. One day, the teacher hit one of her classmates for voicing his opinion. "It was such an ominous sign for all of us. Fear really ruled over us," she says.

Mariam's grandfather, a colonel in the Iranian military, happened to be visiting the United States as the violence intensified. When the family saw members of the military and government being executed, they sent word for him to stay put. "My parents felt, especially my mom, that I couldn't have a future in Iran, particularly as a girl, so we joined my grandparents here in the United States," she says. "We didn't think it would be forever, but it's been forty years now. I am extremely grateful to the United States for having taken us at a time when it wasn't clear if we could even have a life in our home country, never mind a good life."

The family resettled in Frederick, Maryland, and got on a path to earn green cards. "I was very fortunate to grow up there," Mariam says. "I had the very best opportunities. Not because it was a particularly privileged place—it was an ordinary, rural small town—but I had what I consider a few very good teachers. They made all the difference. And everyone was so welcoming and supportive."

At the time, fifty-four Americans were being held hostage by the Iranian regime. "Rather than look at us with suspicion or disdain, the Americans who surrounded me and nurtured me gave me every possible trust," Mariam says. "I couldn't believe that school could be such a happy, playful place."

Eleven years after arriving, Mariam and her family became US citizens. She was eighteen years old and preparing to head to Dickinson College. Her father,

who was a recognized architect in Iran but started out as a home improvement contractor when he arrived in America, launched a successful business developing homes and communities. "I am very proud of my dad for being able to take the best of what this country offers—to move forward, not to dwell on a life that was essentially lost. And I'm proud of my mom for always pushing me to embrace the openness and opportunity of America, rather than be fearful of change."

While the Memarsadeghis became patriotic, contributing, successful Americans, they also held on to their heritage. "Forty years later, we still eat the same foods, speak the Persian language, and talk about Iran and our family who are there," Mariam explains. In short, they demonstrate what makes the melting pot work.

Mariam has dedicated her career to the pursuit of democracy in Iran, becoming a leading activist in that struggle. In 2010, she started a group called Tavaana: E-Learning Institute for Iranian Civil Society, which provides online courses and tools for political action. Despite government restrictions on Internet access, the project has reached millions of Iranians. "It is now a household brand throughout the country and the diaspora, providing civic education and civil society development support," Mariam says. Her ultimate goal is to spur democratization in Iran. "So much of the terrorism, the Islamist ideology, the anti-Americanism, the anti-Semitism, the backwardness, is because of this regime.

"American citizenship is really about a sense of pride and belonging, of giving back to the place that took you in, of believing in its values and rights," Mariam reflects. "We have a moral obligation to listen to our conscience and help others so that they can be free, empowered, and able to create a future. It's only through supporting them and their struggle for a free future that we can all be safe and live much, much better lives."

ARNOLD SCHWARZENEGGER

"I wish every American realized that being born here is the greatest opportunity. You don't know how lucky you are. And because of that, it's our duty to do everything in our power to leave a better America to the next generation."

A S A BOY GROWING UP in Thal, Austria, after World War II, Arnold Schwarzenegger dreamed of a better life. And he knew exactly how he would achieve it: by becoming the world's most muscular man. "It was a very strange time," Arnold says. "We were poor, food was scarce, and the adults were suffering from what we now know as post-traumatic stress. Our house had no plumbing, no shower, and no flushing toilet. The nearest well was almost a quarter mile away, and we had to walk to fetch water, no matter the weather. My father was strict, and he made us train with knee-bends or crunches or push-ups or chores to earn our breakfast."

Arnold took to the physical training more than the chores and started spending time at the gym. His father, a police officer, wasn't too enthusiastic about Arnold's bodybuilding pursuits. "I felt like I was out of place in Austria," Arnold says. "There was no room for my big dreams."

There was even less room inside of the tank Arnold drove as a part of his mandatory military service. Every morning during his year with the Austrian Army, he woke up three hours early to work out. "Focus, visualize . . . whatever it takes," he told himself. In *Arnold's Blueprint*, an ESPN *30 for 30* film, he recounts sneaking off base and onto freight trains in order to reach Stuttgart, Germany, to pose in the 1965 Junior Mr. Europe competition—which he won. "It was one of those important moments, because I realized I wasn't dreaming," he said in an interview for the film. "They've never heard of me, and they picked me. So I must have something that is unique."

When Arnold got back to base, he wasn't exactly greeted with a hero's welcome. His superiors sent him to solitary confinement for going AWOL and sentenced him with the classic punishment of peeling potatoes. The extra time to work out alone and the opportunity to devour protein in the kitchen turned out to be a gift. Arnold gained twenty-five pounds of muscle that year. His comrades started to rally behind him and pushed him to train even harder. The next year, he won Mr. Europe, then Mr. Universe in London in 1967 and 1968.

"I had always thought of coming to America," Arnold says. "I had this gut feeling that I just belonged in America. It was a beacon of opportunity for me, a place where I could make my dreams of becoming a bodybuilding world champion and getting into movies a reality. After I won my second Mr. Universe con-

test in London, I finally got the telegram I dreamed of from Joe Weider, the king of the bodybuilding world, when he offered to bring me to America."

Arnold arrived in Los Angeles in 1968 on a tourist visa to train for the US Mr. Universe and Mr. Olympia competitions. "I remember the generosity of Americans more than anything," he says. He compares moving into his apartment to a sitcom episode: "One bodybuilder brought over a set of dishes; one bodybuilder brought a little old TV; one bodybuilder showed up with a couch. It was an endless parade of big muscular guys just showing up to help me move in and feel at home in a new country." He and his new friends trained hard every day—"focus, visualize . . . whatever it takes." But the man who could bench-press 520 pounds missed his family, and he missed his mom's schnitzel.

Arnold's hard work and sacrifice—and his schnitzel-free diet—soon paid off. In 1970, he fulfilled his dream of becoming the greatest bodybuilder in the world when he was crowned Mr. Olympia in New York City, the youngest ever at age twenty-three. He also won in '71, '72, '73, '74, '75, and, famously, in 1980, after five years away from the sport. The story was chronicled in a documentary called *The Comeback*.

Having proved all the naysayers wrong, Arnold set out to defy expectations again by pursuing a film career. Once again, he was told to give it up. Talent agents said he would never make it in Hollywood with a funny name, heavy accent, and massive body. "Focus, visualize . . . whatever it takes," he told himself. His drive and personality proved even bigger than his twenty-two-inch biceps, and he started to earn roles that called for a unique physique. After Arnold appeared in *Hercules in New York* in 1970, he started the process of getting his green card.

In 1982, Arnold got his big break as an actor when he was cast as Conan the Barbarian. And the next year, he got his biggest break when he became a US citizen. Arnold sent me a photo from what he calls the proudest day of his life. Festooned in red, white, and blue, he looks like a buffer version of Uncle Sam. At his request, I painted him from that photo. I tried to capture his energy, his determination, and his sheer joy in that moment.

"One thing I learned quickly is that nobody becomes a US citizen on their own," Arnold says. "A lot of people helped me along the way. I could never have done it without Joe Weider and countless others who helped with my English and

made me feel like part of the American family. I tell people they can call me Arnie, they can call me schnitzel, they can call me Danny DeVito's twin. Just never, ever call me a self-made man. There is no such thing."

After appearing in dozens of blockbusters and earning a star on the Hollywood Walk of Fame, Arnold set his sights on a new goal: to give back to the country that had given him everything. "To me, being an American means getting off the couch, working your ass off, and changing the world. You can't change the world if you are sitting in front of your television yelling at it," he says. "If you want to be an actor or an athlete, put in the time and training necessary to get there. If you are unhappy about the politicians, voice your opinion. Being an American is being a doer who gives back."

Arnold had gotten a taste for public service when my dad asked him to chair the President's Council on Physical Fitness and Sports. (The two of them struck up quite a friendship. Dad called him "Conan the Republican," and Arnold was at Camp David sledding with my parents when Mom crashed into a tree and broke her leg.) In 2003, Arnold took on perhaps his loftiest goal of all: to become the thirty-eighth Governor of California.

All the experts said he couldn't win. Arnold felt that his state was in a crisis, however, and he had a plan to save it. He campaigned hard and won by more than a million votes. I was President at the time and saw the action hero in action, particularly when wildfires ravaged Southern California. Arnold provided calm, decisive, organized leadership.

When asked if he is living the American dream, Arnold says, "Duh. Who would have thought that a farm boy from Austria could come here and become a bodybuilding champion, then the highest-paid actor, then the Governor of the largest state, all in one lifetime? One of the great things about America is that every time I accomplish one dream, another dream begins. Now my dreams are bigger.

"I wish every American realized that being born here is the greatest opportunity," Arnold says. "You don't know how lucky you are. And because of that, it's our duty to do everything in our power to leave a better America to the next generation." As the proud father of five children, the former Governor is focusing on just that. At the USC Schwarzenegger Institute, he continues his work on issues he cared about as Governor, including the environment, homelessness, and immigration reform.

"Any effort to solve this problem must be comprehensive, and any politician who truly wants to get something done must be ready to compromise," he says about the third item on that list. "We need better border security, we need a better visa system that makes sure we attract the best workers, we need to have penalties for employing illegal immigrants, and we also need a system to deal with the millions of hardworking immigrants who are already here."

I hope our country takes a cue from Arnold—focus, visualize, and do whatever it takes to pass comprehensive immigration reform.

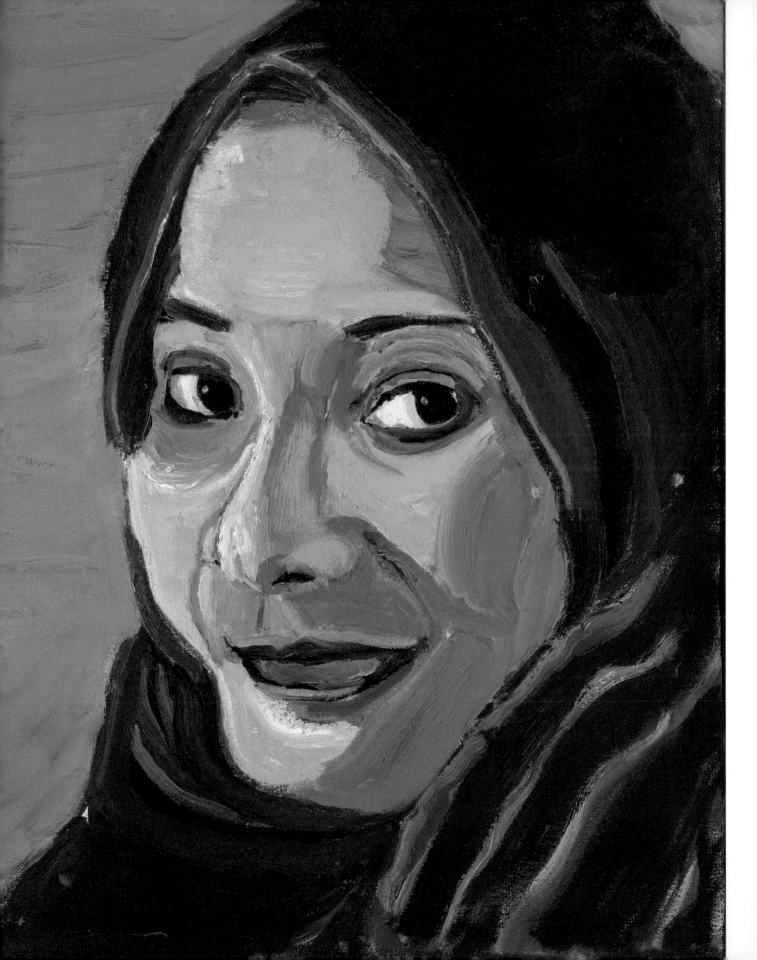

SHABIHA NYMPHI

"Since my childhood,
I always wanted to help others."

O N PAPER, SHABIHA NYMPHI and I don't have much in common. She's a young Muslim woman from Bangladesh by way of Malaysia; I'm an old Methodist man from Texas by way of Connecticut. When we met before her naturalization ceremony at the Bush Center on March 18, 2019, I learned we were both artists. Moments later, we were equal Americans under the law.

Shabiha had a comfortable upbringing in Bangladesh, where she was born in 1989. Her father was an officer in the Army and a respected medical professional while her mother raised Shabiha and her brother. "I am fortunate to have grown up in a very disciplined, well-educated, and economically stable family," she says. "Since my childhood, I always wanted to help others. I saw my dad working for the community and providing free medical services for people who were needy and poor. So that really motivated me to give back."

When her father retired from the Army, he moved the family to Malaysia so he could become a professor of medicine and Shabiha could pursue her bachelor's degree. "It is a more female-dominated country. I pursued law school because I thought it would help me help people." Shabiha jokes that law suits her better anyway, because she loves to talk.

Around then, Shabiha started corresponding with a young gentleman named Rashed, a Bangladeshi-American electrical engineer in Dallas. He visited her in Malaysia, and they married in 2013. When she came to America the next year, Shabiha was worried about whether she'd be accepted. "There is a stigma. I wear a hijab, and I came from a Muslim country," she explains. But when she started working at Sam's Club and HomeGoods, her concerns quickly faded away. "People smiled at me because I looked different and they wanted me to feel welcome. I saw how this country is about tolerance and acceptance. Europe is beautiful, but here I feel that I'm walking with everyone else."

Working in retail, Shabiha was on both the giving and receiving ends of her other American surprise: "I have never seen such great customer service anywhere in the world! I have been to other economically well-off countries, but the culture of tolerance, cooperation, and compassion is something I really appreciate here."

Shabiha continued working while pursuing her MBA at Texas A & M Commerce with a focus in health care administration. Along the way, she and Rashed had a young son, Zayan. (While raising a newborn, Shabiha graduated in 2019 with a 3.9 GPA.) These days, when Zayan takes a nap, she works on building her online art business.

"There are a lot of resources for entrepreneurs in this country," she says. "There are a lot of opportunities, and fewer barriers to entry in terms of starting your own business. I am an artist. I love to paint. Reading books, learning new skills, listening to motivational speeches, and writing are my hobbies. Serving mankind and inspiring others are my passions. America to me is a place where I can practice my values and pursue my passions at the same time."

This young American's story is still unfolding. Shabiha is balancing the needs of her family and the demands of her career as she charts her future in a new land. When I watched Shabiha take the oath of allegiance to the United States on a beautiful spring morning in Dallas, I felt a deep sense of gratitude—to our country, for welcoming a talented newcomer, and to a talented newcomer, for choosing our country.

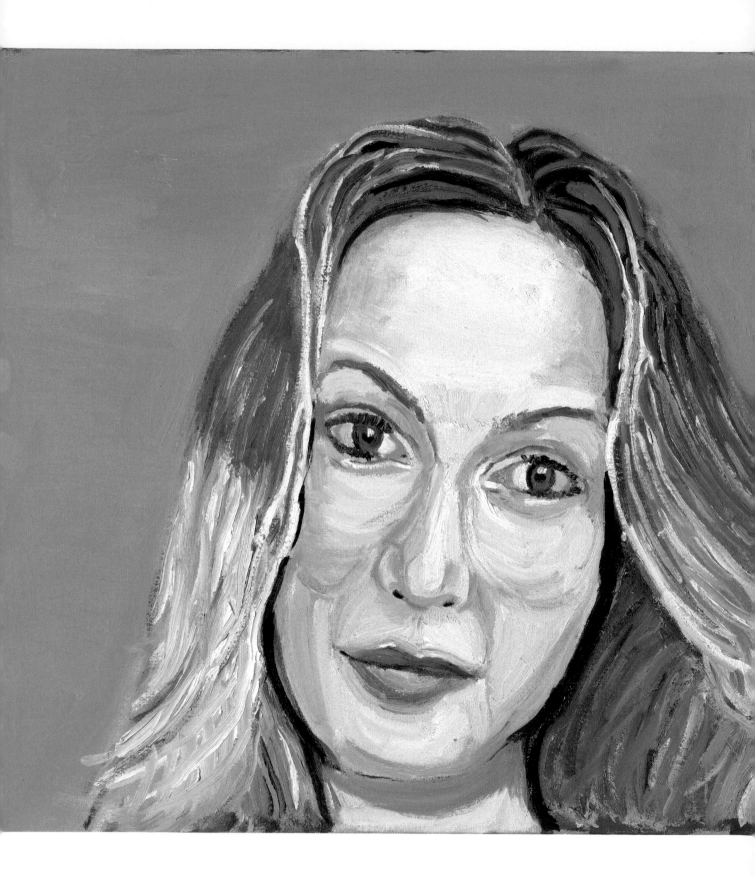

SANJA
PARTALO

———————

FOR THE FIRST TEN YEARS of her life, Sanja Partalo had a comfortable, carefree childhood. She grew up in Banja Luka, Bosnia and Herzegovina, which was then a part of Yugoslavia. "My mother was an electrical engineering professor—the only woman in her graduating class, and to date, still one of the most brilliant people I know. My father worked for an oil and gas company. They were high school sweethearts," Sanja says. "Our home was always ringing from the sounds of lively conversation and random visitors. My extended family lived nearby, and we spent a lot of time together. We were close, we were fun, and we were many."

"It was a beautiful life," she remembers. "War put an end to all of it."

In 1992, the Bosnian war pitted Serb (Orthodox Christian), Croat (Catholic), and Bosniak (Muslim) forces against one another. Sanja's city was taken over by extremists. Her father, of Orthodox Christian heritage, was issued "wartime orders" and forced to leave home. Before departing, he taught ten-year-old Sanja and her mother how to shoot a gun to protect themselves.

"For the next four years of my life, I watched my home country disintegrate into a lawless, artillery-shelled purgatory that swallowed everything I once held dear," Sanja says. "It would take merely weeks for ethnic cleansing to begin, first in the dark of night and then in broad daylight."

Soon, Muslims and Catholics were no longer welcome in Banja Luka, a divide that ran through Sanja's own household. "My mother and family, because of their Muslim background, were subjected to persecution and daily instances of humiliation—being forced to sweep the streets, called names, and spat on," Sanja says. "Toward the end of our time in Bosnia, we spent the majority of our days in

our basement waiting for the air-raid sirens to stop." After being injured, Sanja's mom decided to leave as soon as she recovered.

"It's an utterly disorienting feeling to pack your whole life in a backpack and leave your home, your community, every smiling face that knows you and cares about you, not knowing when you will see them again, or if you ever will," Sanja says. She, her mom, and her sister joined a group of Muslim and Catholic refugees and began a two-week trek toward the Hungarian border.

At one point, the group was captured and imprisoned in an abandoned school. Ironically, it was an attack that saved them. "The area was bombed, and the military retreated, leaving us behind in a collapsing building, able to scatter into the countryside."

For nearly two years, they lived in a refugee camp in Békéscsaba, Hungary—which today houses Syrian refugees. "It was a deeply depressing experience to be confined behind barbed wire, without any hope or near-term solution," Sanja says. "We had escaped war, and now it felt like we were in jail.

"It would take a series of suicides to attract the attention of the international community," she explains. "In 1996, the United States, Canada, and Australia opened up a program to accept Bosnian refugees still living in camps. It all culminated with a flight from Budapest to Minneapolis that November. It was the first time I'd been on a plane."

Sanja's only reference point for her new home was knowing that a character from the show *Beverly Hills, 90210* came from Minnesota. Starting from nothing was difficult, but her family was warmly received by Catholic Charities. They took them to the DMV to get identification, enrolled the girls in school, and covered the $400 security deposit for their one-bedroom apartment. "Resettlement agents are special people," Sanja says, "and organizations that do this type of work should be celebrated more than they are. Ours, Mr. Kossel, worked small miracles for us."

At almost fifteen years old, Sanja went back to school for the first time in two years. "I spoke little English and had only finished the sixth grade in Bosnia," she says. "I was placed in ninth grade and was afraid I would never catch up. So I got to work. And I did not stop." She perfected her English and quickly excelled at Edison High School. At the same time, Sanja worked thirty hours a week in a secondhand store. She cleaned houses with her mom on the weekends and taught

her English at night. "I was our translator, our negotiator, our second income, and my mom's partner in crime in helping her find a job in her field."

In time, Sanja's family rebuilt the beautiful life that they had lost decades ago. Her dad made it to the United States a few years later and became a bus driver. Her mom went on to lead engineering teams at Seagate, a premier technology company. Her parents recently retired and migrated one last time, from Minnesota to Florida. Sanja's sister lives in New York City, where she runs marketing for Spotify. And Sanja, a graduate of George Washington University and Columbia Business School, now works as the youngest executive vice president at WPP—the largest marketing services company in the world. She teaches at Columbia Business School and serves as a board member of Human Rights First, where she supports refugees as they make their own way in her adopted home.

"I will forever be thankful to this country and the many Americans who showed me kindness," Sanja says. "They could have chosen to see a sack of skin and bones in secondhand clothes, speaking in broken English. What they chose to see instead was a fighter. An ambitious young person. Someone worthy of betting on. That is uniquely American."

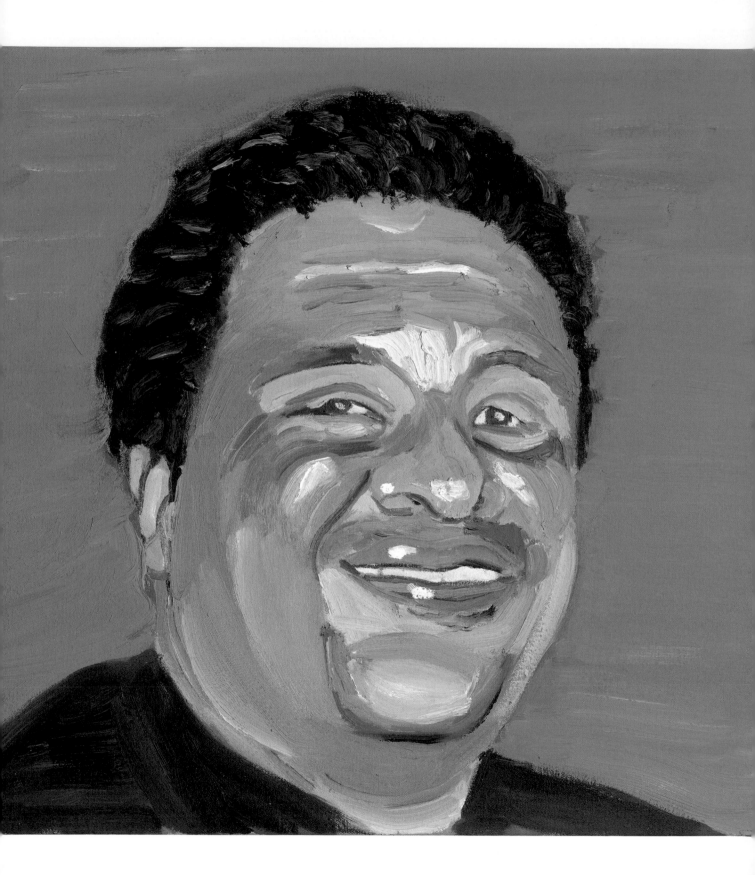

JUAN CARLOS CADREMY

IN LATE 2016, Biscayne Bay Brewing Company received a résumé from Juan Carlos Cadremy. The executive team couldn't believe their luck. The manager of brewing at Cervecería Regional, Venezuela's second-largest beer producer, was applying to work for their small craft brewery outside of Miami.

At the time, Regional produced six million barrels a year. Biscayne Bay? A thousand. Jose Mallea, who worked down the hall from the Oval Office during my presidency, had founded the brewery in 2012. He interviewed Juan Carlos by video, and Juan Carlos arrived in Miami the day after Christmas 2016. A few days later, he reported for work.

Juan Carlos had grown up in Maracaibo, Venezuela's second-largest city, and never imagined leaving. He was born in 1974, when an oil boom and one of the freest market economies in the world helped make Venezuela's wages the highest in Latin America. "My mother was a primary school teacher for thirty-three years, and my father was a merchant," Juan Carlos says. "Thanks to their efforts, my siblings and I were all able to study at university."

In 2001, Juan Carlos earned his degree in chemical engineering from Universidad del Zulia. It was a popular major in the petroleum-rich country, but Juan Carlos didn't go to work in the oil fields. He went straight for the beer. He had interned at Cervecería Regional during college, and they hired him as an engineer-in-training.

His talents—along with his gregarious, jovial personality—helped him advance quickly. In less than fifteen years with the company, Juan Carlos was promoted to supervisor, assistant brewmaster, brewmaster, and eventually manager of brewing, overseeing the plant's entire production. Along the way, he

picked up a master's in brewing technology from the Polytechnic University of Madrid in Spain and married Tabata, a national project manager with Cervecería Regional. They had a daughter in 2004, and life was good.

As Juan Carlos's personal circumstances improved, the country around him began to collapse. Hugo Chavez came to power in 1999 with the promise of helping working-class Venezuelans through his brand of "twenty-first-century socialism." ("Those who want to go directly to hell," Chavez declared, "they can follow capitalism.")

Juan Carlos watched as Chavez morphed into a corrupt dictator, destroying his country in the process. Chavez and his successor, Nicolas Maduro, ruined Venezuela's economy. They seized private property and nationalized corporations. Price controls and massive overspending on welfare programs contributed to hyperinflation. Currency manipulation made it difficult for companies to conduct business. Regional and other brewers struggled to import barley needed for production. And violent, government-backed labor unions imposed crippling strikes. During one thirty-day work stoppage, Juan Carlos had to climb a fence and sneak into the brewery to save sixty tanks of beer.

Thousands of companies have closed, and millions of people have fled the country since Chavez came to power. Meanwhile, Maduro and his cronies enriched themselves selling drugs and contraband, which led to a rare indictment of a foreign leader by the United States in March 2020. Across the country, Venezuelans suffer from power blackouts, pitiful access to health care, food shortages and starvation, and a deadly crime wave.

"Meat and bread were almost impossible to buy," Juan Carlos explains. "My ID had the number five on it, and that meant we could only shop on Wednesdays and during certain times on Sundays. Since we worked, that meant we only had four hours to shop a week. We had to stand in line, and most of what we needed wasn't there. It was dangerous because of robbers looking for food and money. I was scared for my wife and daughter."

When a petition to oust Maduro failed in late 2016, Juan Carlos and his family decided it was time to get out. They had traveled all over the United States with the Master Brewers Association of the Americas and wanted to resettle in Miami. Biscayne Bay Brewing Company became his family's ticket out. He was grateful for his job, but it was a demotion from the job he had done at Regional twenty

years earlier. "We arrived in an empty house with only one bedroom for all my family," he remembers. "We slept on an air mattress for six months."

With help from the brewery, Juan Carlos has spent the past three years navigating the complex immigration process. He has spent more than $15,000 pursuing permanent residency and asylum status. As I write this in 2020, both are still pending. Jose Mallea says his company needs Juan Carlos to survive. "He has helped our brewery become one of the fastest-growing in Florida, and we can't find anyone else with his experience and qualifications," Jose says.

Juan Carlos says being an American "means being brave, being proud of this country, and being confident that we will succeed." I am confident that if we continue to welcome brave souls like Juan Carlos, America will continue to succeed.

INDEX

MADELEINE ALBRIGHT
CZECHOSLOVAKIA
Oil on stretched canvas, 18" × 24"
Page 27

JAVAID ANWAR
PAKISTAN
Oil on stretched canvas, 16" × 20"
Page 87

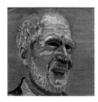

SALIM ASRAWI
LEBANON
Oil on stretched canvas, 20" × 20"
Page 35

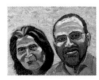

TONY GEORGE BUSH AND HIS MOTHER, LAYLA
IRAQ
Oil on stretched canvas, 40" × 30"
Page 76

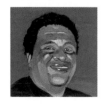

JUAN CARLOS CADREMY
VENEZUELA
Oil on stretched canvas, 20" × 20"
Page 193

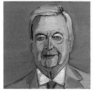

ARMANDO CODINA
CUBA
Oil on stretched canvas, 24" × 24"
Page 95

ZUNITA CUMMINS
PANAMA
Oil on stretched canvas, 24" × 24"
Page 90

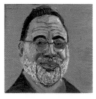

ALFREDO DUARTE
MEXICO
Oil on stretched canvas, 24" × 24"
Page 43

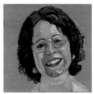

AMY EBSA
ETHIOPIA
Oil on stretched canvas, 24" × 24"
Page 111

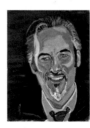

DAVID FEHERTY
NORTHERN IRELAND
Oil on stretched canvas, 18" × 24"
Page 126

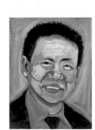

BOB FU
CHINA
Oil on stretched canvas, 18" × 24"
Page 73

FLORENT GROBERG
FRANCE
Oil on stretched canvas, 24" × 36"
Page 119

JOSEPH KIM
NORTH KOREA
Oil on stretched canvas, 16" × 20"
Page 17

MARK HAIDAR
LEBANON
Oil on stretched canvas, 16" × 20"
Page 65

HENRY KISSINGER
GERMANY
Oil on stretched canvas, 18" × 24"
Page 31

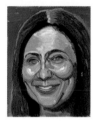

SUMERA HAQUE
PAKISTAN
Oil on stretched canvas, 18" × 24"
Page 166

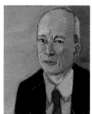

JEANNE CELESTINE LAKIN
RWANDA
Oil on stretched canvas, 30" × 30"
Page 51

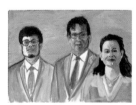

**DENNYS HERMOZA,
SAMANTHA TASAYCO,
SEBASTIAN HERMOZA**
PERU
Oil on stretched canvas, 40" × 30"
Page 57

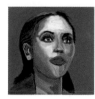

YUVAL LEVIN
ISRAEL
Oil on stretched canvas, 20" × 24"
Page 83

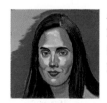

ALFIA ILICHEVA
RUSSIA
Oil on stretched canvas, 30" × 30"
Page 123

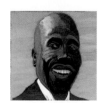

PHILIP ALIER MACHOK
SUDAN
Oil on stretched canvas, 36" × 36"
Page 155

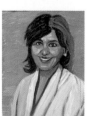

DILAFRUZ KHONIKBOYEVA
TAJIKISTAN
Oil on stretched canvas, 18" × 24"
Page 135

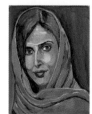

ROYA MAHBOOB
AFGHANISTAN
Oil on stretched canvas, 30" × 40"
Page 139

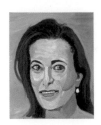

DINA POWELL MCCORMICK
EGYPT
Oil on stretched canvas, 20" × 24"
Page 147

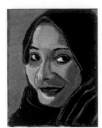

SHABIHA NYMPHI
BANGLADESH
Oil on stretched canvas, 18" × 24"
Page 185

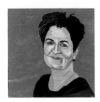

MARIAM MEMARSADEGHI
IRAN
Oil on stretched canvas, 30" × 30"
Page 175

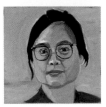

SHINHAE OH
NORTH KOREA
Oil on stretched canvas, 20" × 20"
Page 107

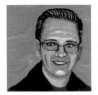

CARLOS MENDEZ
MEXICO
Oil on stretched canvas, 20" × 20"
Page 131

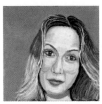

SANJA PARTALO
BOSNIA
Oil on stretched canvas, 24" × 24"
Page 189

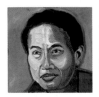

KIM MITCHELL
VIETNAM
Oil on stretched canvas, 24" × 24"
Page 61

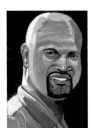

ALBERT PUJOLS
DOMINICAN REPUBLIC
Oil on stretched canvas, 24" × 36"
Page 115

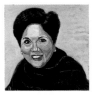

INDRA NOOYI
INDIA
Oil on stretched canvas, 36" × 36"
Page 39

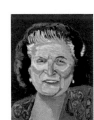

PAULA RENDON
MEXICO
Oil on stretched canvas, 18" × 24"
Page 23

DIRK NOWITZKI
GERMANY
Oil on stretched canvas, 30" × 40"
Page 102

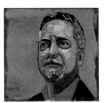

CARLOS ROVELO
EL SALVADOR
Oil on stretched canvas, 20" × 20"
Page 151

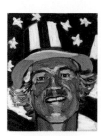

ARNOLD SCHWARZENEGGER
AUSTRIA
Oil on stretched canvas, 18" × 24"
Page 179

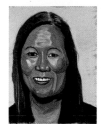

ANNIKA SÖRENSTAM
SWEDEN
Oil on stretched canvas, 24" × 24"
Page 68

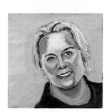

THEAR SUZUKI
CAMBODIA
Oil on stretched canvas, 30" × 40"
Page 99

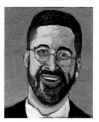

LEV SVIRIDOV
RUSSIA
Oil on stretched canvas, 20" × 24"
Page 171

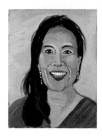

TINA TRAN
VIETNAM
Oil on stretched canvas, 18" × 24"
Page 163

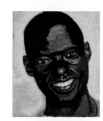

GILBERT TUHABONYE
BURUNDI
Oil on stretched canvas, 18" × 24"
Page 47

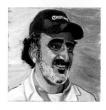

HAMDI ULUKAYA
TURKEY
Oil on stretched canvas, 36" × 36"
Page 143

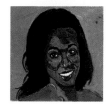

EZINNE UZO-OKORO
NIGERIA
Oil on stretched canvas, 20" × 20"
Page 158

Facts on Immigration

Immigrants have always been a part of the United States. Their contributions have added to the success of this nation throughout history.

1850 1880 1900 1920 1940

CANADA

U.S. IMMIGRANTS REGION OF ORIGIN

FOREIGN-BORN POPULATION AS A PERCENTAGE OF U.S. POPULATION 1850-2018

EUROPE & MIDDLE EAST

REGION NOT REPORTED

REGION NOT REPORTED

Since 1901, 132 U.S. immigrants have been awarded a Nobel Prize, one third of all U.S. prize-winners.

Physics
Medicine
Chemistry
Economics
Literature
Peace

Immigrant awarded a Nobel Prize

0%

1850 1880 1900 1920 1940

Immigration to America peaked in 1890, when 14.8% of our population was foreign-born.

FOREIGN-BORN POPULATION AS A PERCENTAGE OF U.S. POPULATION

100%

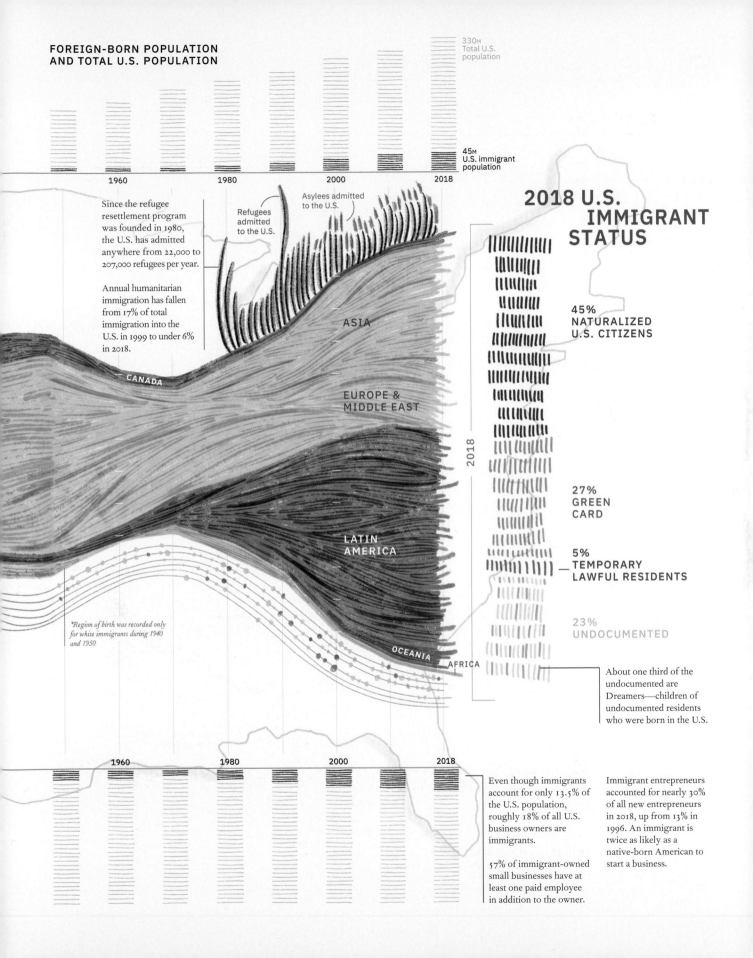

FOREIGN-BORN POPULATION
AND TOTAL U.S. POPULATION

330M
Total U.S.
population

45M
U.S. immigrant
population

1960 1980 2000 2018

Since the refugee resettlement program was founded in 1980, the U.S. has admitted anywhere from 22,000 to 207,000 refugees per year.

Annual humanitarian immigration has fallen from 17% of total immigration into the U.S. in 1999 to under 6% in 2018.

Refugees admitted to the U.S.

Asylees admitted to the U.S.

ASIA

CANADA

EUROPE & MIDDLE EAST

LATIN AMERICA

*Region of birth was recorded only for white immigrants during 1940 and 1950

OCEANIA

AFRICA

2018

2018 U.S. IMMIGRANT STATUS

45%
NATURALIZED
U.S. CITIZENS

27%
GREEN
CARD

5%
TEMPORARY
LAWFUL RESIDENTS

23%
UNDOCUMENTED

About one third of the undocumented are Dreamers—children of undocumented residents who were born in the U.S.

1960 1980 2000 2018

Even though immigrants account for only 13.5% of the U.S. population, roughly 18% of all U.S. business owners are immigrants.

57% of immigrant-owned small businesses have at least one paid employee in addition to the owner.

Immigrant entrepreneurs accounted for nearly 30% of all new entrepreneurs in 2018, up from 13% in 1996. An immigrant is twice as likely as a native-born American to start a business.

Becoming an American

There are four main ways to obtain a green card in the United States. Each path varies in length, time, and expense. Of the 19 million people who applied, about 1.1 million people were granted green cards in 2018. There are about 5 million people stuck in the green card applicant backlog, visualized in the background of this piece. Of these, about 14% face such a long wait in line that they are likely to die before a green card becomes available to them.

1. EMPLOYMENT

Among OECD countries, the United States places the least amount of emphasis on work-based immigration, with only 5.8% of green cards issued for employment or skills in 2018.

1,000,000 PEOPLE ARE BACKLOGGED FOR EMPLOYMENT GREEN CARDS

START HERE

You receive job offer in U.S.

Employer files labor certification with Department of Labor

Employer posts ads and interviews workers in U.S. who meet minimum requirements

DOES QUALIFIED U.S. WORKER EXIST?
NO / YES

If qualified U.S. worker exists, employer must hire U.S. worker → **NO GREEN CARD**

DID THE DEPARTMENT OF LABOR APPROVE LABOR CERTIFICATION?
YES / NO

Once visa is available, employer files petition to sponsor you

File petition to apply for permanent residence

YOU ARE:

Abroad: consulate conducts visa interview

Already in U.S.: file an adjustment of status petition

WAS THE EMPLOYER PETITION APPROVED?
YES / NO

Approved employer petition sent to National Visa Center

NO GREEN CARD

Wait for visa to become available

Receive visa and enter U.S. as permanent resident

DID YOU PASS USCIS SECURITY CHECK?
PASS / FAIL

DID YOU PASS U.S. CONSULATE VISA INTERVIEW?
PASS / FAIL

Receive stamp in passport at port of entry *(temporary evidence of lawful permanent residence)*

DID YOU RESPOND ON TIME TO REQUEST FOR EVIDENCE?
YES / NO

NO GREEN CARD

DID YOU PASS USCIS SECURITY CHECK?
PASS / FAIL

Wait for visa to become available

130,000 PEOPLE AND THEIR DEPENDENTS RECEIVED EMPLOYMENT GREEN CARDS IN 2018

RECEIVE GREEN CARD

2. DIVERSITY

14,000,000 PEOPLE APPLIED FOR THE DIVERSITY GREEN CARD LOTTERY IN 2019

There are 55,000 diversity visas available every year. The lottery runs from October to December, and the Department of State sets the lottery rules every year. You can apply whether you are in the U.S. or abroad.

START HERE

You are native of country with low rate of immigration to U.S.
OR
You claim nativity to country with low rate of immigration through spouse or parent
YES / NO

Submit completed paperwork and lottery entry form to Department of State by deadline

NO GREEN CARD

DID YOU MEET DEADLINE?
YES / NO

DID RANDOM COMPUTER-GENERATED LOTTERY PICK YOU?
YES / NO

Receive notification if selected by computer

Submit visa application

Pay application and other fees

YOU ARE:
Abroad: consulate conducts visa interview
OR
Already in U.S.: file an adjustment of status petition
PASS / FAIL

DID YOU COMPLETE BEFORE DEADLINE OR BEFORE AVAILABLE VISAS RAN OUT?
YES / NO

NO GREEN CARD

Receive visa to enter U.S. as legal permanent resident, or adjust status in U.S.

45,000 PEOPLE RECEIVED DIVERSITY GREEN CARDS IN 2019

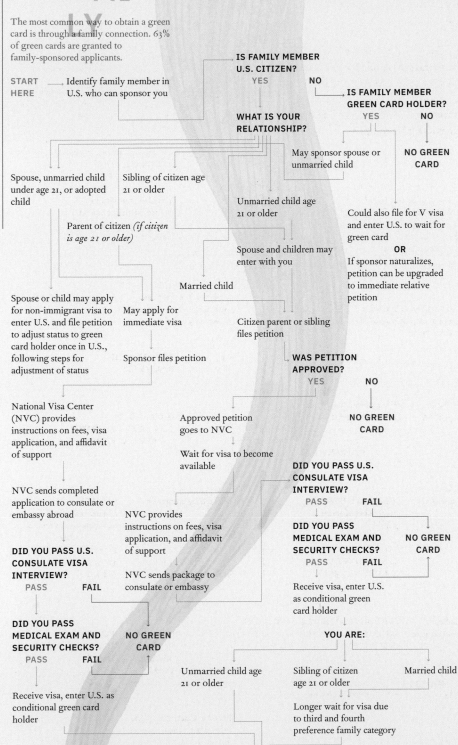

3. FAMILY

The most common way to obtain a green card is through a family connection. 63% of green cards are granted to family-sponsored applicants.

START HERE → Identify family member in U.S. who can sponsor you

IS FAMILY MEMBER U.S. CITIZEN?
YES NO

WHAT IS YOUR RELATIONSHIP?

IS FAMILY MEMBER GREEN CARD HOLDER?
YES NO

May sponsor spouse or unmarried child

NO GREEN CARD

Spouse, unmarried child under age 21, or adopted child

Sibling of citizen age 21 or older

Unmarried child age 21 or older

Could also file for V visa and enter U.S. to wait for green card

OR

If sponsor naturalizes, petition can be upgraded to immediate relative petition

Parent of citizen *(if citizen is age 21 or older)*

Spouse and children may enter with you

Married child

Spouse or child may apply for non-immigrant visa to enter U.S. and file petition to adjust status to green card holder once in U.S., following steps for adjustment of status

May apply for immediate visa

Sponsor files petition

Citizen parent or sibling files petition

WAS PETITION APPROVED?
YES NO

National Visa Center (NVC) provides instructions on fees, visa application, and affidavit of support

Approved petition goes to NVC

NO GREEN CARD

Wait for visa to become available

NVC sends completed application to consulate or embassy abroad

NVC provides instructions on fees, visa application, and affidavit of support

NVC sends package to consulate or embassy

DID YOU PASS U.S. CONSULATE VISA INTERVIEW?
PASS FAIL

DID YOU PASS MEDICAL EXAM AND SECURITY CHECKS?
PASS FAIL

NO GREEN CARD

DID YOU PASS U.S. CONSULATE VISA INTERVIEW?
PASS FAIL

DID YOU PASS MEDICAL EXAM AND SECURITY CHECKS?
PASS FAIL

NO GREEN CARD

Receive visa, enter U.S. as conditional green card holder

Receive visa, enter U.S. as conditional green card holder

YOU ARE:

Unmarried child age 21 or older

Sibling of citizen age 21 or older

Married child

Longer wait for visa due to third and fourth preference family category

RECEIVE GREEN CARD

4. INVESTMENT

The EB-5 visa is available to prospective immigrants who have at least $900,000 to invest in the U.S. Only 10,000 EB-5 visas are available each year.

START HERE

You start business in U.S.
OR
You transform existing business
OR
You save struggling business
YES NO

Invest at least $1.8 million
OR
Invest $900,000 in "Targeted Employment Area"
YES NO

NO GREEN CARD

Create 10 jobs
OR
Maintain employee level at struggling business
YES NO

Submit petition

YOU ARE:
Abroad: consulate conducts visa interview
OR
Already in U.S.: file an adjustment of status petition
PASS FAIL

NO GREEN CARD

Receive visa

Enter U.S. on conditional green card *(two-year limit)*

Within 90 days of two-year anniversary, petition to remove conditions on green card

RECEIVE PERMANENT GREEN CARD

ACKNOWLEDGMENTS

I am a project-oriented person. It wasn't long after finishing *Portraits of Courage* that I started thinking about ideas for my next one. I knew I wanted to spotlight people of character and consequence. As I was brainstorming in 2018, Ken Mehlman, who managed my 2004 re-election campaign, dropped by to see me in Dallas. A successful investment banker and like-minded conservative, he urged me to get involved in the current immigration debate, the tone and direction of which concerned us both deeply.

I told Ken that the Bush Institute was already leading on the issue, and I felt most comfortable weighing in through its work. I reminded him of my preference to steer clear of the political issues of the day so as not to second-guess my successors. Ever the skillful negotiator, Ken changed tacks and spoke to the eager painter in me. He suggested that I paint portraits of immigrants to reflect my belief in the positive effects they have on our country. At that moment, this book came to life, and I thank Ken for planting the seed.

I asked my chief of staff Freddy Ford, who helped with *Portraits of Courage*, to collaborate with me once more and spearhead the project. This book would not have happened without Freddy's creativity and hard work, and I thank him. He wisely reassembled the dream team from *Portraits of Courage*. Bob Barnett of Williams & Connolly provided able and affable representation, as always. Under the enthusiastic and thoughtful leadership of David Drake (an immigrant whom I am proud to call my fellow American) and Tina Constable, Crown Publishing proved themselves yet again to be the best partners in the business. Derek Reed's meticulous editing and organization made the book better. Marysarah Quinn and Linnea Knollmueller, the dynamic design and production duo, turned my amateur paintings into a beautiful volume worthy of display. Many other professionals at Crown worked hard on this book, and I am grateful to them all, including Sally Franklin, Dyana Messina, Mark Birkey, Dan Zitt, and Allison Fox.

As we identified subjects, gathered photos, and researched candidates and policies, Freddy and I relied on a lot of help from the dedicated staff at the Office

of George W. Bush and the George W. Bush Presidential Center. In my office, Natalie Lomont and Charles Branch were particularly helpful in liaising with the immigrants in this book, keeping us organized, and providing important research and edits. Even before I finished the manuscript, Caroline Link was working on the book tour—our fourth together. Caroline Floeck, Logan Garner, Christina Piasta, Madeline Rice, and Carol White contributed too, and I thank them.

I am unbelievably proud of what we've achieved at the George W. Bush Presidential Center since we opened our doors less than a decade ago. And the credit belongs with the people there. I am fortunate that my friend Ken Hersh, a successful business executive, serves as president and CEO, and that Holly Kuzmich, a dynamic policy expert, is executive director of the Bush Institute. The leadership team was behind this project all the way, and I thank Hannah Abney, Brian Cossiboom, Guy Kerr, and Michael McMahan, as well as General Patrick Mordente of the George W. Bush Presidential Library and Museum. Laura Collins heads up our immigration work, and I relied on her expertise and advice every step of the way as we developed this project. I'm grateful to everyone who pitched in in various and important ways, including but not limited to Emily Casarona, Sarah Gibbons, Andrew Kaufmann, Kristin Kent Spanos, Kristin King, Lindsey Knutson, Lindsay Lloyd, Katie Lynam, Matthew Rooney, Kevin Sullivan, Jenny Villatoro, and Chris Walsh. I would be remiss if I did not also acknowledge the immigrants who work at the George W. Bush Presidential Center in addition to Joseph Kim, such as Kat Cole, Jeff Kim, Ioanna Papas, Farhat Popal, Jieun Pyun, and Caterina Rossini.

The research for this book was based primarily on oral and written interviews with the men and women I painted. In addition to thanking them for their time and candor, I would like to acknowledge those who helped with that process: Jean Becker, Jeb Bush, Jeb Bush, Jr., Lesley Berry, Bill DeWitt, Don Evans, Jacob Freedman, Jackie Gil, Mary Pat Higgins, Patty Huizar, Daniel Ketchell, Michael Kives, Martha Lein, Susan Lenihan, Jessee LePorin, Jason Lutin, Brenda Magnotta, Mike McGee, Liza Romanow, Nishant Roy, Lara Beth Seager, Jan Stewart, and Shea Vandergrift. Throughout the book are the names of others who helped along the way, all for whom I am appreciative.

Grant Miller, a talented White House photographer during my presidency, came to Dallas when I did in 2009 and has captured much of my post-presidency. He shot a lot of the pictures from which I painted, and I would like to credit Grant

and the other photographers whose work inspired me: Charles Branch, Nick Del Calzo/The Medal of Honor Portrait Collection, Paul Ernest Photography, Freddy Ford, Getty Images/NBA Photos, Gary Gnidovic, Timothy Greenfield-Sanders, Noa Griffel, Sid Hoeltzell/The Miami Foundation, Andrew Kaufmann, Gina Kelly/Pujols Family Foundation, Motofish Images, Arpi Pap, Anthony Rathbun, Holly Reed, Mark Roper, Jason Schmidt, and Brandon Wade/*Dallas Morning News*. My Maine mountain-biking friend Chris Smith of C. A. Smith Photography took the photos of my art studio in the opening pages and captured Javaid Anwar's portrait for the book. Coupralux, an art printer in Dallas, scanned the rest of the portraits and did the color correction for the book. Thanks also to Giorgia Lupi—an American immigrant from Milan, Italy—and her colleagues at Pentagram Design, Phillip Cox and Sarah Kay Miller, for designing the "Facts on Immigration" and "Becoming an American" illustrations.

As in my last book, I want to thank my art instructors—Gail Norfleet, Jim Woodson, and Sedrick Huckaby—for teaching me to paint. And I especially thank my wife, Laura, whose patience knows no bounds. She waited decades for me to pay any attention to art. Now that we share that interest, I continue to test her patience—now by tracking paint from my studio onto her furniture. I am grateful to her for encouraging my newfound passion and sharing the world of art with me.

WHY WE NEED IMMIGRATION
(AND REFORM)

Since America's founding, immigration has been an important part of our nation's story. Immigrants helped transform an eighteenth-century farming colony into the world's leading innovator and manufacturer—a superpower.

The data is clear on immigration's benefit to the economy. Immigrants come here to work, and they contribute to economic growth. Most Americans recognize the numerous ways immigrants strengthen our communities. Our outdated immigration system, however, does not.

President Bush and the Bush Institute are committed to comprehensive immigration reform. To that end, we have published *America's Advantage,* a handbook of research on immigration. Our Central America Prosperity Project brings together leaders to strengthen economies, expand markets, and reduce pressure on our southern border. And we convene a nonpartisan immigration policy working group to develop a blueprint for comprehensive immigration reform.

We believe that successful immigration reform should be based on the following principles:

- A robust, efficient immigration system must focus on employment and skills while increasing overall levels of immigration to meet the needs of our economy.
- We must secure our borders with physical barriers, manpower, and advanced technology—and by working with our neighbors to help them ensure their countries can provide the freedom and prosperity their citizens want.

- We must uphold our long-standing tradition of welcoming refugees and asylum seekers who are fleeing perilous situations all over the world.
- A more efficient temporary entry program should allow foreign workers to fill a job need in our country and then return home. We must create a rigorous, fair process for the undocumented to get right with the law, including paying a meaningful fine and back taxes, learning English, and documenting their work history. Immigrants who meet these conditions and demonstrate the character that makes a good citizen should earn the opportunity to apply for citizenship.
- We must create a special pathway to citizenship for the Dreamers, undocumented immigrants brought to the United States as children. They have not broken our immigration laws. Dreamers who are getting an education or serving in our armed forces and have passed a background check should have the opportunity for their status to reflect that they are fundamentally American.
- Full assimilation of immigrants into the American economy and culture is the responsibility of both the immigrants and the citizenry. The success of our country depends upon helping newcomers embrace our common identity as Americans—our shared ideals, history, flag, and language.

Although efforts were made in the 1980s and 1990s to address border security and the undocumented, whom we choose to admit to the United States has not changed substantially since the mid-1960s. Today's challenges are fundamentally different, and our current national debate on immigration policy is badly off track.

Every year that goes by without reforming our broken system means that we miss opportunities to ensure the future prosperity, vitality, and security of our country. When immigrants assimilate and advance in our society, they realize their dreams, renew our spirit, and add to the unity of America. At the Bush Institute, we are committed to changing the terms of this debate and offering solutions that are both bold and politically viable.

To learn more, visit
bushcenter.org/immigration